Herreshoff

AND HIS YACHTS

Other titles of interest

Sparkman & Stephens

UK ISBN 978 07136 64133

US ISBN 978 0 937822 75 3

This is a celebration of the work of arguably the most famous yacht design company in the USA. Their influence on the development of yachting and the dominance of their designs from 6, 8 and 12 metre boats to America's Cup yachts as well as ground-breaking cruising and racing yachts is quite remarkable. Franco Pace's stunning photography captures the grace and elegance of all the yachts in this collection.

Charles E Nicholson

UK ISBN 9 780713 657364

This magnificent photographic collection celebrates the work of Nicholson, the most important British yacht designer of the 20th century. In a fascinating preface, yachting historian William Collier chronicles the development of Nicholson's designs from the 1890s to the start of the Second World War.

William Fife

US ISBN 978 0 937822 49 4

A celebration of some of the most beautiful, most elegant and fastest yachts ever built.

Herreshoff

AND HIS YACHTS

FRANCO PACE

Adlard Coles Nautical
London

WoodenBoat
BOOKS
BROOKLIN, MAINE USA

Published 2008 in the UK by Adlard Coles Nautical
an imprint of A & C Black (Publishers) Ltd
38 Soho Square, London W1D 3HB
www.adlardcoles.com

Published in the USA, 2008, by WoodenBoat Books
Naskeag Road, PO Box 78
Brooklin, Maine, 04616
www.woodenboats.com

First published 2006 in Germany by Delius Klasing Verlag

UK ISBN 978-0-7136-0379-1
US ISBN 978-0-937822-98-2

A CIP catalogue record for this book is available from the British Library.

This book is produced using paper that is made from wood grown in
managed, sustainable forests. It is natural, renewable and recyclable.
The logging and manufacturing processes conform to the environmental
regulations of the country of origin.

Typeset in 13 on 17pt Celeste
Printed in Germany

Contents

Herreshoff History

The early 19th century was the era when steam engines influenced commerce and trade throughout the world. Tycoons such as Cornelius Vanderbilt owed much of his initial wealth to his fleet of steam ships, which plied the rivers of the USA and along the American east coast as far south as Nicaragua. It was, therefore, a strange quirk of fate that this steam-derived wealth helped to fund the genius of one of the world's most famous yacht designers.

Nathanael Greene Herreshoff was born in 1848 and grew up in Bristol, Rhode Island, 10 miles from Newport where Vanderbilt had built a house. Herreshoff's father was a farmer, but had a passion for boats. The area was already famous for shipbuilding due to a long season of good weather; in winter the north-easterly storms from Cape Cod weaken by the time they reach Rhode Island, and the Indian summer can last until Christmas. Whaling fleets were based there, and the Narragansett Bay shipyards were known for a variety of designs, including slave ships, brigs and topsail schooners. In colonial times, one of the Herreshoff forefathers had captained a privateer along the coastlines of the French colonies. Herreshoff's father, Charles Frederick, owned sailing boats; his elder brothers built boats for themselves; and soon young Nathanael also began to build his own.

Steam engines were increasingly being installed on board large ships. This relatively new science appealed to Herreshoff who studied for a career as a steam engineer at the Massachusetts Institute of Technology. After some years as an employee at the Corliss Steam Engine Company in Providence, he became self-employed, and in 1878 he and his brother, John Brown Herreshoff, founded the Herreshoff Manufacturing Company in Bristol. Although blind, John Brown was responsible for the commercial side of the shipyard, which built steamships in various sizes. His disability did not prevent him from having a hand in the designs – Nathanael Herreshoff built wooden models which John Brown assessed by touch.

Columbia's crew won twice against her challengers; defeating Shamrock I in 1899 and in 1901 beating Shamrock II.

Following a fatal accident in 1888 during the speed trials of a 138 foot (42 metre) steam yacht, which Nathanael was supervising, he lost his licence as a steam engineer. 'I believe he had to surrender his licence for steam engines forever,' stated his son Lewis Francis in the biography of his father, *The Wizard of Bristol*. From then on Herreshoff's destiny lay in the creation of sailing yachts. In 1891 he designed the *Gloriana*, a milestone in the new 46 foot (14 metre) waterline class. Following its success, C Oliver Iselin gave him the opportunity to design a yacht to defend the 1893 America's Cup against the challenger *Valkyrie II*, and so *Vigilant* was built in his shipyard. Herreshoff himself took the helm on board *Vigilant*, and the New York Yacht Club retained the Cup.

For the 1895 defence of the Cup, Herreshoff created an extreme design, the 123 foot (37.5 metre) *Defender*, for C Oliver Iselin, this time in partnership with William Kissam Vanderbilt II and E D Morgan. The composite construction, with steel frames, bronze plating underwater and aluminium topsides, reacted in sea water as one might expect. She was very fast, giving the Lords Dunraven, Lonsdale and Wolverton no chance of victory, but due to galvanic corrosion in the salt water she soon began to disintegrate. Four years later the shipyard had to rebuild her from the keel up and she became a sailing sparring partner for *Columbia*, Herreshoff's third Cup defender, racing in

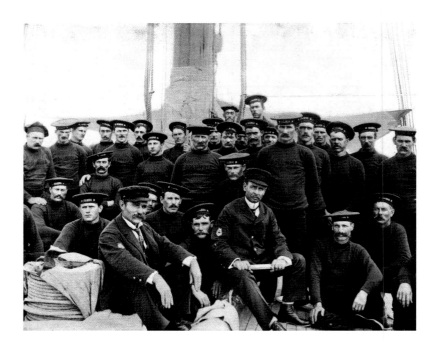

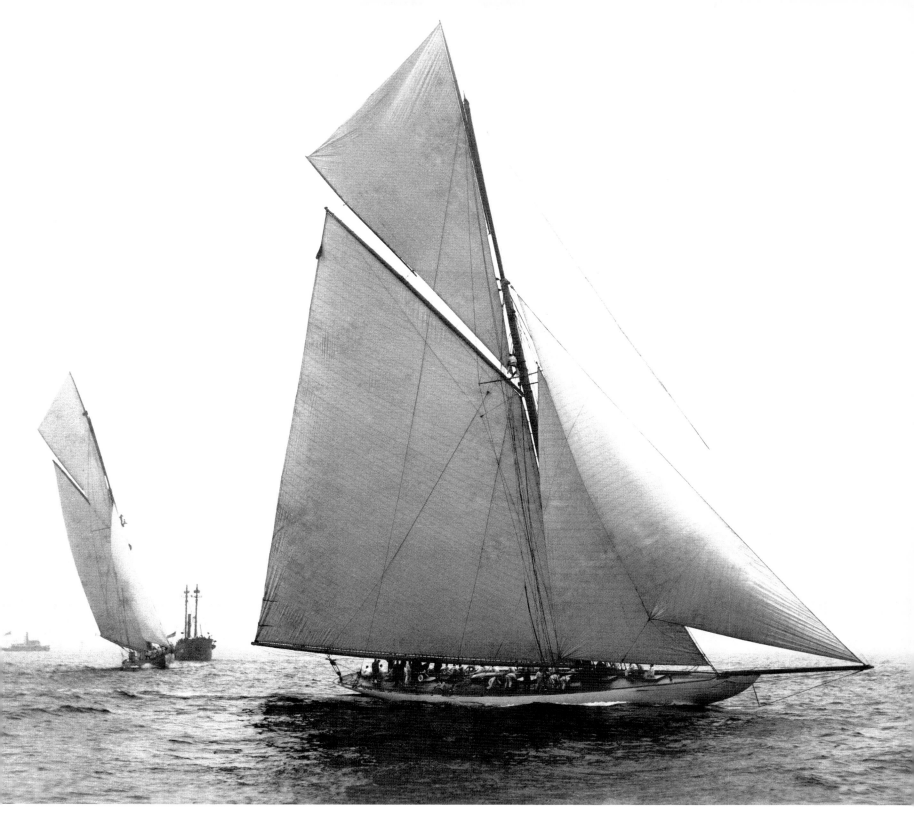

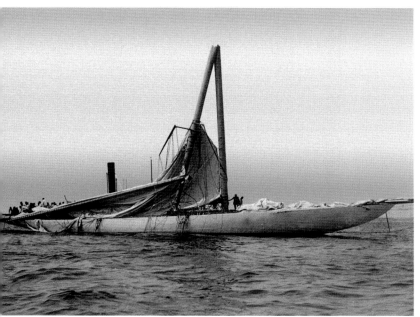

ABOVE *Herreshoff's third successful America's Cup defender* COLUMBIA. *Below the waterline,* COLUMBIA's *hull was of bronze, but unlike the 1895 Cup winner,* DEFENDER, *the topsides were not aluminium but nickel-plated steel. Because* COLUMBIA *needed a sparring partner, J Pierpont Morgan, one of the principal sponsors, asked Herreshoff to rebuild the corroded* DEFENDER *from the keel up.*

LEFT *During a race against* DEFENDER, *prior to the Cup races,* COLUMBIA's *mast folded. The hollow steel tube proved not to be as strong as the designer had hoped.*

1899 and 1901. *Columbia* won twice against the challenger Sir Thomas Lipton who raced *Shamrock I* and *Shamrock II*.

In October 1902 the New York Yacht Club received Lipton's third challenge, and a week later the contract for the defender was signed – 1,500 square metres of sail area would be kept upright, closehauled, by 127 tons of displacement, including 90 tons of lead ballast. For the extreme-design *Reliance*, Herreshoff created a hollow rudder which, when filled with seawater, eased the helmsman's task when the yacht was heeled. It succeeded. Immediately, the 144 foot *Reliance*, skippered by the legendary Charlie Barr, outclassed all competitors. She belongs among those yachts which confirm the well-known dictum that, with a few exceptions, the most successful yachts fully exhaust a rating rule, after which it often becomes yet more extreme and dangerous. She had a short life – within a year *Reliance* was laid up ashore and never raced again.

In 1903 the 'King of Teas' *Shamrock III* would lose against the Herreshoff-designed *Reliance*, this time helmed by her owner Cornelius Vanderbilt III, and in 1920 Lipton would lose again when *Shamrock IV* was defeated by *Resolute*.

The next Cup defenders did not come from the drawing board of the 80-year-old master, though they were built by the Herreshoff Manufacturing Company. The famous J-Class came from a different lineage, and

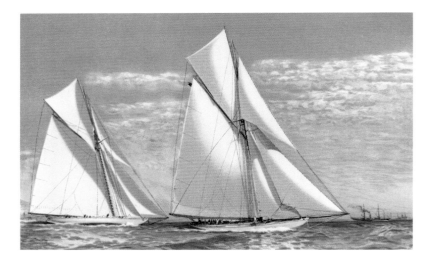

ABOVE *In 1895, DEFENDER retained the America's Cup against the British challenger VALKYRIE III.*

RIGHT *The twice victorious America's Cup winner COLUMBIA had two masts, one constructed of pine and a lighter one made of steel.*

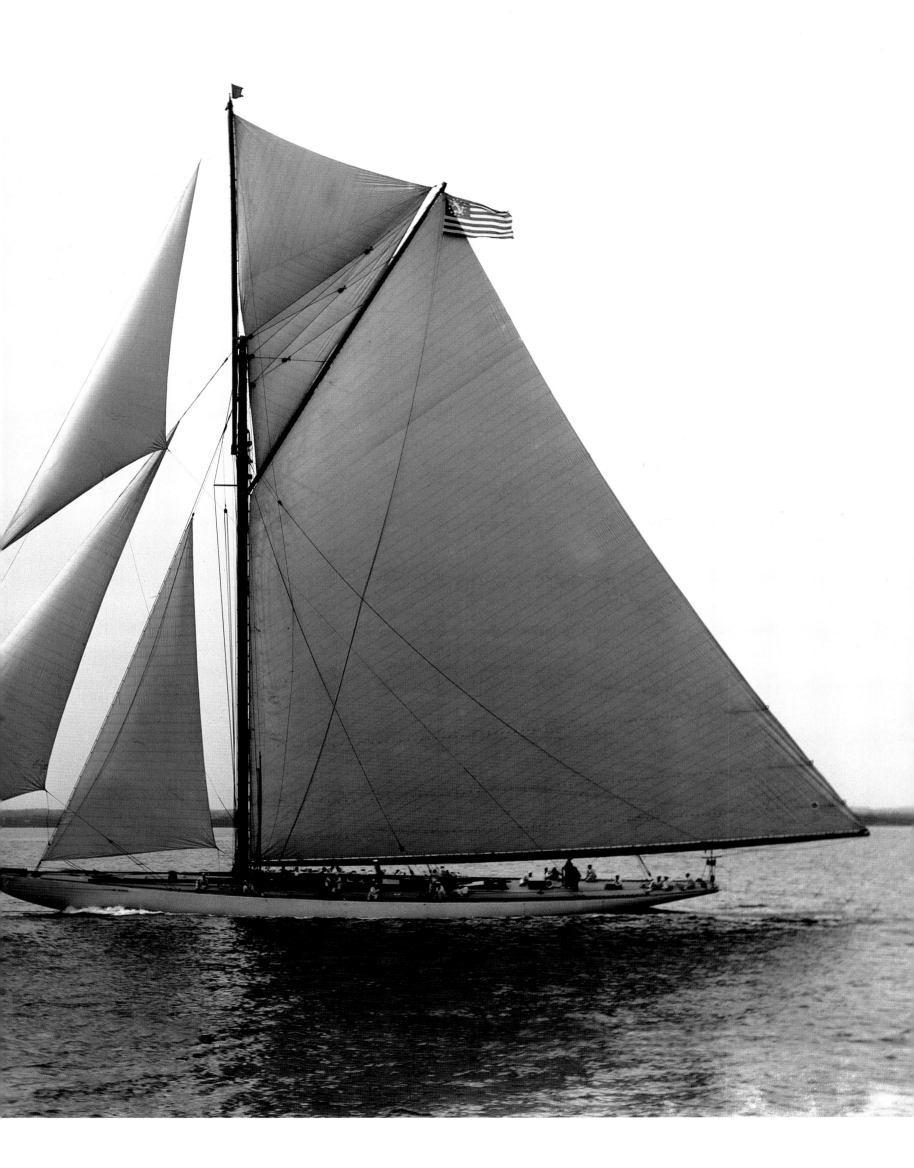

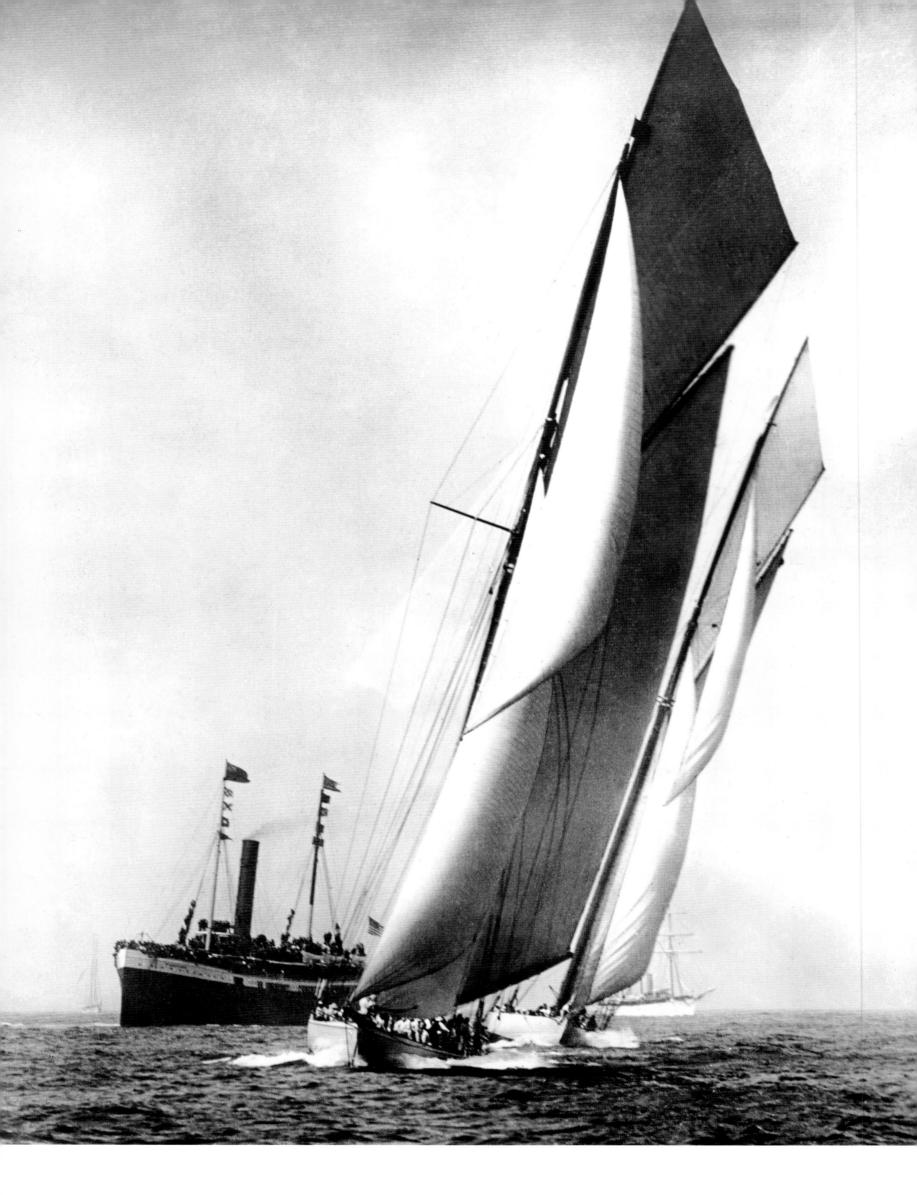

W Starling Burgess became the new design talent in the company. Burgess was a born designer. His father, Edward Burgess, had created three successful Cup defenders in as many years: *Puritan* in 1885, *Mayflower* in 1886, and *Volunteer* a year later. Burgess provided the Vanderbilt heir Harold Sterling and his syndicate with two outstanding boats: the first J-Class yacht *Enterprise* for the 1930 defence and *Rainbow* for the campaign in 1934. Both were built by the Herreshoff yard – it was not until Vanderbilt's third successful Cup defence, with *Ranger* in 1937, that the Herreshoff link was broken. Nathanael Greene Herreshoff had dominated the America's Cup as a boatbuilder and designer from 1893 until 1934.

OPPOSITE PAGE *VALKYRIE III took the lead in the first race in 1895, but later lost to DEFENDER. Although she won the second race, it was disallowed by the Race Committee. In the third race VALKYRIE III crossed the starting line and then retired, leaving DEFENDER to sail the course alone. Both these valiant yachts were broken up in 1901.*

BELOW *Alexander S Cochran's VANITIE (left) during selection trials for the 1920 Cup defence. The honour went to the Herreshoff-designed J-Class RESOLUTE (right) owned by Henry Walter.*

FOLLOWING PAGE ABOVE *In 1913 Henry Walters commissioned the design and build of RESOLUTE from Herreshoff for a price of $123,000. Her hull was constructed of riveted bronze plates on steel frames; she had a limited sail area which resulted in a lower rating.*

FOLLOWING PAGE BELOW *WEETAMOE takes the lead from ENTERPRISE. Both yachts were built by the Herreshoff Manufacturing Company for the 1930 defence of the Cup, though designed by Clinton Crane and W Starling Burgess respectively.*

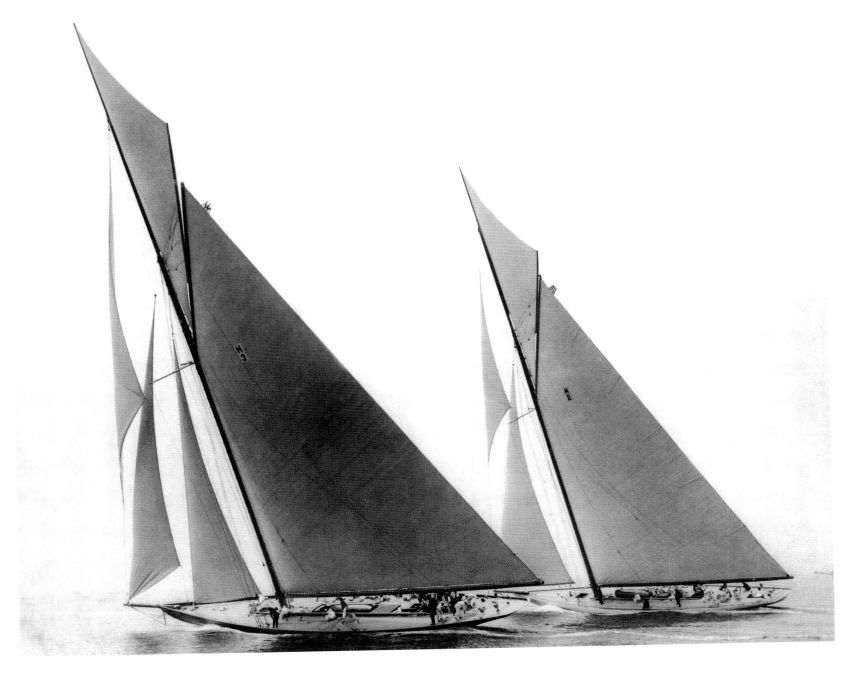

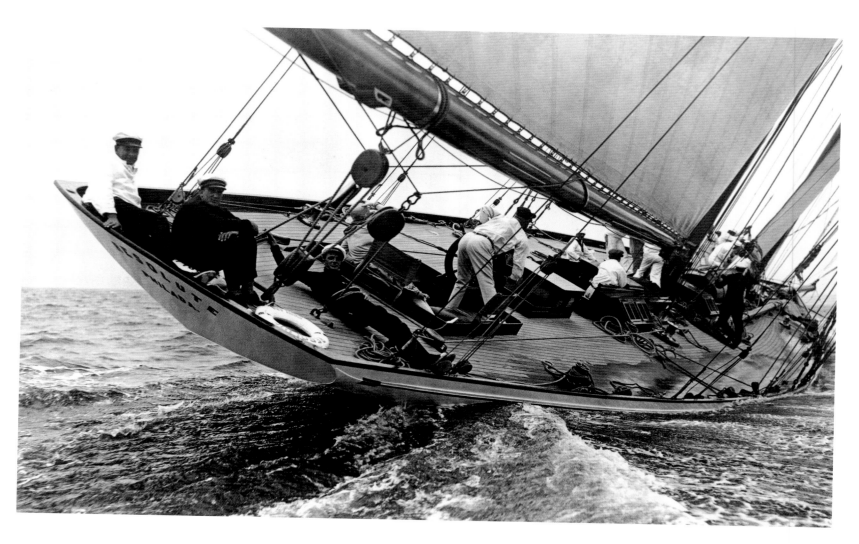

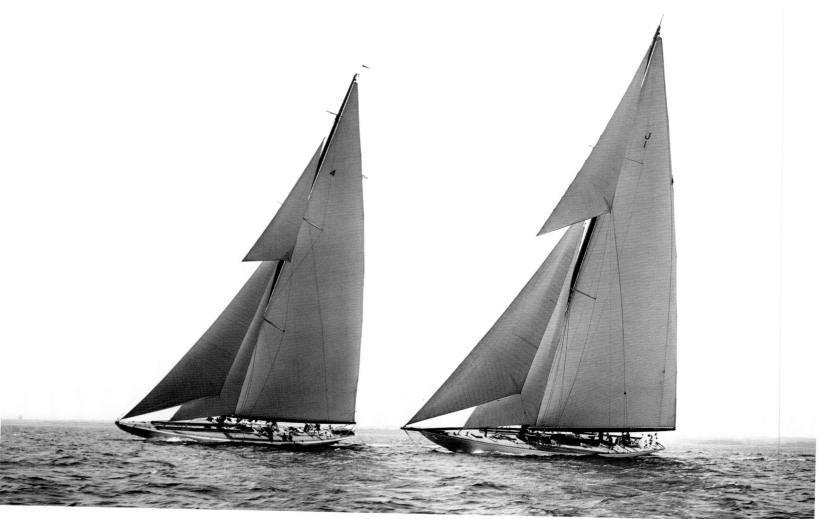

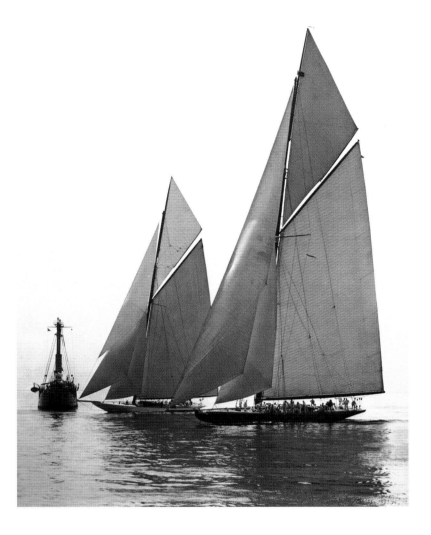

LEFT *Due to the outbreak of World War One,* Resolute *did not meet Sir Thomas Lipton's* Shamrock IV *off Sandy Hook until late in 1920.*

BELOW LEFT Resolute, *the successful defender for the 1920 Cup, before being converted from gaff to Marconi (or Bermudan) rig in 1929 as a race mate for* Enterprise, *17 years her junior.*

BELOW *In 1930, Harold S Vanderbilt helmed* Enterprise *to victory, beating* Shamrock V.

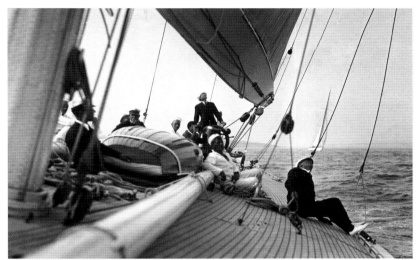

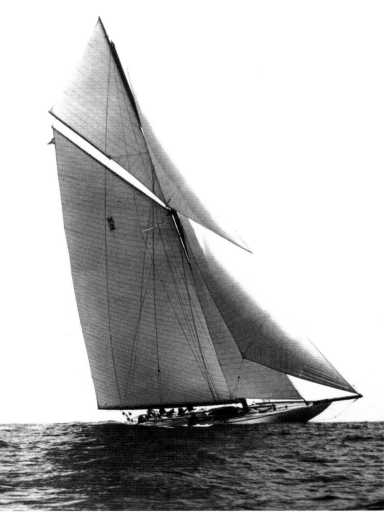

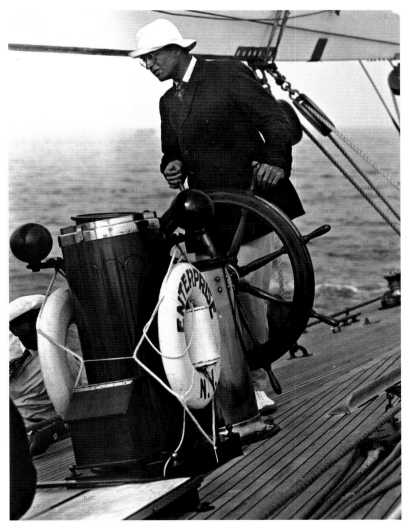

RIGHT AND BOTTOM *The Sparkman & Stephens yawl* ODYSSEY, *built for a member of the Vanderbilt family, was launched in 1938 by the Herreshoff yard. She has been restored and is still sailing – as a training vessel for young people.*

BELOW *In his later years Cap'n Nat watched from a launch as his Cup yachts raced.*

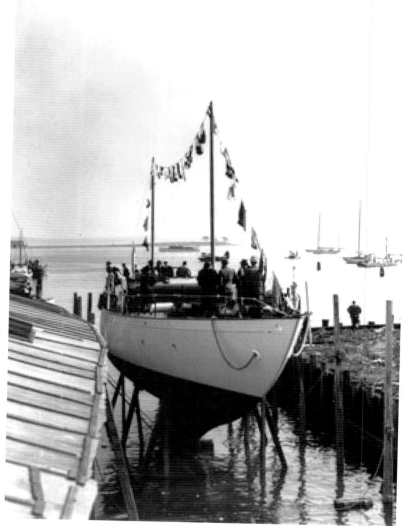

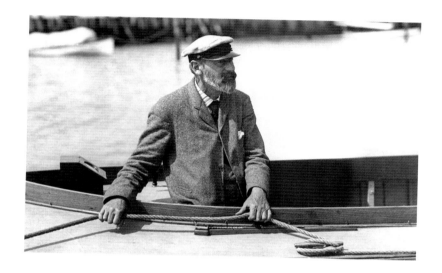

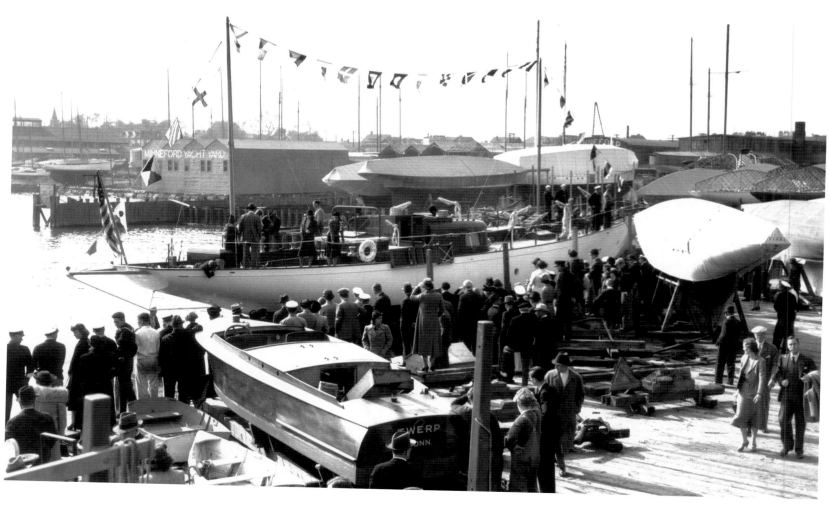

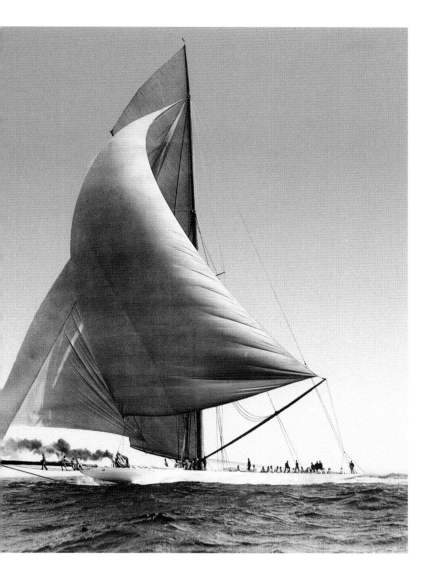

LEFT AND BOTTOM *In 1903* RELIANCE, *an extreme design which featured a very tall mast, won against* SHAMROCK III.

BELOW *Ashore, Cap'n Nat Herreshoff makes a point to his son and a foreman.*

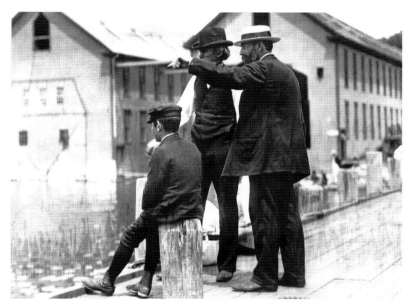

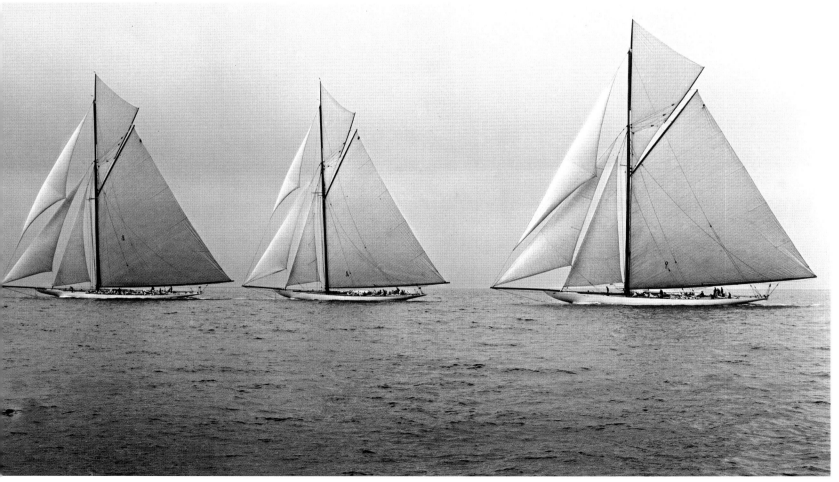

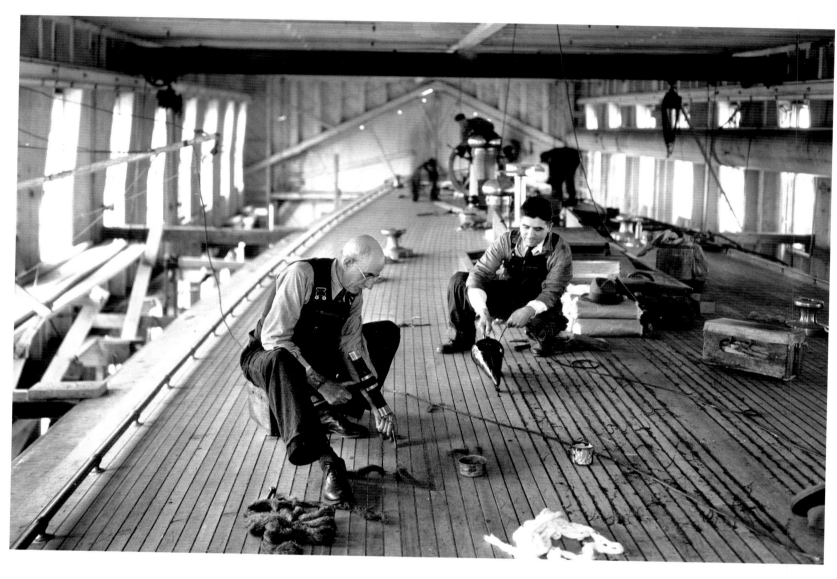

TOP *The Herreshoff shipwrights at work in 1934 caulking* RAINBOW's *deck.*

ABOVE AND RIGHT *Commissioned by Harold S Vanderbilt, the time allowed between production of the final model and stepping the huge mast was just 100 days.*

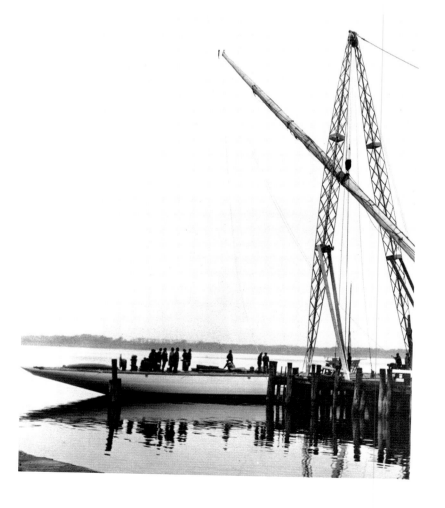

THIS PAGE *With his yachts* ENTERPRISE *and* RAINBOW, *Harold S Vanderbilt tried to repeat the success of his father, William K Vanderbilt whose* DEFENDER *swept to victory in 1895. The manufacture and stepping of* RAINBOW's *mast in 1934 was achieved in record time.*

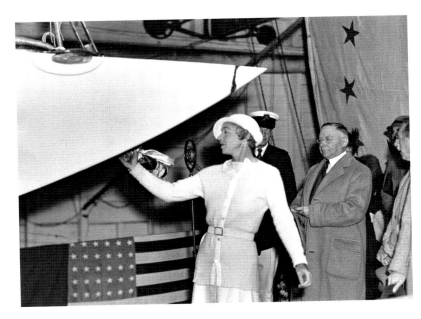

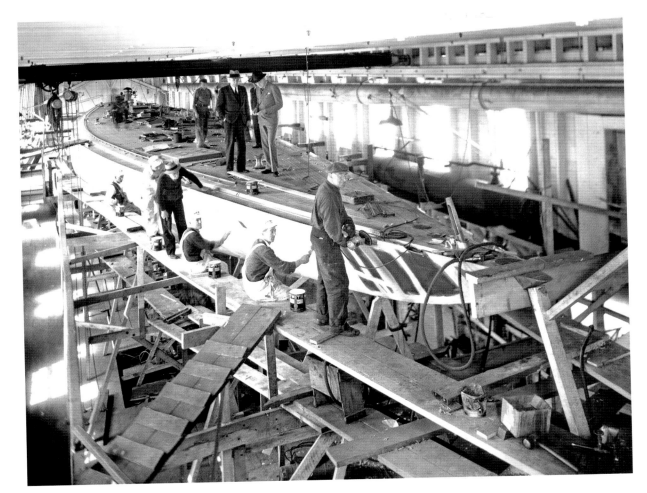

Gertrude Vanderbilt christens RAINBOW *(above). Like* ENTERPRISE, *she was designed by W Starling Burgess and built by the Herreshoff Manufacturing Company. She beat the Sopwiths'* ENDEAVOUR *by four races to nil.*

For many decades Nathanael Greene Herreshoff had perfected lightweight construction and helped to develop the modern light displacement yacht. He was a pioneer in technical evolution, although he did attract criticism for his elegant designs which some people thought were very extreme.

His design range included torpedo boats for the US Navy prior to the First World War; his last design, the 54 foot yawl *Belisarius*, was launched in 1935. He sold his shares in the shipyard soon after the death of his brother John Brown in 1915, but still remained involved in the management of the company and from 1924 advised the Haffenreffer family who owned the majority of the shares. Herreshoff died in 1938 at the age of 90. Seven years later, after the end of the war, the Herreshoff Manufacturing Company closed, and today the Herreshoff Museum occupies the former shipyard premises

In 1920 W Starling Burgess employed Herreshoff's son Lewis Francis, born in 1890, as a draftsman. Burgess, together with Frank Paine and Herreshoff's former chief designer A Loring Swasey, founded a design office in Boston and Lewis Francis joined the group. It was about that time that he began noting down ideas for *Joann*, the forerunner of *Tioga*. A subsequent modification built in 1936, with a longer waterline, became the yacht *Ticonderoga* that has been admired throughout the world to the present day (page 142).

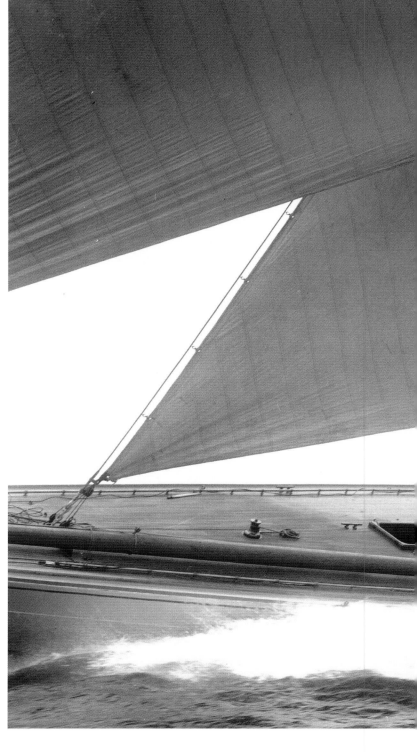

ABOVE RIGHT *In the 1930s, owners sailed aboard their own J-Class yachts in the America's Cup. Unlike* ENDEAVOUR, RAINBOW *was fully fitted out below.*

PHOTOS RIGHT RAINBOW *needed a crew of 24 to handle her racing sail area, even with the help of a coffee-grinder winch.*

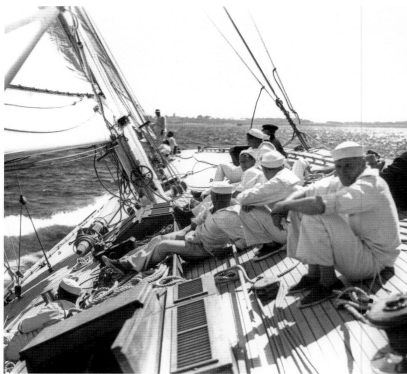

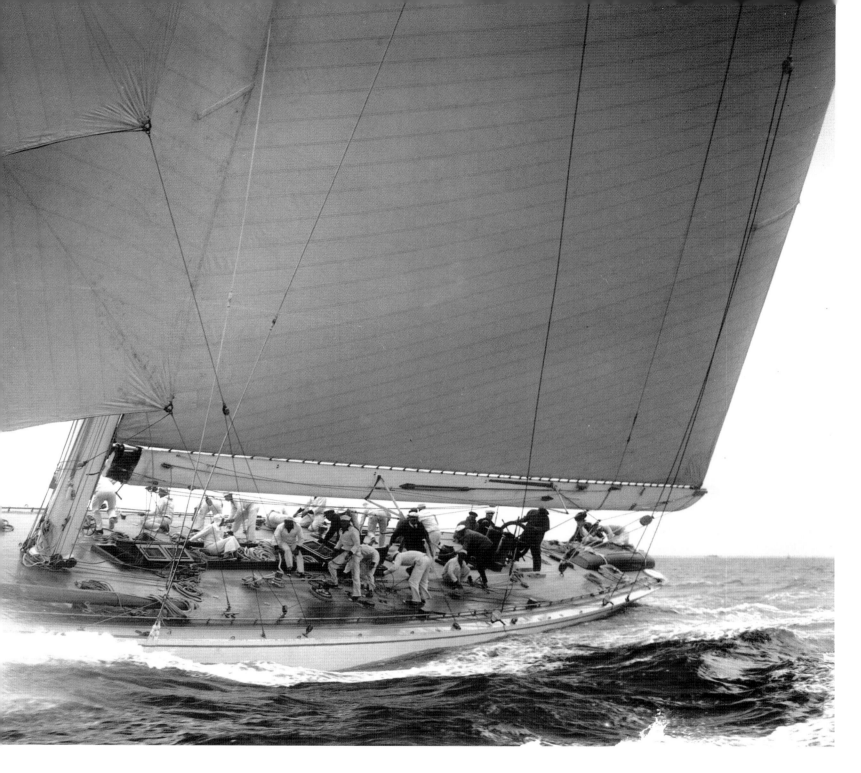

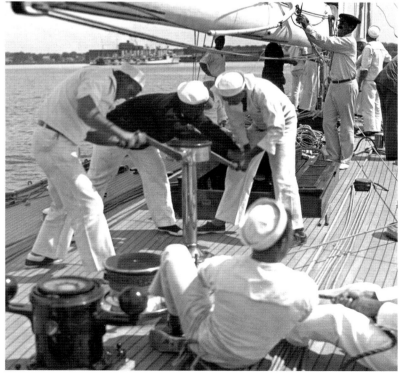

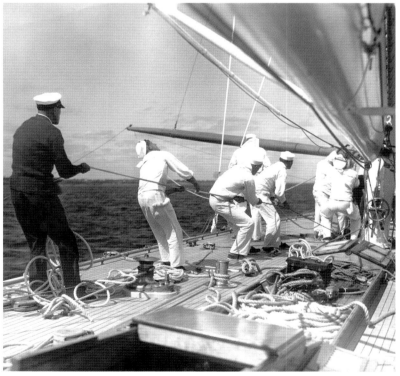

RIGHT *In 1930, the Herreshoff yard laid the keel for the Clinton H Crane-designed* Weetamoe, *J4. She is seen here during the qualification races in 1934 just ahead of* Rainbow, *J5.*

BELOW Yankee *(J2) leads* Weetamoe *(J4) during the selection trials in 1934. However, neither of these yachts were chosen and* Rainbow *went on to retain the Cup.*

OPPOSITE PAGE *In 1893* Vigilant, *the first of Nathanael Greene Herreshoff's five Cup-winning designs, beat the Earl of Dunraven's* Valkyrie II.

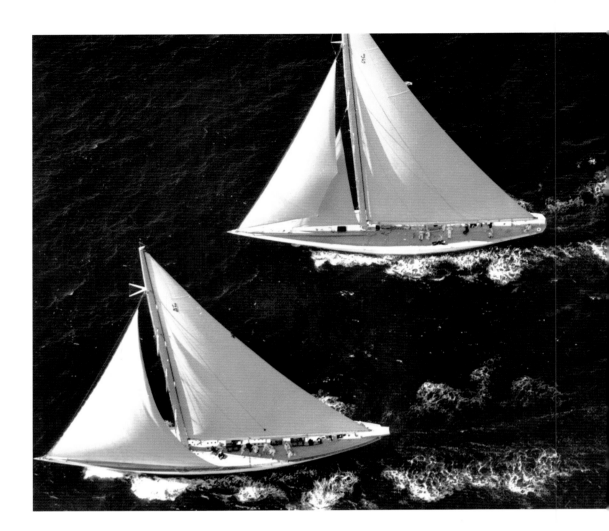

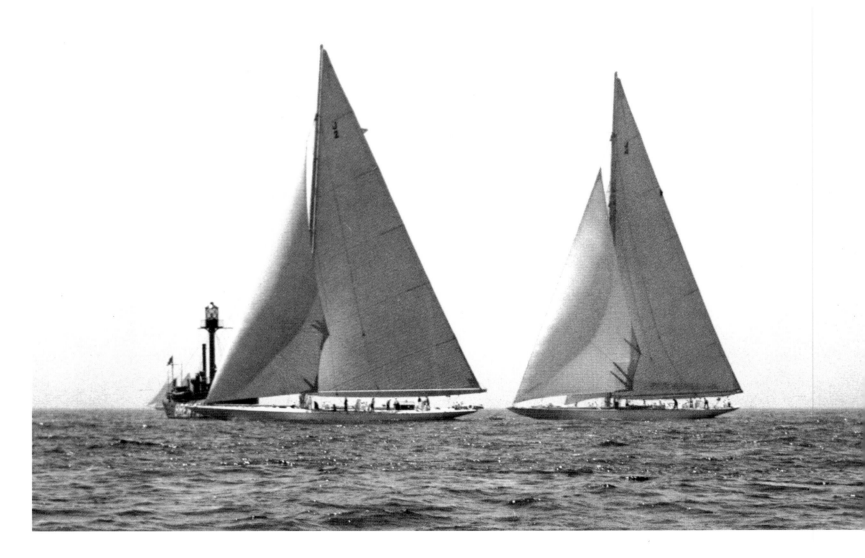

In 1926 Lewis Francis left the partnership to set up his own firm in Marblehead, Massachusetts. At first he dealt almost exclusively with racing yachts, and in 1929 attempted his first and only America's Cup project, *Whirlwind*, which was one of four J-Class yachts built for the 1930 defence. Lewis Francis pushed the J formula to the limits, which resulted in problems with classification. The *Whirlwind* project also turned disastrous for Lewis Francis because the owners interfered in the design, making modifications which inflated the cost and resulted in delays. The glory of defending the Cup then went to Burgess's *Enterprise*, which beat the gallant loser Sir Thomas Lipton and his *Shamrock V*. However Lewis Francis made a name for himself as an author with the biography of his father entitled *Capt Nat Herreshoff: The Wizard of Bristol.*

In addition to more than 2000 designs, including many famous and incomparable yachts, the long list of Nathanael Herreshoff's achievements also includes many inventions which still benefit sailing yachts and their owners and crews today. He invented the fin and bulb keels, the spade rudder, the two-speed geared winch and the hollow aluminium mast. But it is little known that the folding propeller also originated in his workshops, as well as sail slides, low-stretch 7 and 15 strand wire rope, and the wire-to-rope splice technique. Herreshoff was the the first yacht designer to specify cross-cut sails, where the panels reach the edges at right angles, a technique that he tried out for *Glorianna* in 1891.

Many of the yachts designed and built by Nathanael Herreshoff, such as *Reliance*, met an early fate. However, the very active New York 30 one-design class still actively celebrates the history of these extraordinary yachts; it commemorated its 100th anniversary off Newport in 2005 (page 66). Many small daysailers, deeply loved and carefully maintained by their owners, also survive as part of the Herreshoff legacy, and a number are featured in this book.

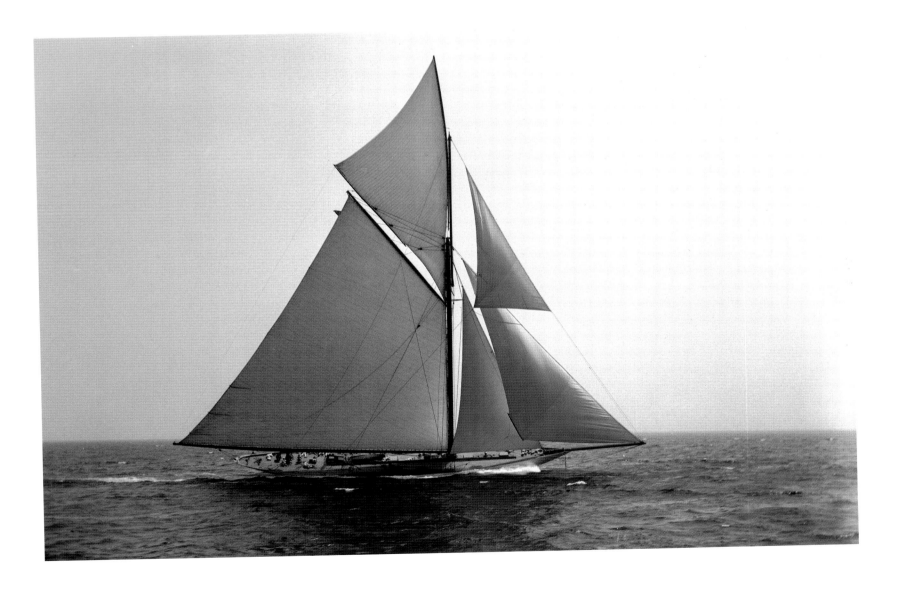

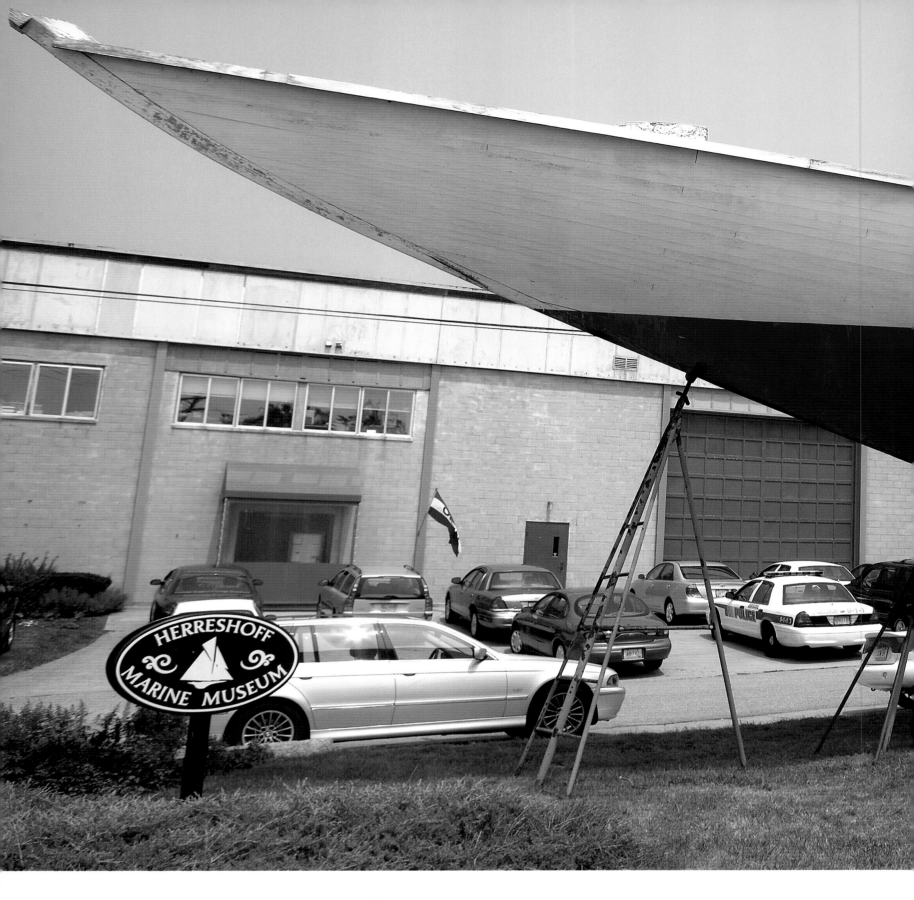

The Herreshoff Marine Museum

The Herreshoff boatyard is situated at Bristol, Rhode Island, about a 25-minute drive southwest of Providence. The museum was created in the original boatyard in 1971 by Captain Nat's eldest son, Algernon Sidney DeWolf Herreshoff and his wife Rebecca Chase Herreshoff, assisted by others who were passionate about building a commemorative collection.

The heart of the museum is the Hall of Boats. There have been many valuable objects donated to the museum over the years, which require constant care, but the most celebrated exhibits are the first and last Herreshoff boats – *Sprite* and *Belisarius*. Herreshoff designed *Sprite*, a 20-foot catboat, at the age of 11 and *Belisarius*, a 56-foot yawl, at the end of his career in 1935, when he was 87. There are over 60 boats in the collection.

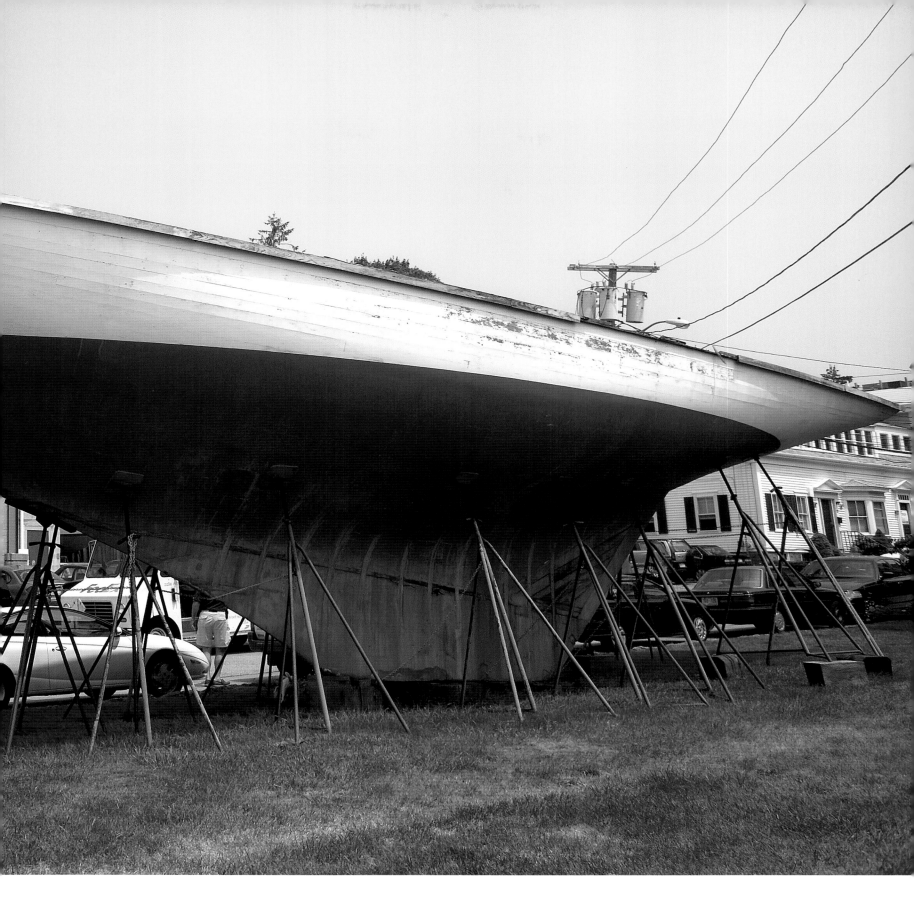

In addition to plans and photographs, the museum houses Herreshoff's journals, his calculations, his hand drawings and his letters relating to the America's Cup from the years 1893 to 1920. These documents are all held in the library.

The museum also has background collections and proceedings of conferences relating to the pleasures of the Belle Epoque. It runs a sailing school and, on the other side of the coast road, there is the America's Cup Hall of Fame, which displays numerous half models and original artefacts.

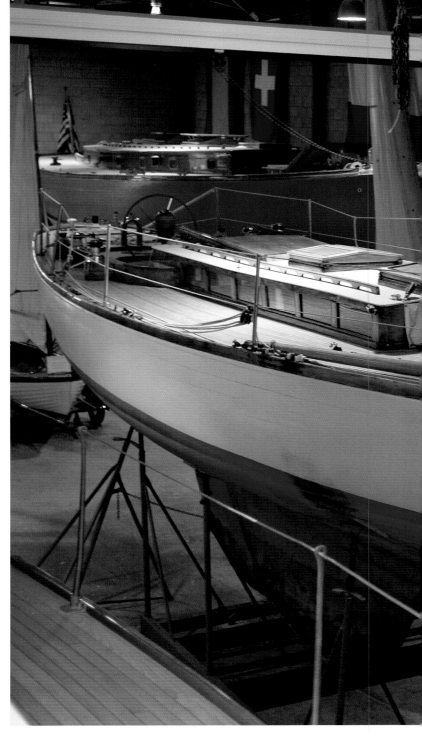

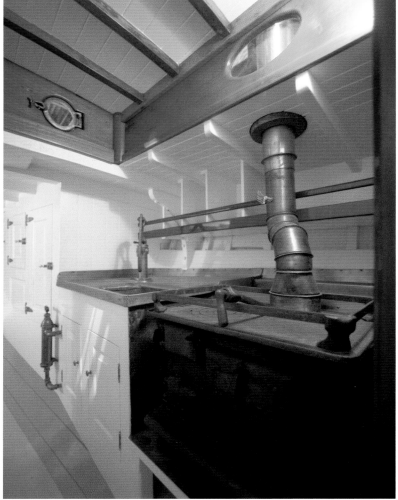

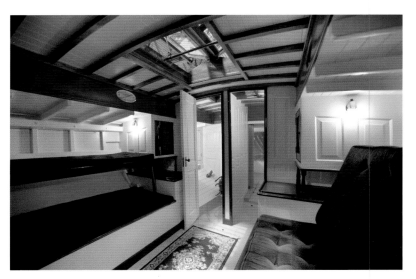

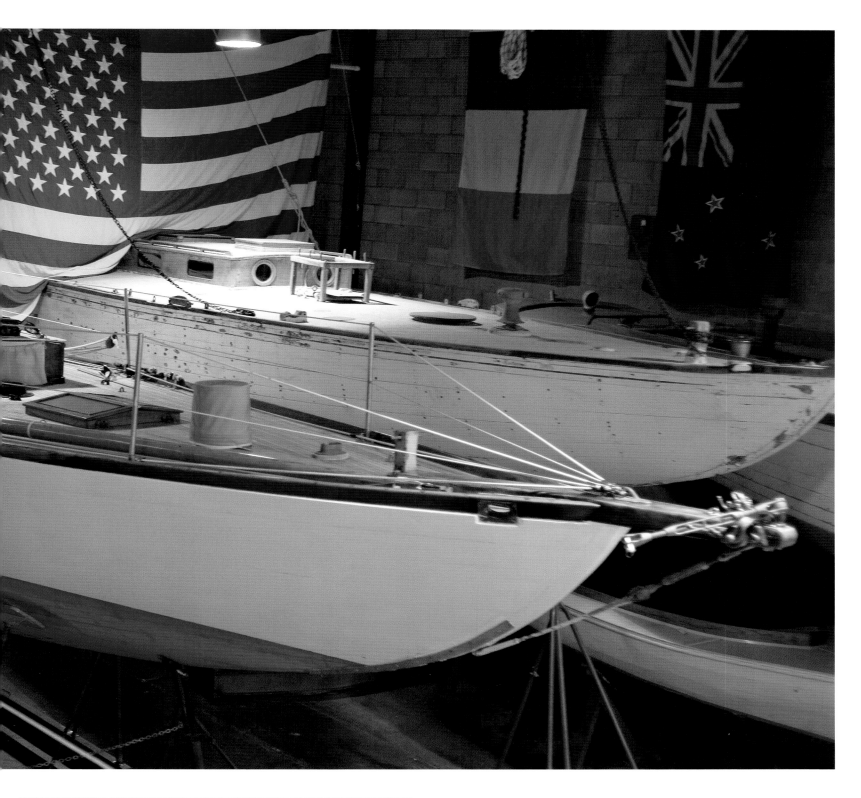

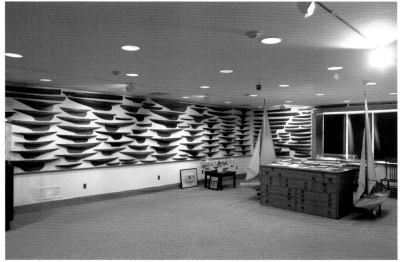

PRECEDING DOUBLE PAGE
The entrance to the Herreshoff Marine Museum. The NY 50 SPARTAN, seen here, is currently being restored by MP&G in Connecticut (see page 108).

ABOVE AND LEFT
In the Hall of Boats is displayed TORCH, a Fishers Island 31, restored with her original fittings, together with a number of other one-designs.

LEFT, AND FOLLOWING DOUBLE PAGE
The museum dedicates two rooms to half models – from dinghy to J-Class – all made by Herreshoff himself. Also on display are Cap'n Nat's workbench and tools.

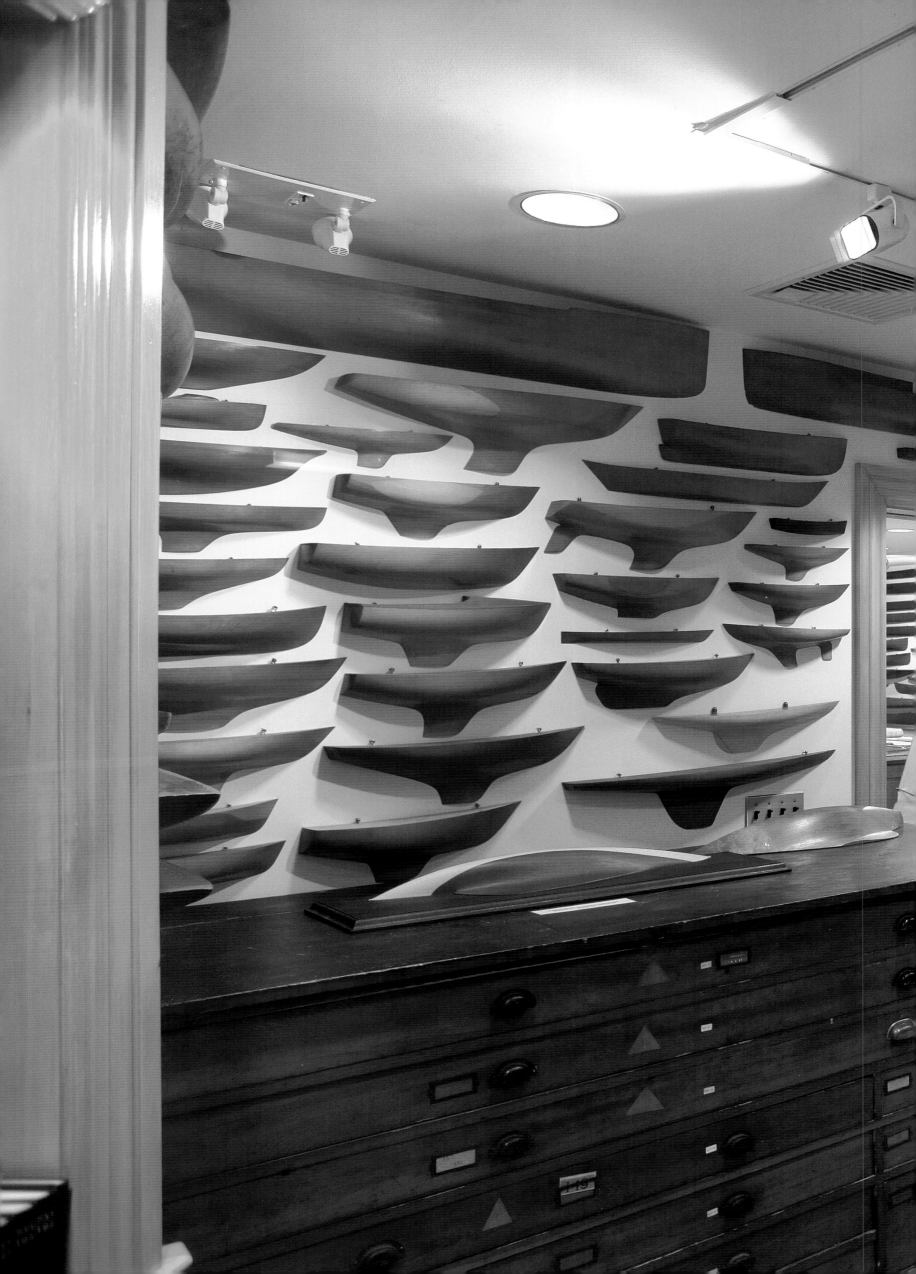

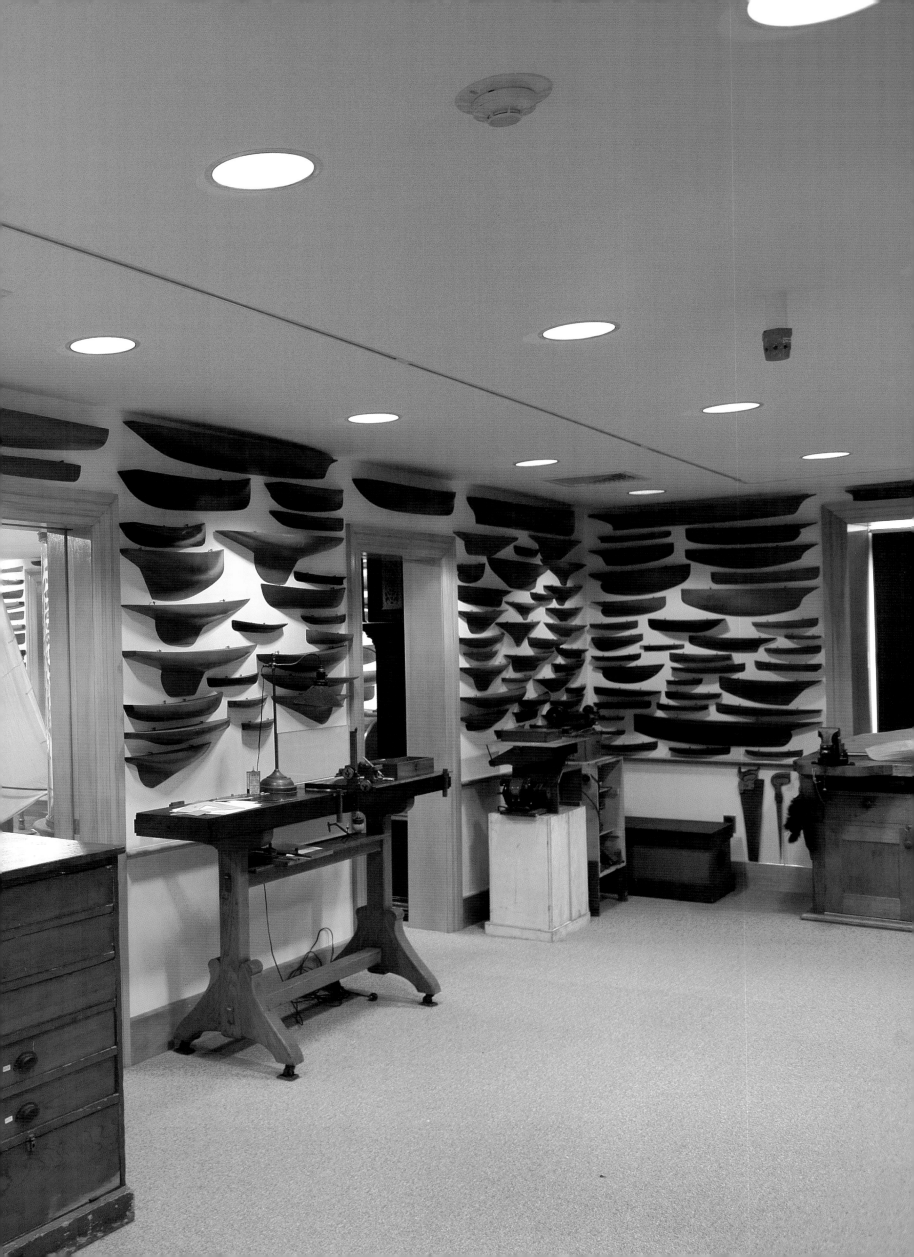

Eleonora

Year of construction	2001	
Length overall	162ft 5in	(49.5m)
Length on deck	136ft 2in	(41.5m)
Length of waterline	96ft 1in	(29.3m)
Beam	26ft 11in	(8.2m)
Draught	17ft 4in	(5.28m)
Sail area	11,836sq ft	(1100m²)
Designer	Nathanael Herreshoff	
Builder	Van der Graaf BV, Netherlands	

In 1908, Herreshoff had received a commission from New York owner Alexander S Cochran to build *Westward* at a cost of US $118,000. With the famous Charlie Barr as helmsman and a crew of 31, she won almost all the prizes available in Europe at that time. She had several changes of both owner and name (among them *Hamburg II*) but in 1947 the riveted steel yacht was scuttled off the Jersey coast following the death of her last owner, TB Davis; sadly attempts to find a sail training school willing to take her had failed.

In 2000, exactly 90 years after *Westwood* had been launched, she celebrated her resurgence as *Eleonora*, this time in the Netherlands. Her owner had much experience with replicas and was able to build *Eleonora* based on the original Herreshoff drawings, which are stored in the archives of the Hart Nautical Collection in the MIT Museum in Massachusetts. The Dutch shipyard where she was built could even refer to detailed information for stanchions, scuppers and cleats. The owner largely overcame the temptation to make the schooner faster by using modern materials, though *Eleonora* differs slightly from *Westward* in providing higher standards of comfort.

The rig is a ton lighter, while decreased righting moment from the keel is compensated for by the weight of engine and generators. On deck, electric winches reduce the number of crew needed, which has enabled greater interior comfort; unlike the original, *Eleonora* does not need to accommodate a large crew with hammocks in the forepeak. Instead, eight charter guests can enjoy comfortable cabins. Also, unlike the owners of *Westward*, *Eleonora*'s owner can enjoy a hot bath.

LEFT AND RIGHT *ELEONORA, the replica of the schooner* WESTWARD, *was built by the Dutch shipyard Van der Graaf BV, based on the original Herreshoff drawings and true to the original. The detailed drawings are in the care of the Hart Nautical Collection of the Massachusetts Institute of Technology (MIT).*

OPPOSITE PAGE *The owner often sails* ELEONORA *in the Mediterranean and the Caribbean, both racing and on charter. Sometimes the topsails remain below.*

FOLLOWING DOUBLE PAGE ELEONORA *remains true to the tradition of the nine yachts of the* WESTWARD *type, which sailed with different rigs as Big Class racing schooners.*

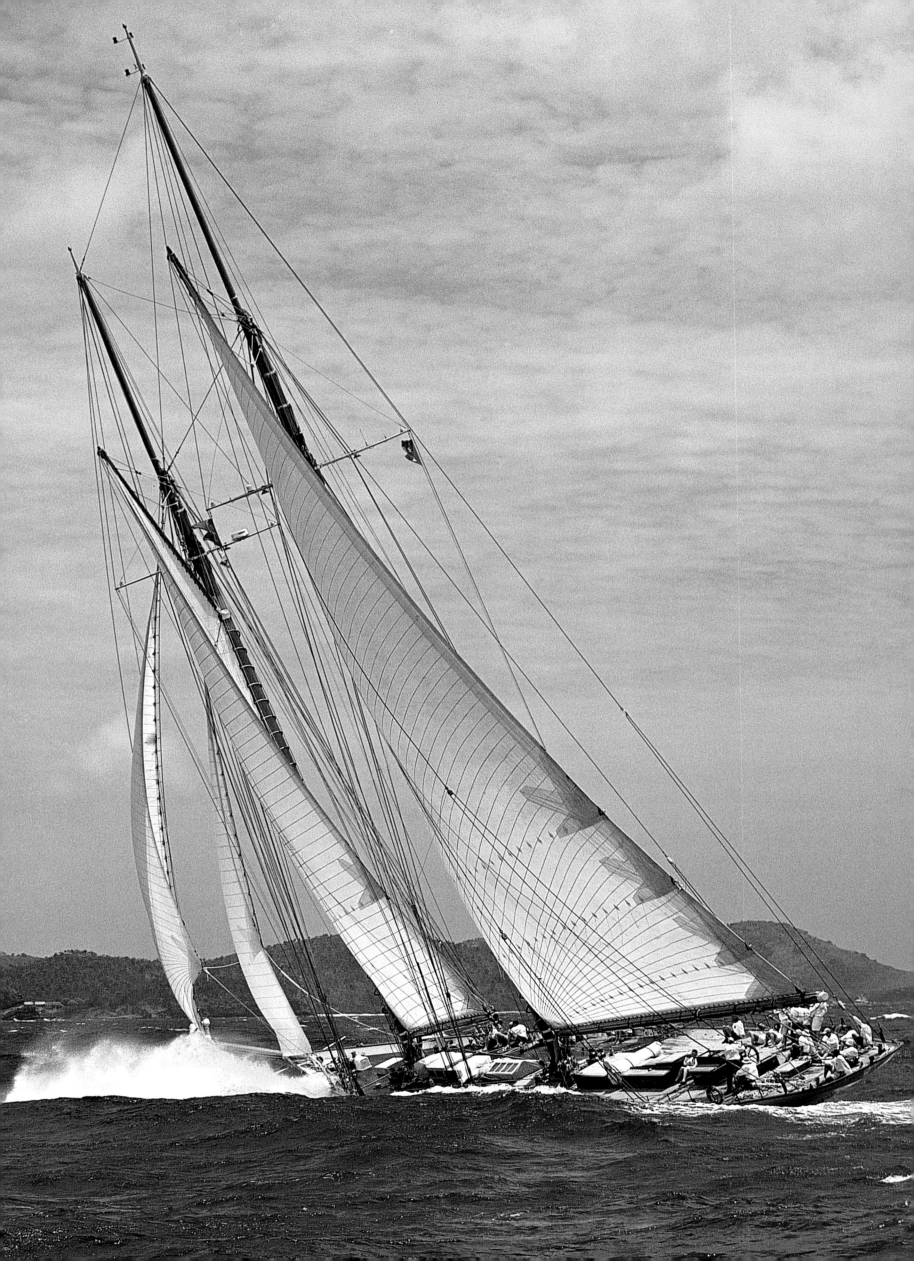

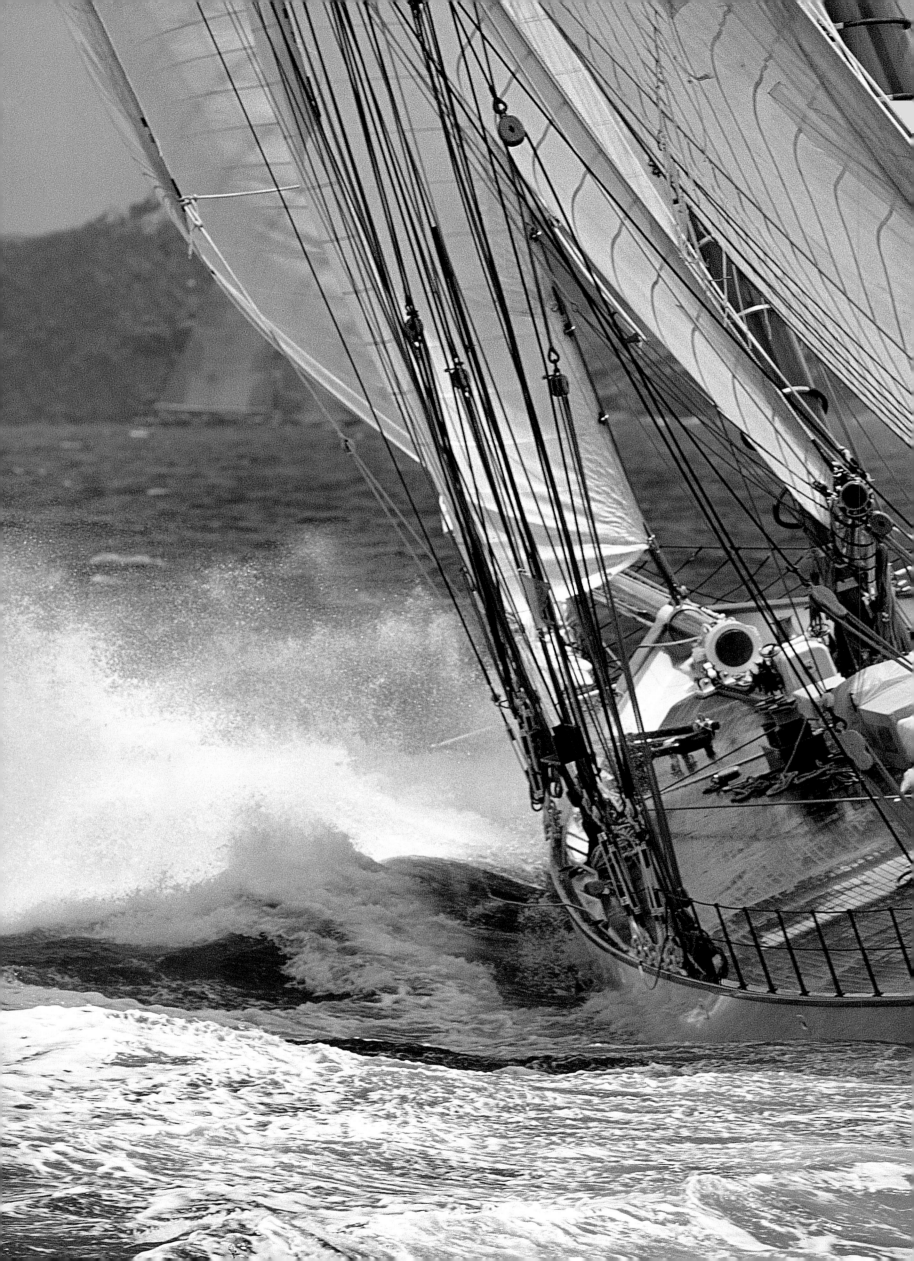

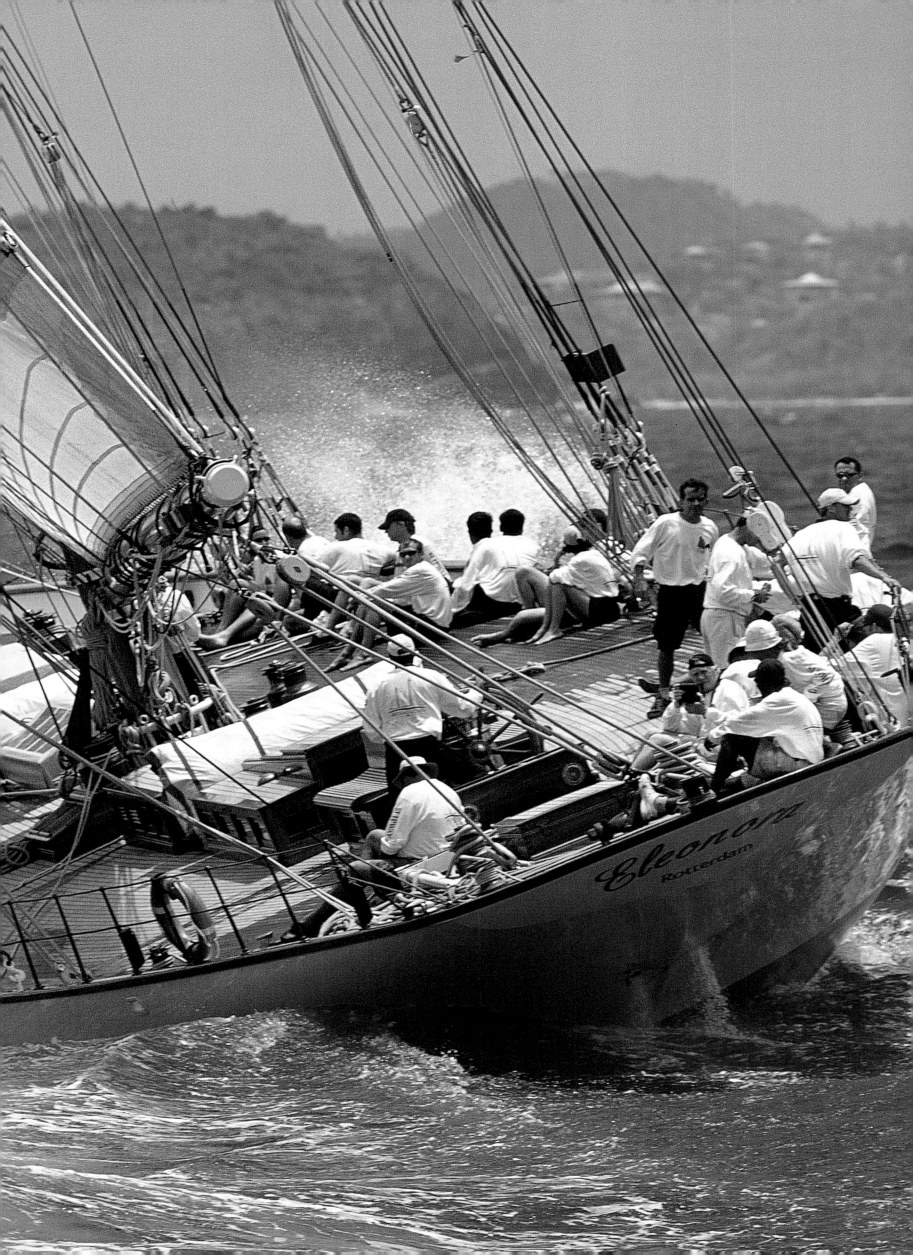

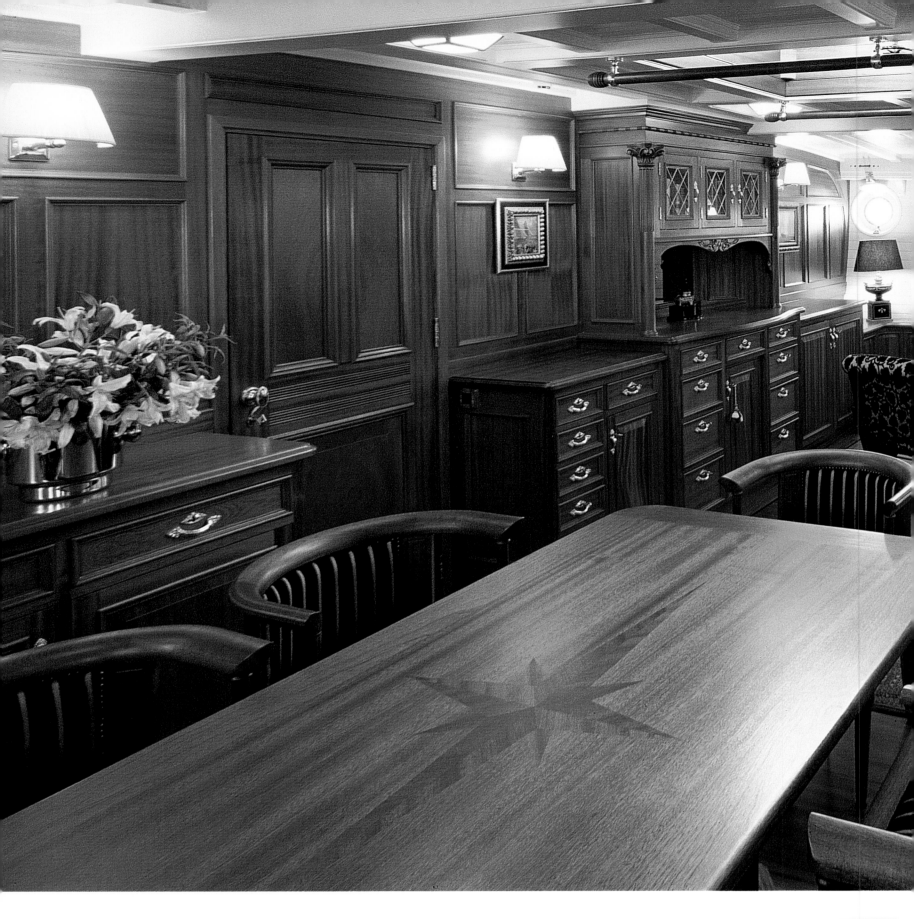

ABOVE *Eleonora's owner customised the accommodation to suit modern tastes. He opted for a more comfortable interior of varnished mahogany and light panelling.*

RIGHT *The shipyard crafted fiddle rails and ornate joinery in the style of the early 20th century for the saloon and the owner's cabin and throughout the yacht.*

FAR RIGHT *Even in the owner's bathroom, panelling and decoration in the style of 1900 recreates the atmosphere of the original Herreshoff era.*

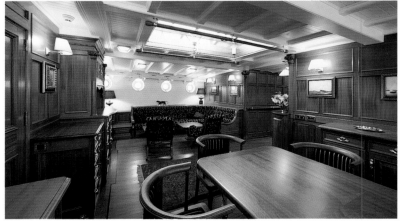

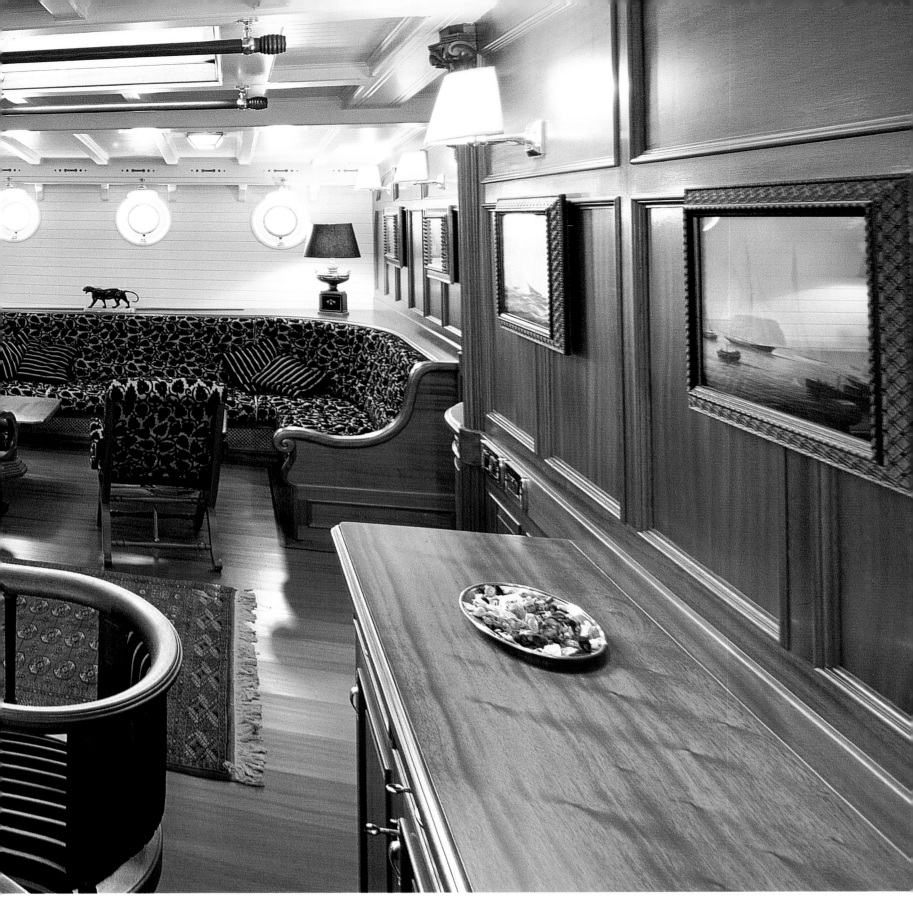

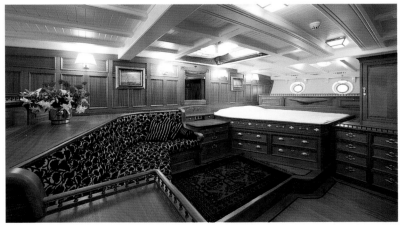

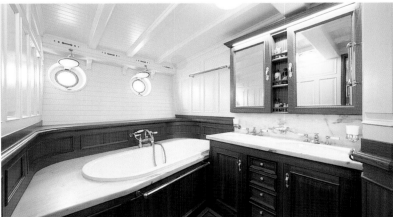

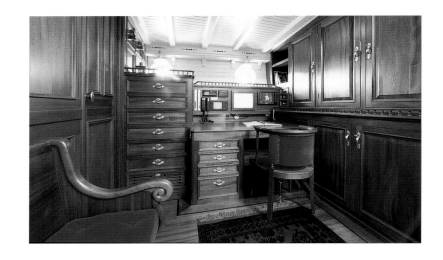

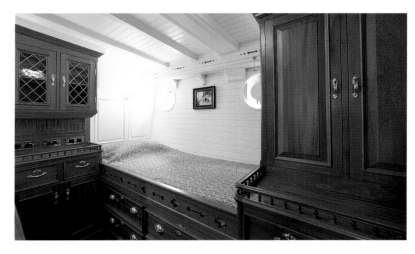

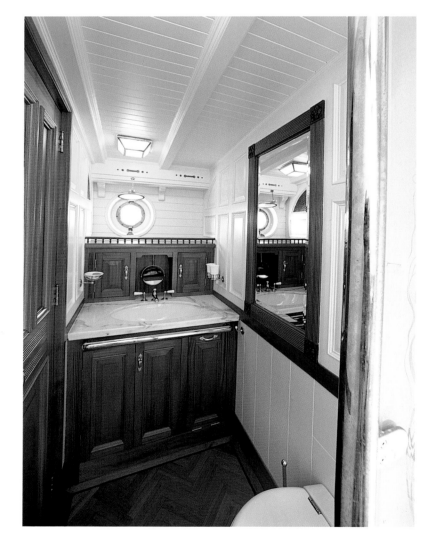

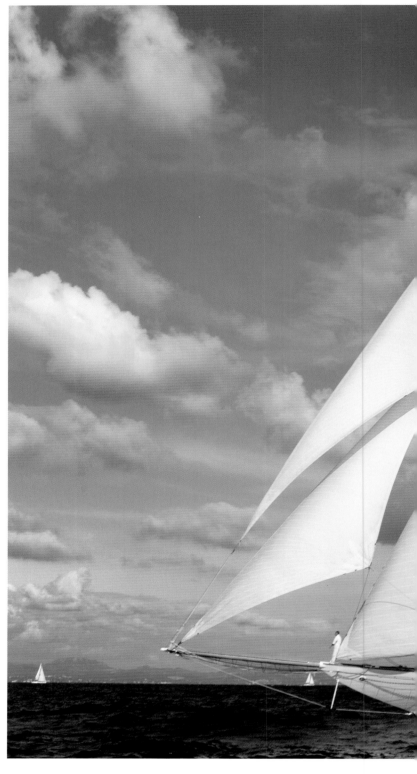

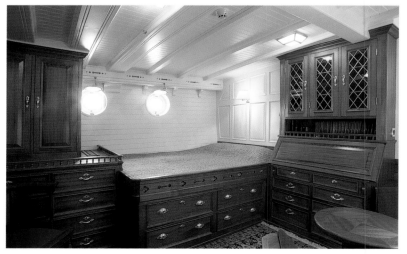

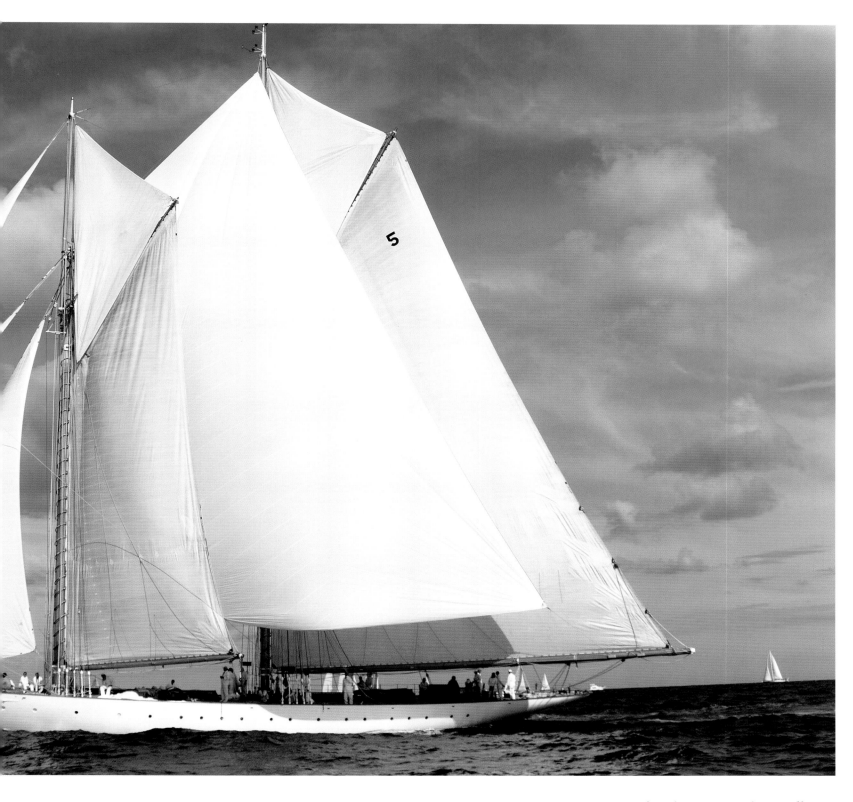

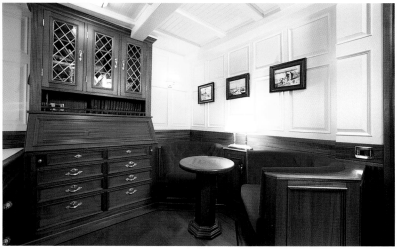

ABOVE *ELEONORA measures 162 feet (49.5 metres) overall. Her 136-foot (41.5 metre) hull, with a designed waterline of only 96 feet (29.3 metres), results in impressive overhangs.*

OPPOSITE PAGE, ABOVE *The shipwrights built the navigator's work station in the style of the original, though the instruments date from the year 2000.*

OPPOSITE PAGE, BELOW *Eight guests can be accommodated on board the schooner. Each of the four cabins has its own toilet and shower, complete with marble washbasin.*

LEFT *With seating corners like this, the interior gives the atmosphere of a gentlemen's club. Cream-coloured panelling harmonises with exotic woods.*

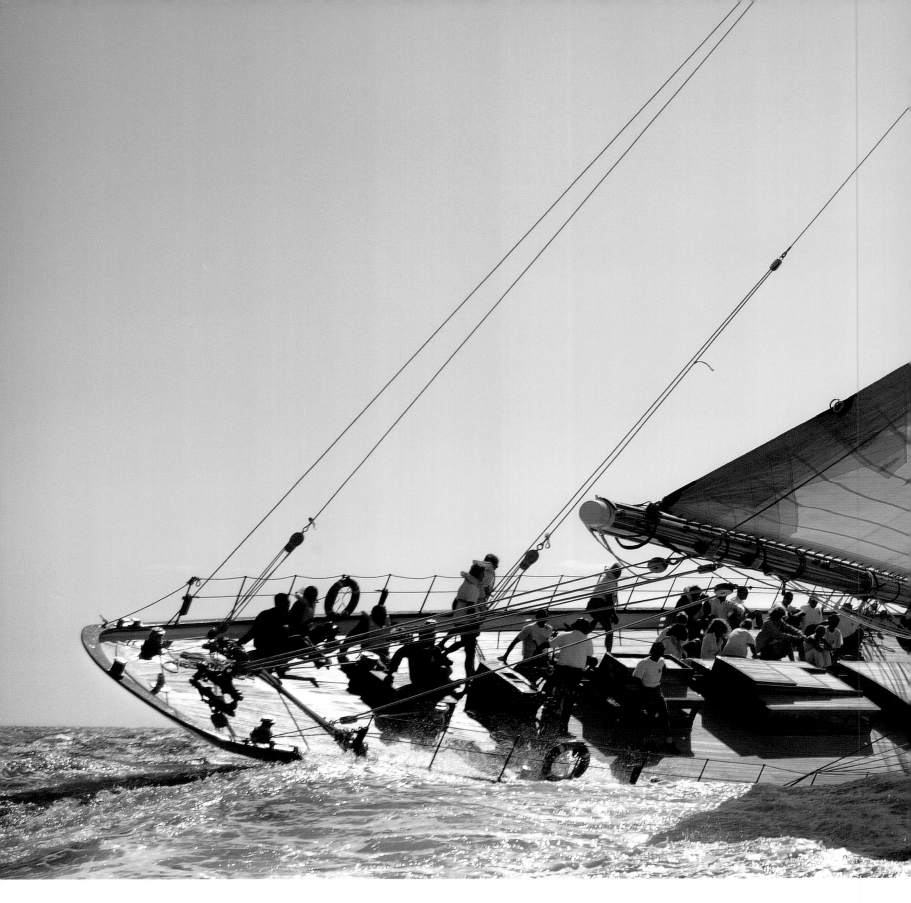

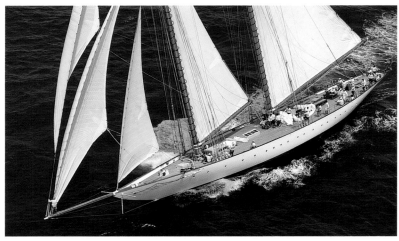

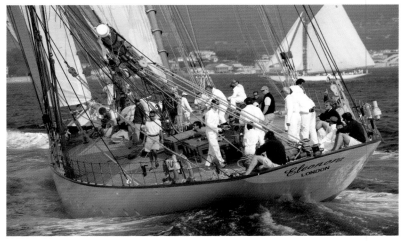

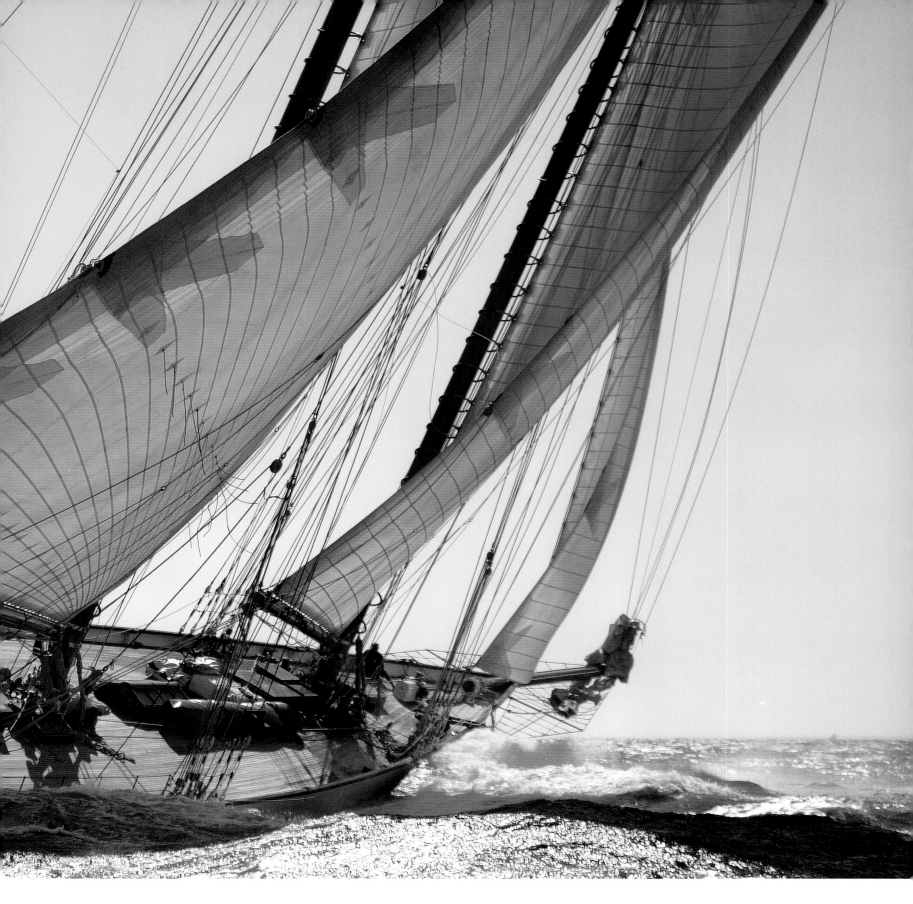

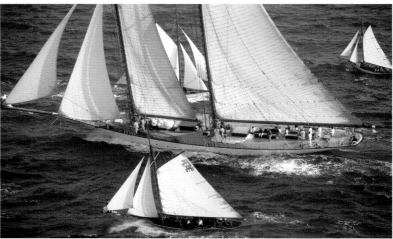

ABOVE *For WESTWARD, Herreshoff designed three alternative rigging plans. ELEONORA's owner decided on the handy 'ocean rig' with 11,836 square feet (1100 square metres) of sail area.*

LEFT *Although a lover of the traditional style, the owner is also a keen racing yachtsman and expects his yacht to perform.*

FOLLOWING DOUBLE PAGE *Like the original, ELEONORA has masts and spars of well-seasoned spruce. However, sails of cotton canvas are now a thing of the past.*

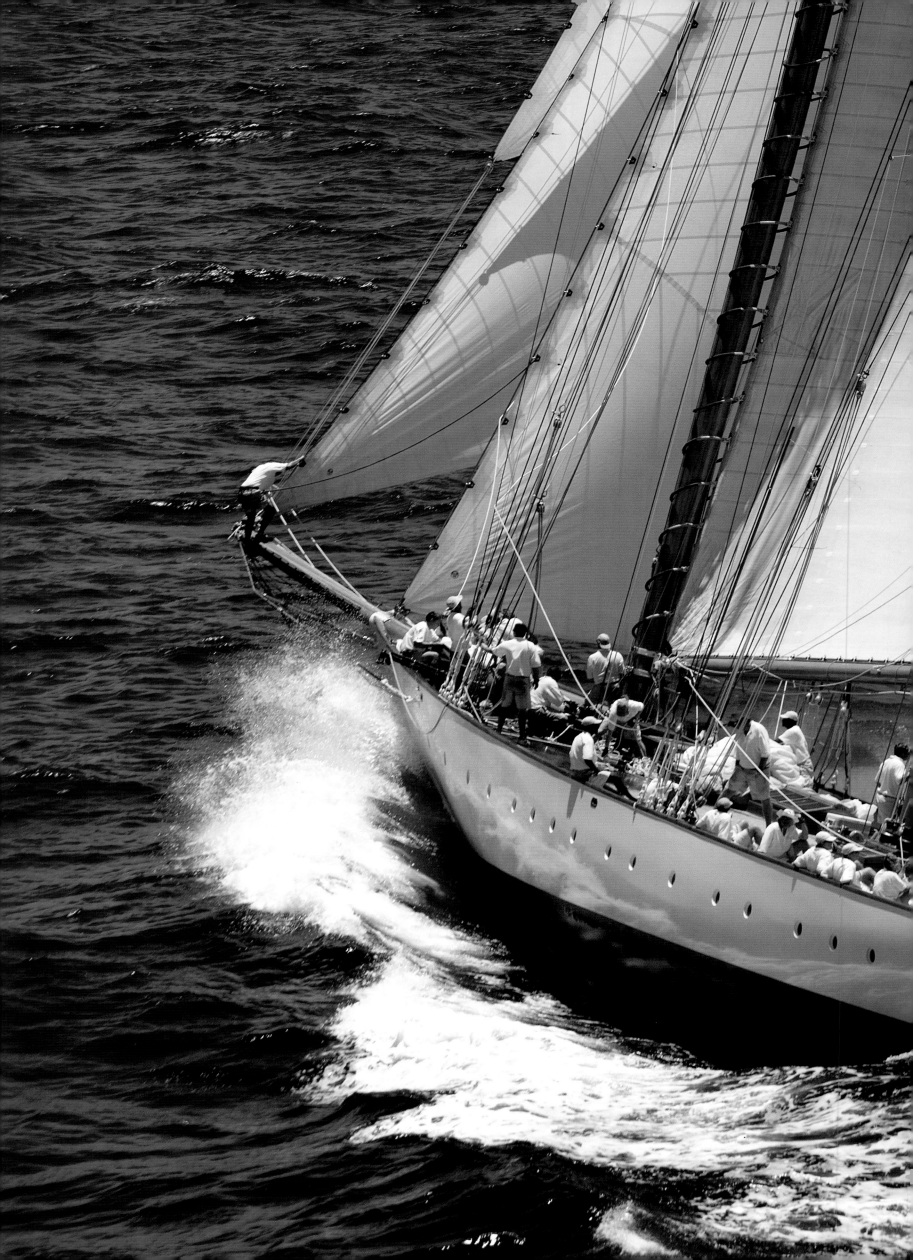

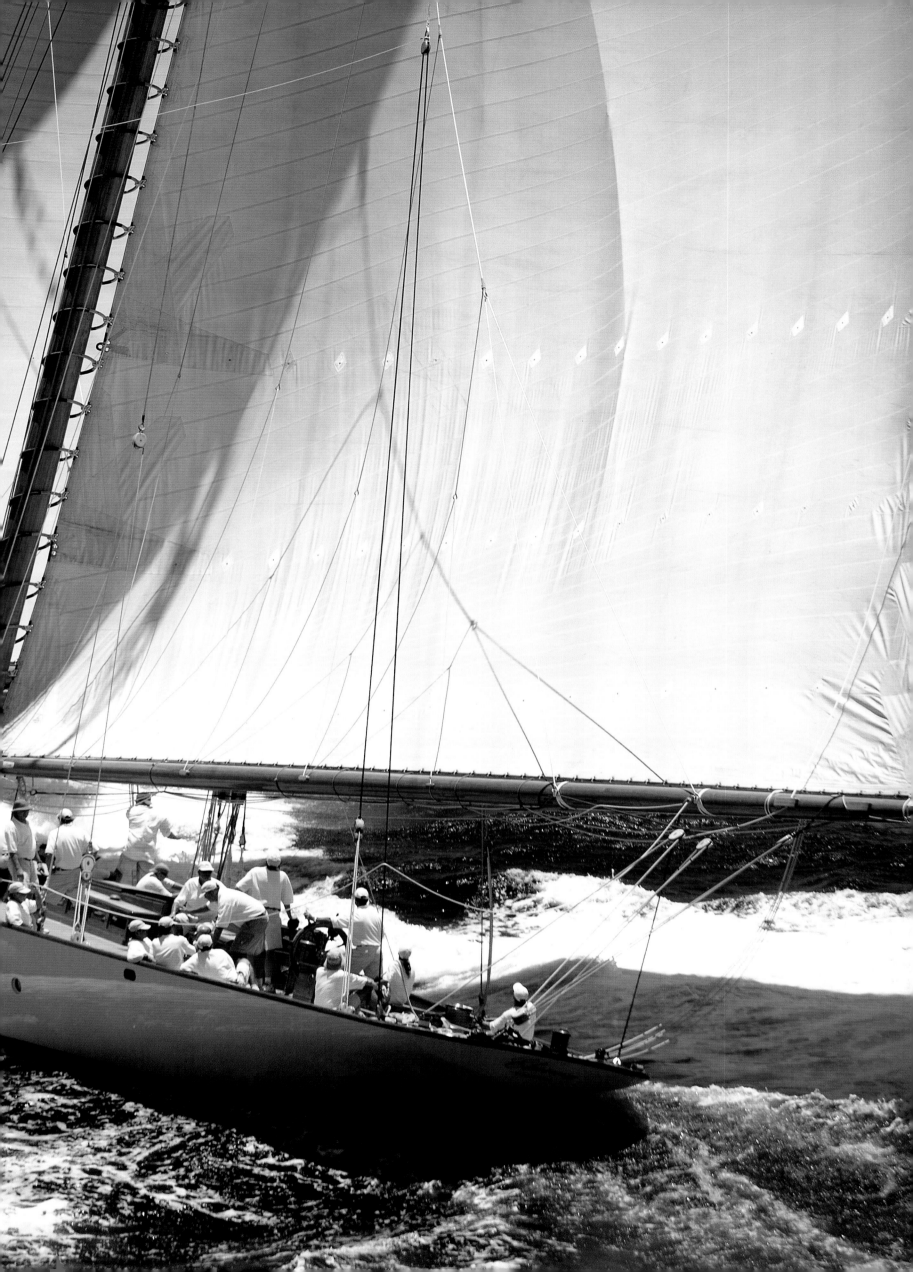

Mariette

Year of construction	1915	
Length overall	138ft	(42.06m)
Length on deck	110ft	(33.5m)
Length of waterline	80ft	(24.38m)
Beam	23ft 7in	(7.2m)
Draught	13ft 9in	(4.2m)
Sail area	11,115sq ft	(1033m²)
Designer	Nathanael Herreshoff	
Builder	Herreshoff Manufacturing Company	

In 1912 Herreshoff shaped a wooden model at his workbench. As design number 719 it was to become *Vagrant II* for Harold S Vanderbilt and one of Herreshoff's nine large schooners. A few years later, Boston cotton merchant Jacob Frederick Brown admired it, and ordered *Mariette* – design number 772 – in October 1915 for a price of US $75,000. He and his family enjoyed many regattas and voyages aboard the steel schooner from 1916 until 1927, when she was sold to Francis B Crowninshield. She was renamed *Cleopatra's*

Barge II and converted to a Bermudan rig. Over the next 50 years she had a variety of owners, names and rigs and sailed in the Caribbean and in the Mediterranean. She was largely rebuilt by an Italian shipyard in the 1980s.

Even at the age of 80, she captured the heart of Thomas J Perkins, an experienced yachtsman from San Francisco. He purchased the schooner from her Italian owner and arranged a refit at the Italian Beconcini yard; the Bermudan spars were removed and her original gaff topsail rig reinstated. The owner was heavily involved, polishing the mahogany interior of the saloon himself. Following this refit *Mariette* took part in the Atlantic Challenge Cup from Sandy Hook to The Lizard in 1997, and now participates at all the important events for veterans of the Classic Division, such as the Antigua Classic Yacht Regatta and the Voiles de St Tropez.

BELOW *By the end of the extensive refit at the Italian Beconcini yard,* Mariette *had been restored to her original state. The new rig was created by Spencer Thetis Wharf in Cowes, Isle of Wight.*

RIGHT Mariette *had sailed as a Bermudan schooner since 1927, but her 1995 refit included the reinstatement of her original gaff rig.*

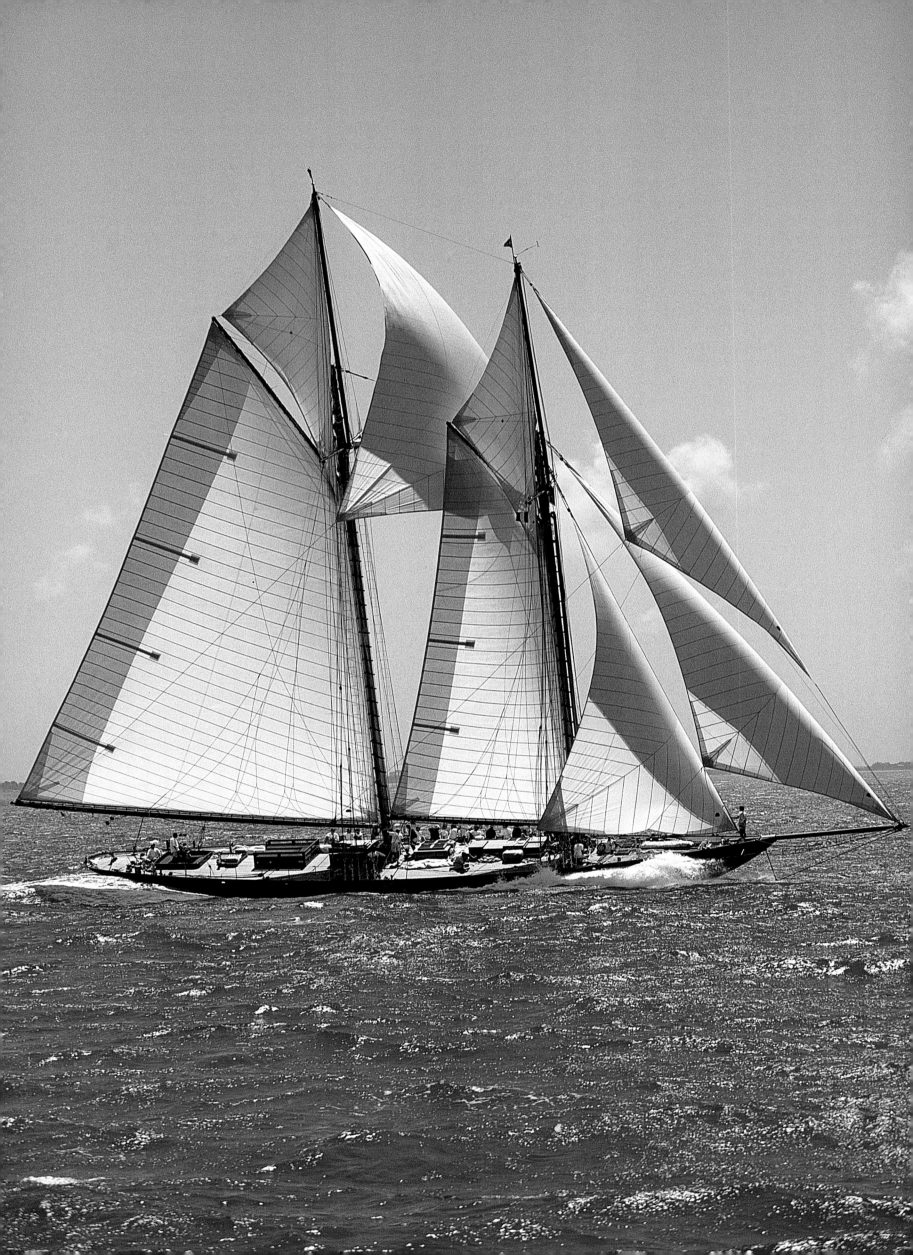

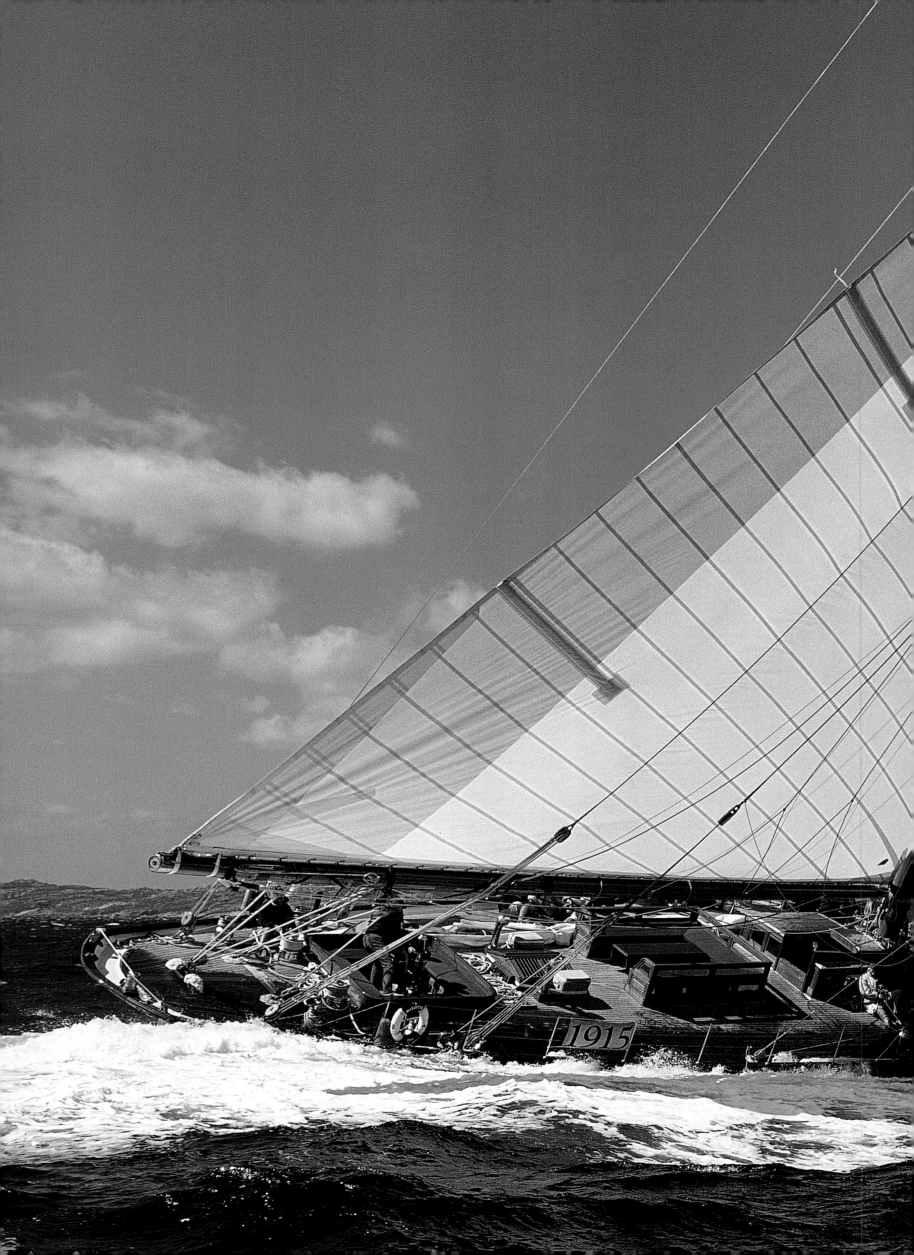

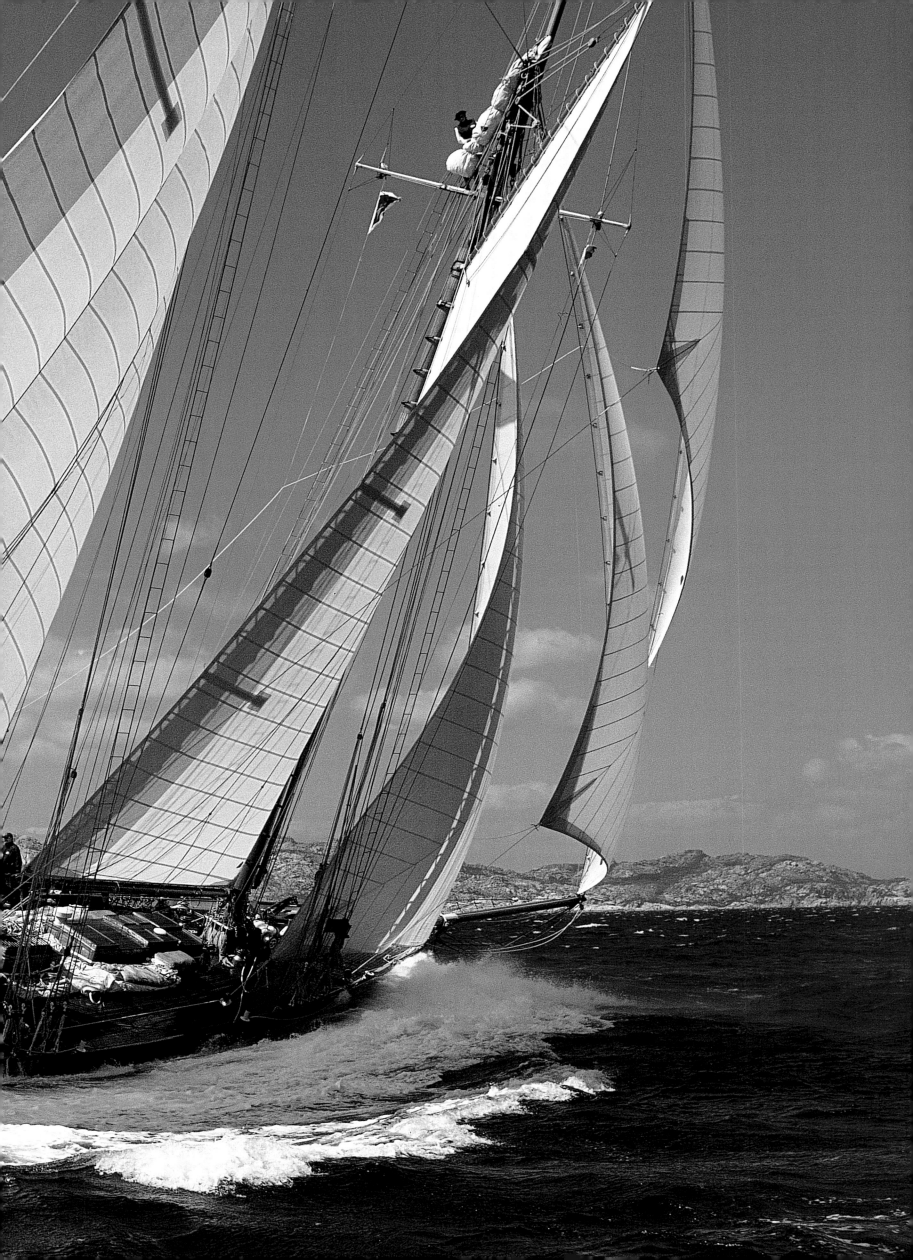

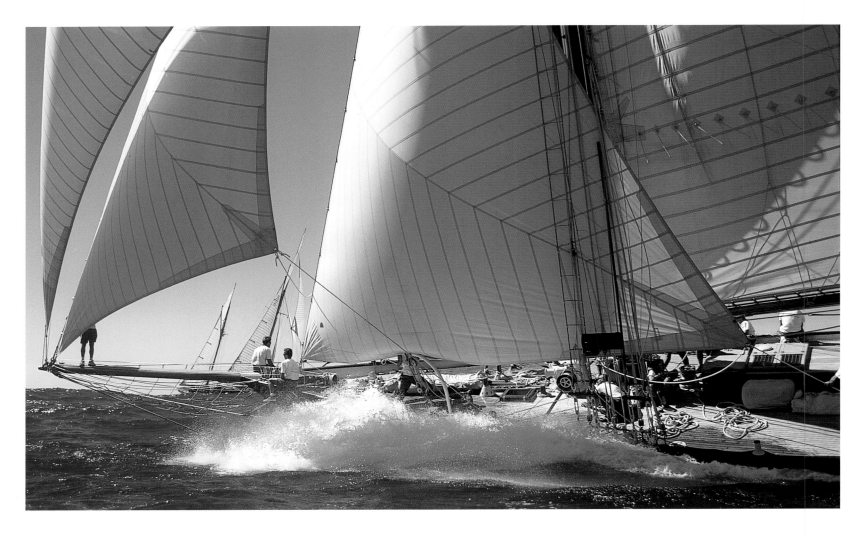

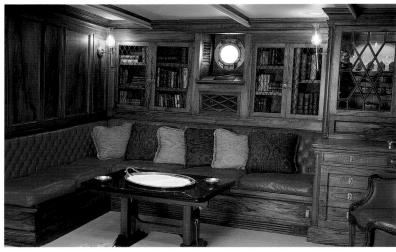

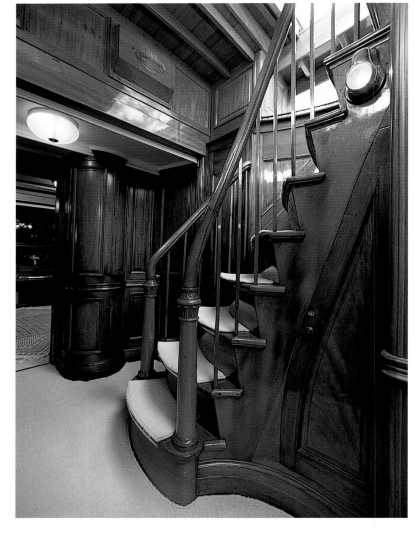

PRECEDING DOUBLE PAGE *In 1997 MARIETTE returned to New England waters, for the first time in 50 years, to take part in the Atlantic Challenge Cup.*

THIS PAGE AND ABOVE RIGHT *MARIETTE's 1995 refit resulted in uncluttered decks and varnished mahogany below, as Herreshoff would probably would have specified in his day.*

BELOW RIGHT *The schooner has an overall length of 138 feet (42 metres), length on deck of 110 feet (33.55 metres), designed waterline of 80 feet (24.3 metres) and 14 foot (4.3 metres) draught.*

FOLLOWING DOUBLE PAGE *MARIETTE's owner, Thomas J Perkins, is an enthusiastic competitor in Mediterranean regattas.*

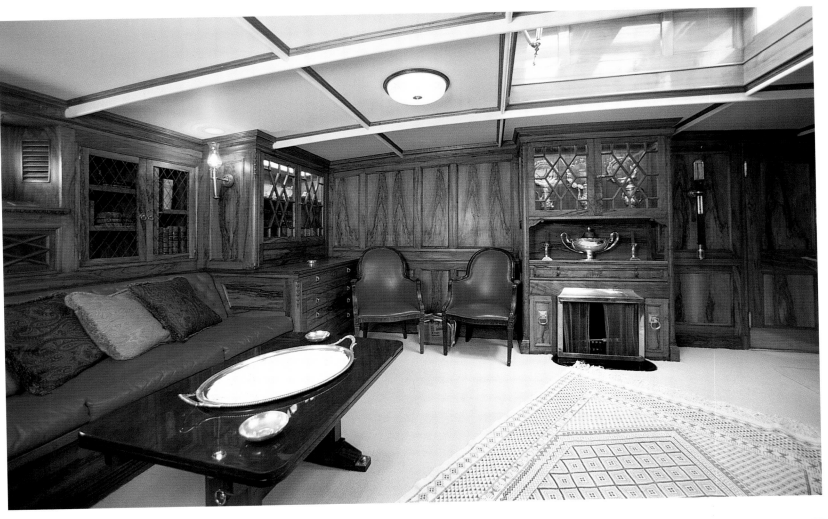

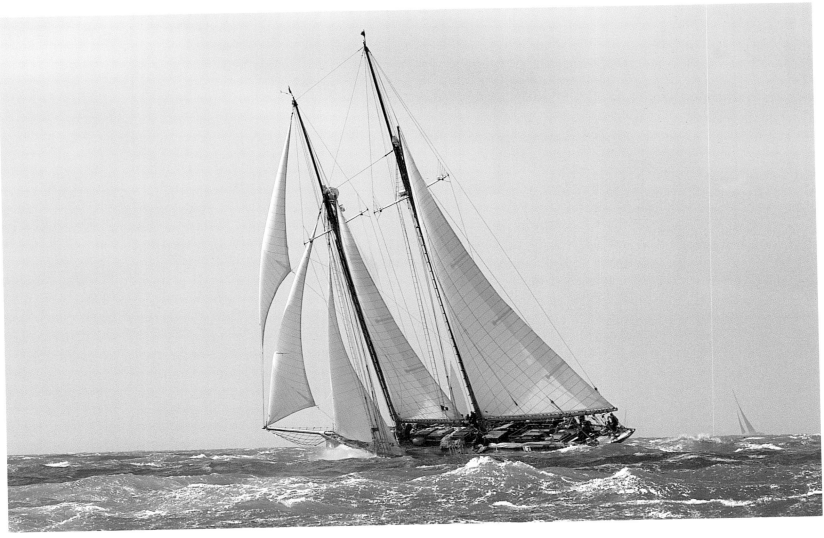

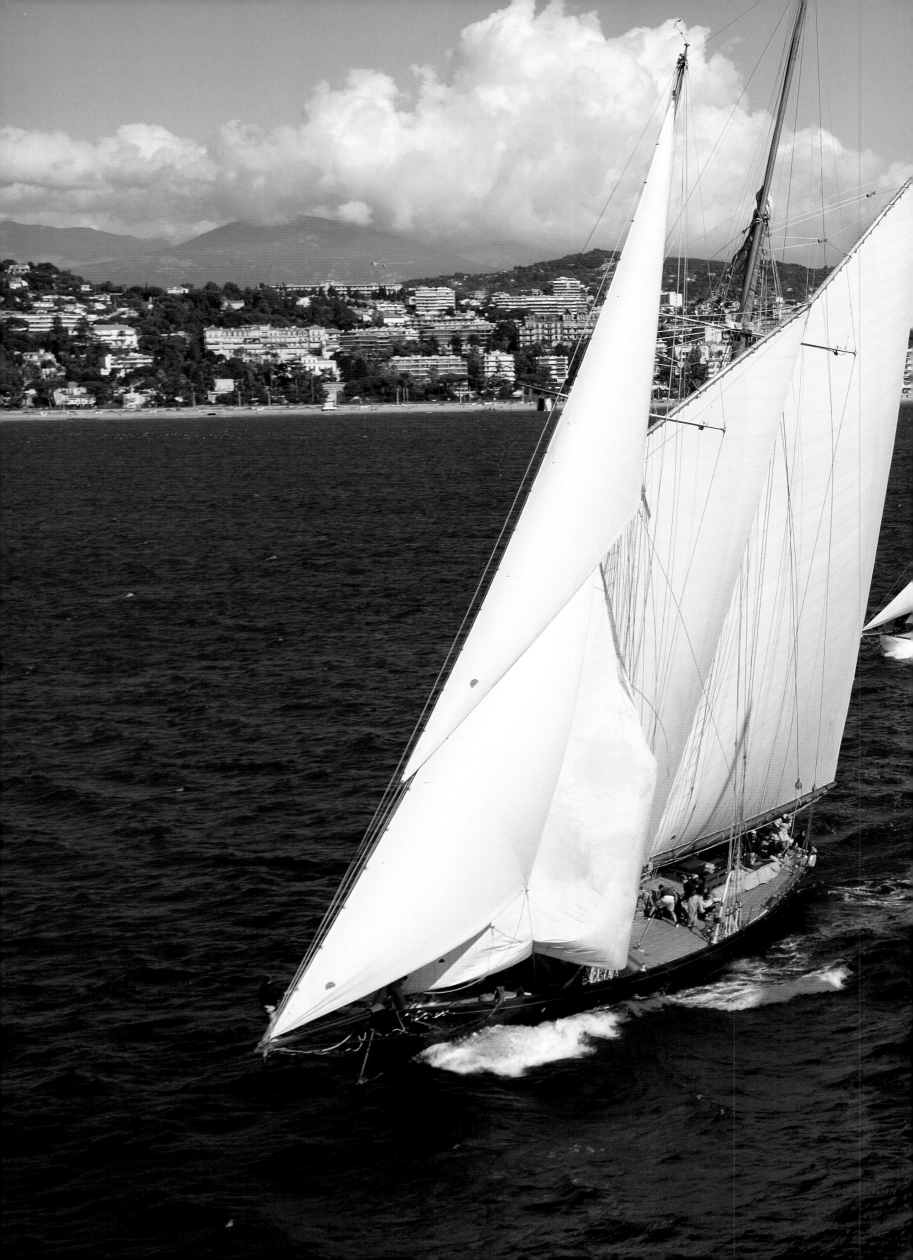

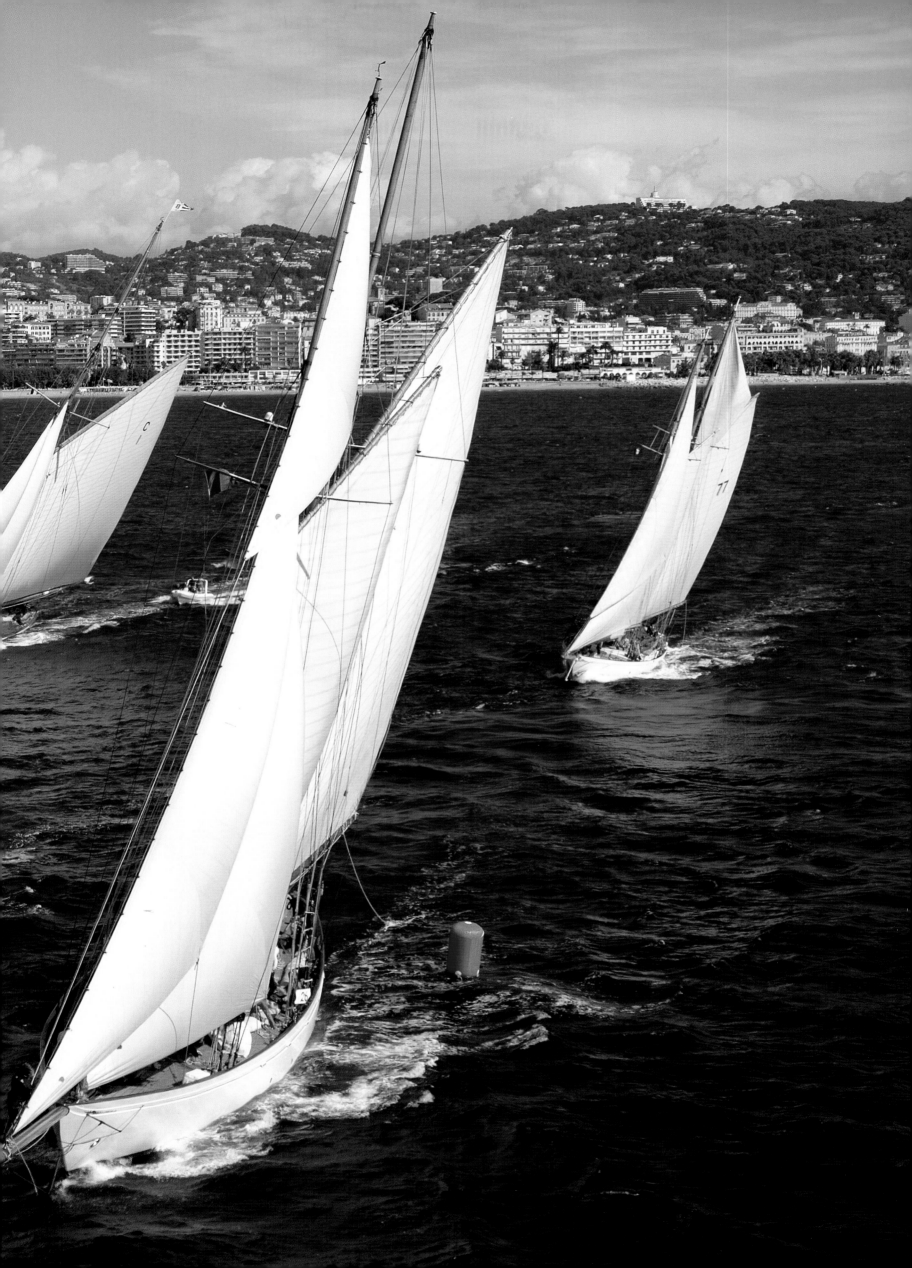

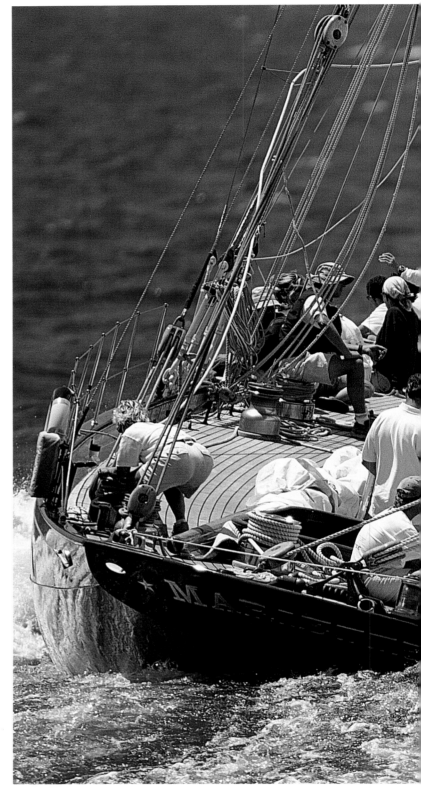

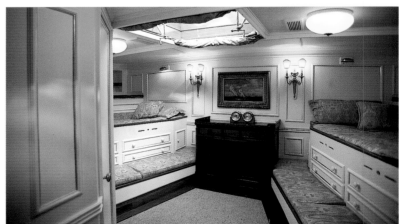

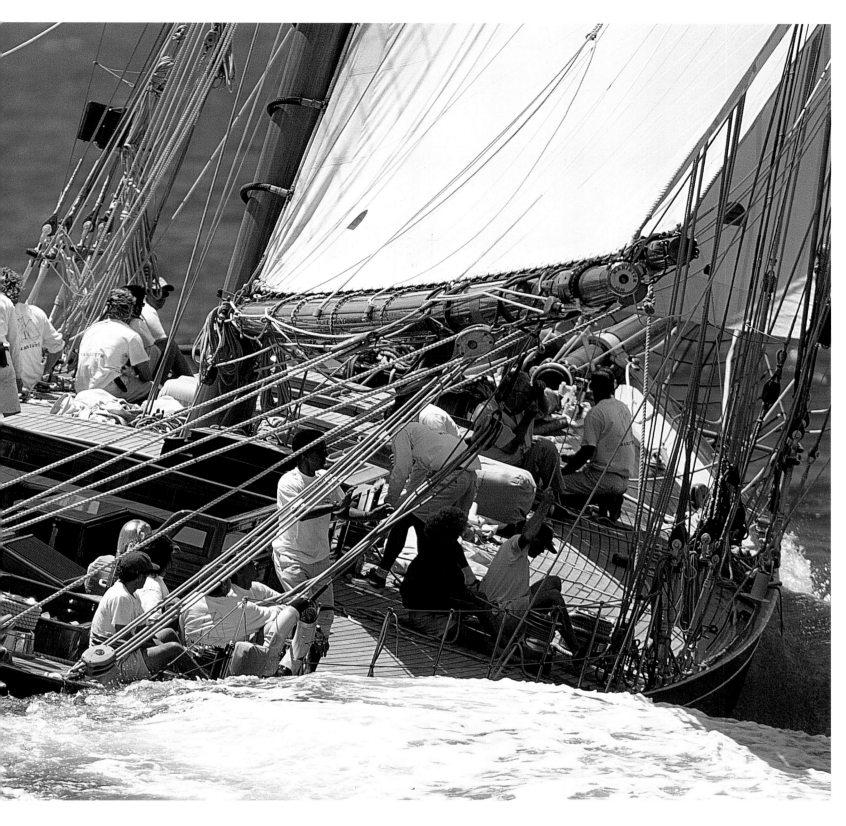

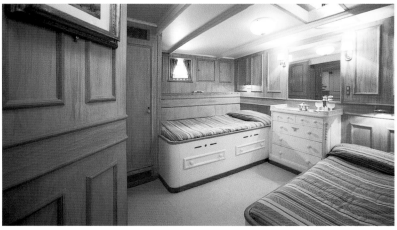

ABOVE *At the time she was launched, MARIETTE was one of the fastest yachts afloat and carried a rig that could barely be excelled for elegance.*

LEFT *The accommodation, including the owner's aft cabin and bathroom, is painted cream and gold.*

FOLLOWING TWO DOUBLE PAGES *MARIETTE's owner prefers to sail her in the Mediterranean, where she has won silver awards at the classic regattas and attracted much attention and admiration.*

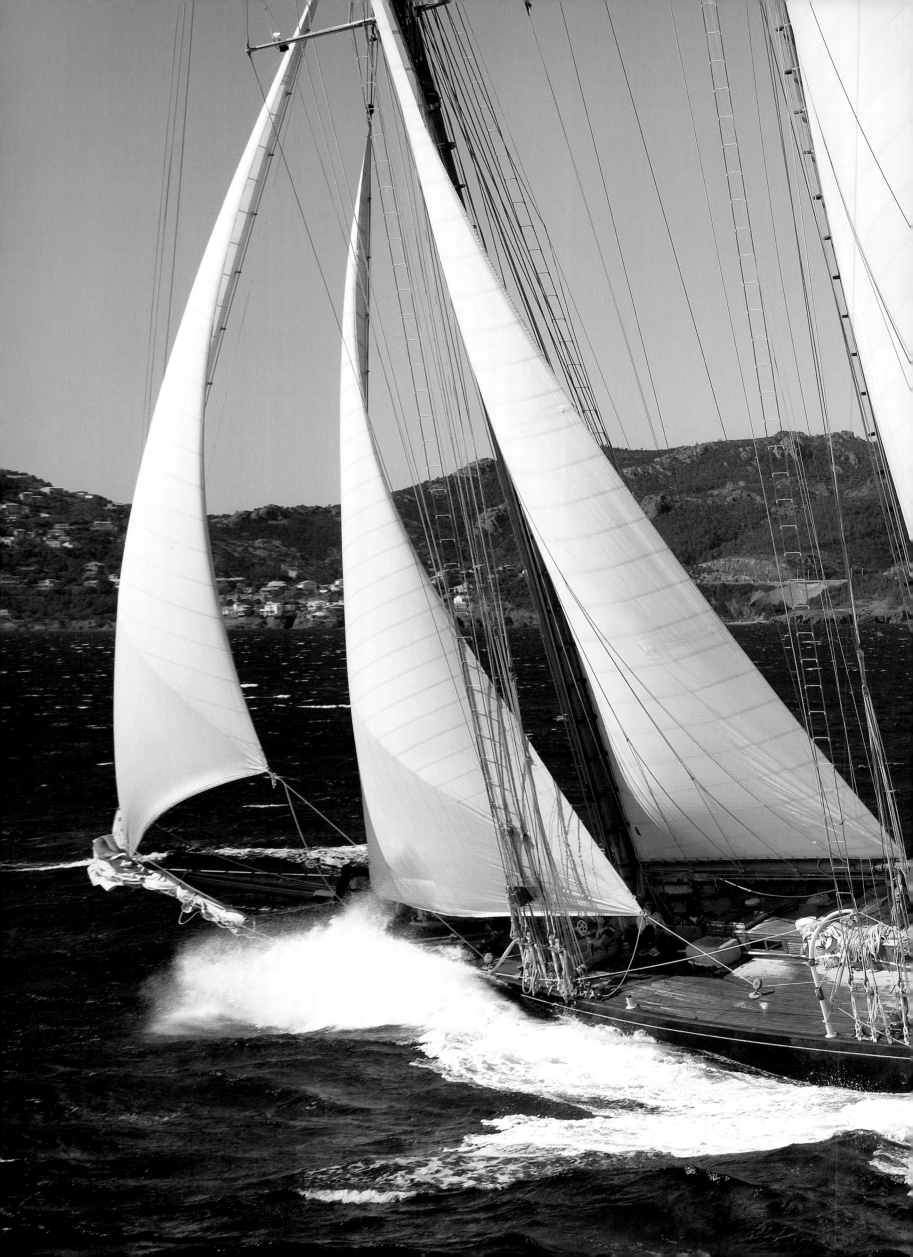

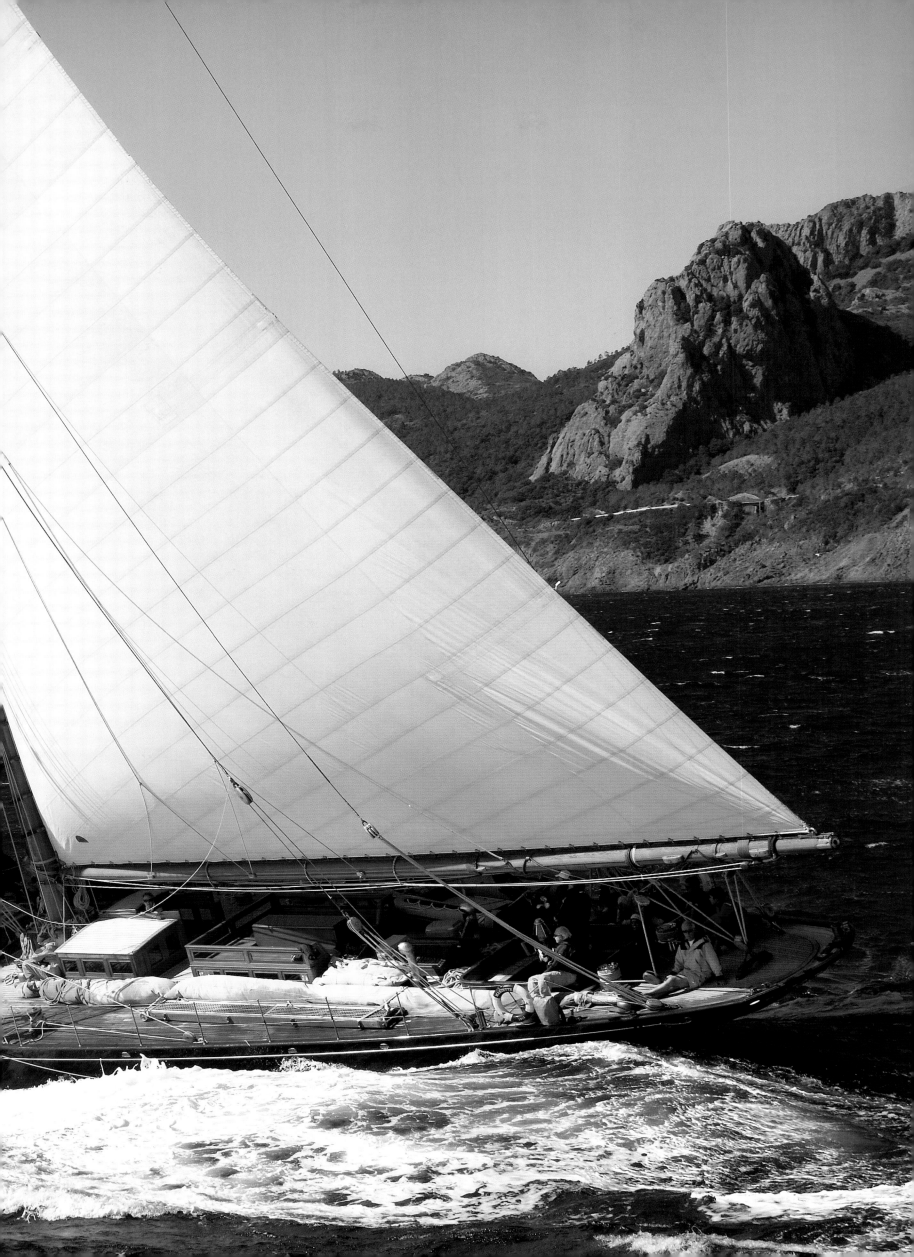

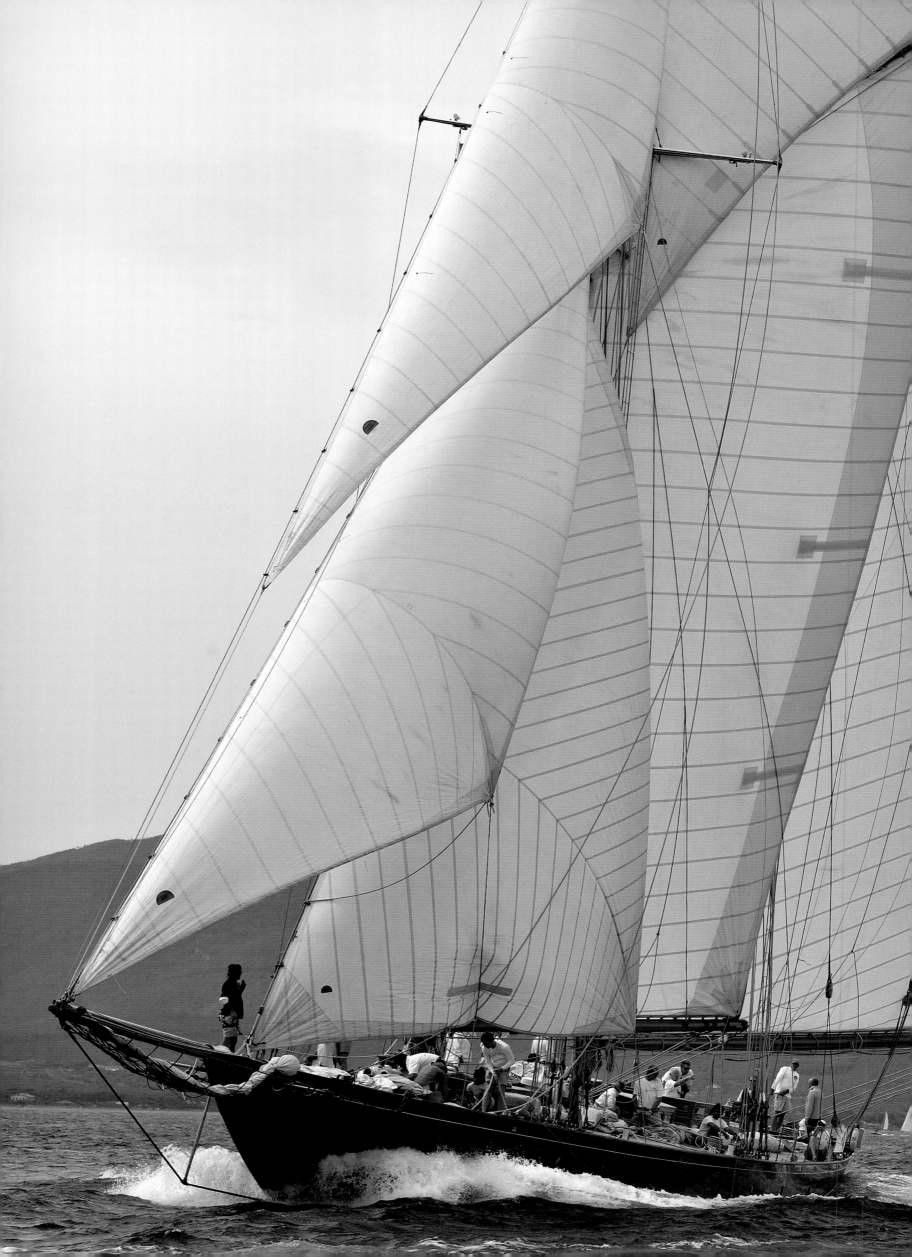

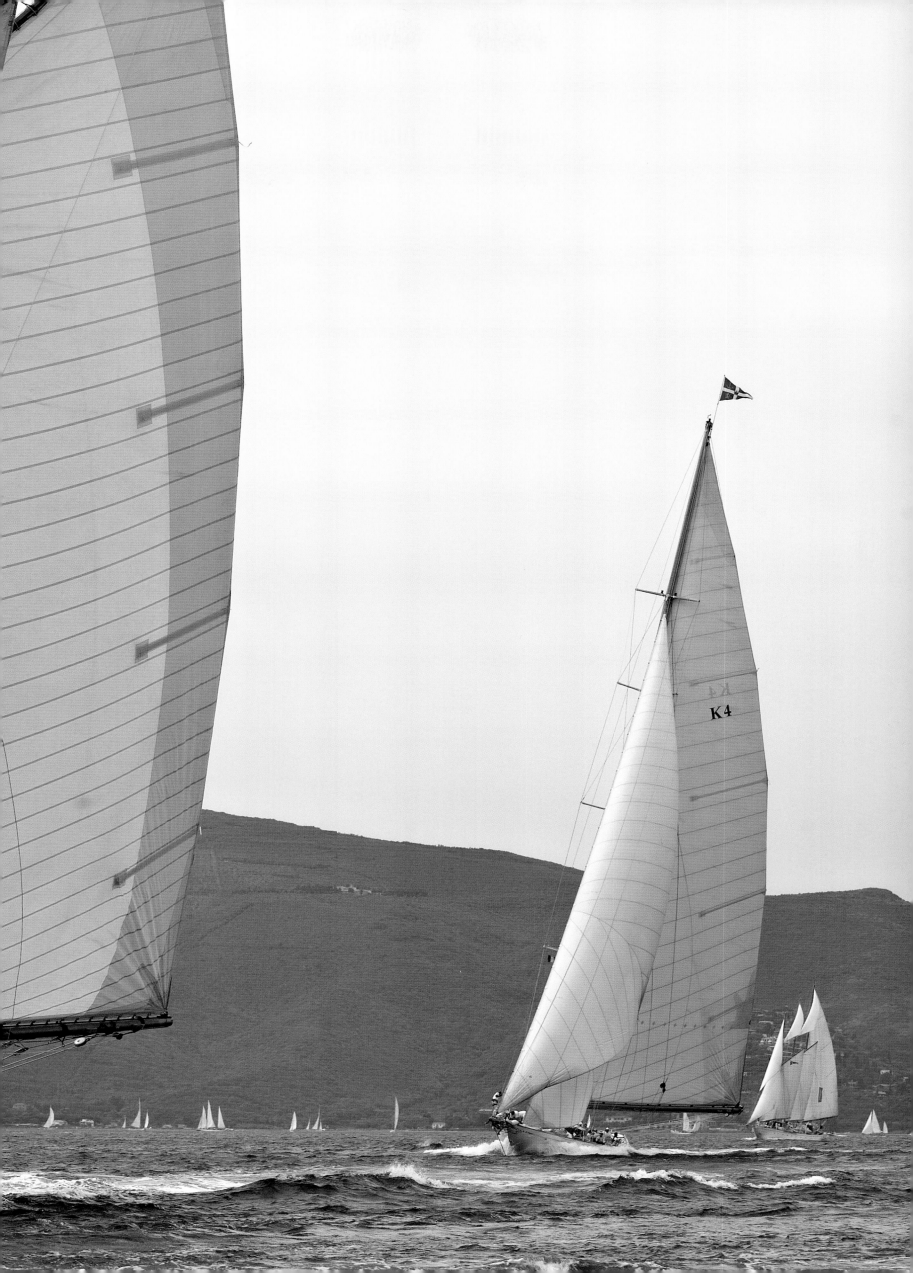

Marilee

Year of construction	1926	
Length overall	65ft 11in	(20.1m)
Length on deck	59ft	(18m)
Length of waterline	40ft	(12.2m)
Beam	14ft 6in	(4.42m)
Draught	7ft 10in	(2.4m)
Sail area	2421sq ft	(225m²)
Designer	Nathanael Herreshoff	
Builder	Herreshoff Manufacturing Company	

Herreshoff was undoubtedly the 'favourite of the court' among North American industrial tycoons, notably the Vanderbilts. However, he not only specialised in America's Cup yachts but also in the design of small and medium sized one-design class boats, mostly ordered by members of the New York Yacht Club. The NY 40 was to be Herreshoff's last one-design class for the club. He began to build the model immediately after the death of his brother and business partner, John Brown Herreshoff in 1915. The club ordered the NY 40 as a low-priced cruiser, which would not require professional crew and would be suitable for cruising as well as racing. A relatively generous beam, high freeboard, a flush deck and short overhangs resulted in plentiful space below, for which the design was disparaged among tough-minded racing yachtsmen as a sailing houseboat. Opinions changed, however, and the boats were soon known as the 'Fighting Forties'. Differing from today's convention, this refers to the length of waterline – on deck *Marilee* measures 59 feet (18 metres). In 1926, under her first owner Edward Cudahy, *Marilee* became part of the NYYC fleet. Today she belongs to a syndicate of five NYYC members.

BELOW *In 2000* Marilee *was restored to a high gloss finish by William Cannell Boatbuilding in Camden, Maine. Her mast and main boom came from Spencer Thetis Wharf in Cowes, Isle of Wight.*

RIGHT *One of the characteristics of the New York 40 is her flush racing deck. Herreshoff increased the freeboard to achieve this.*

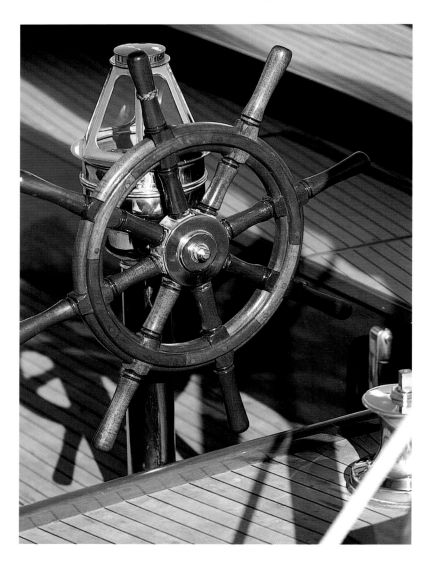

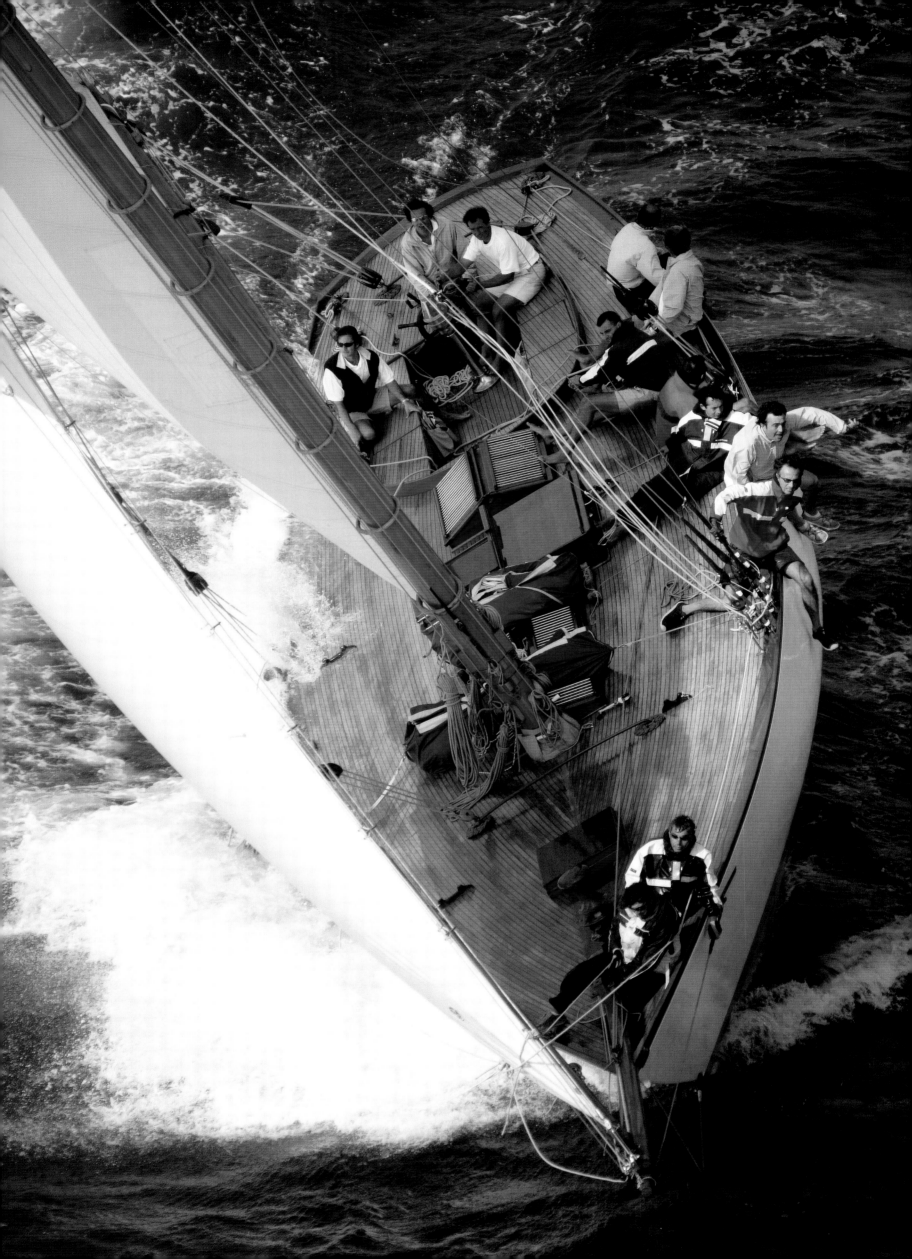

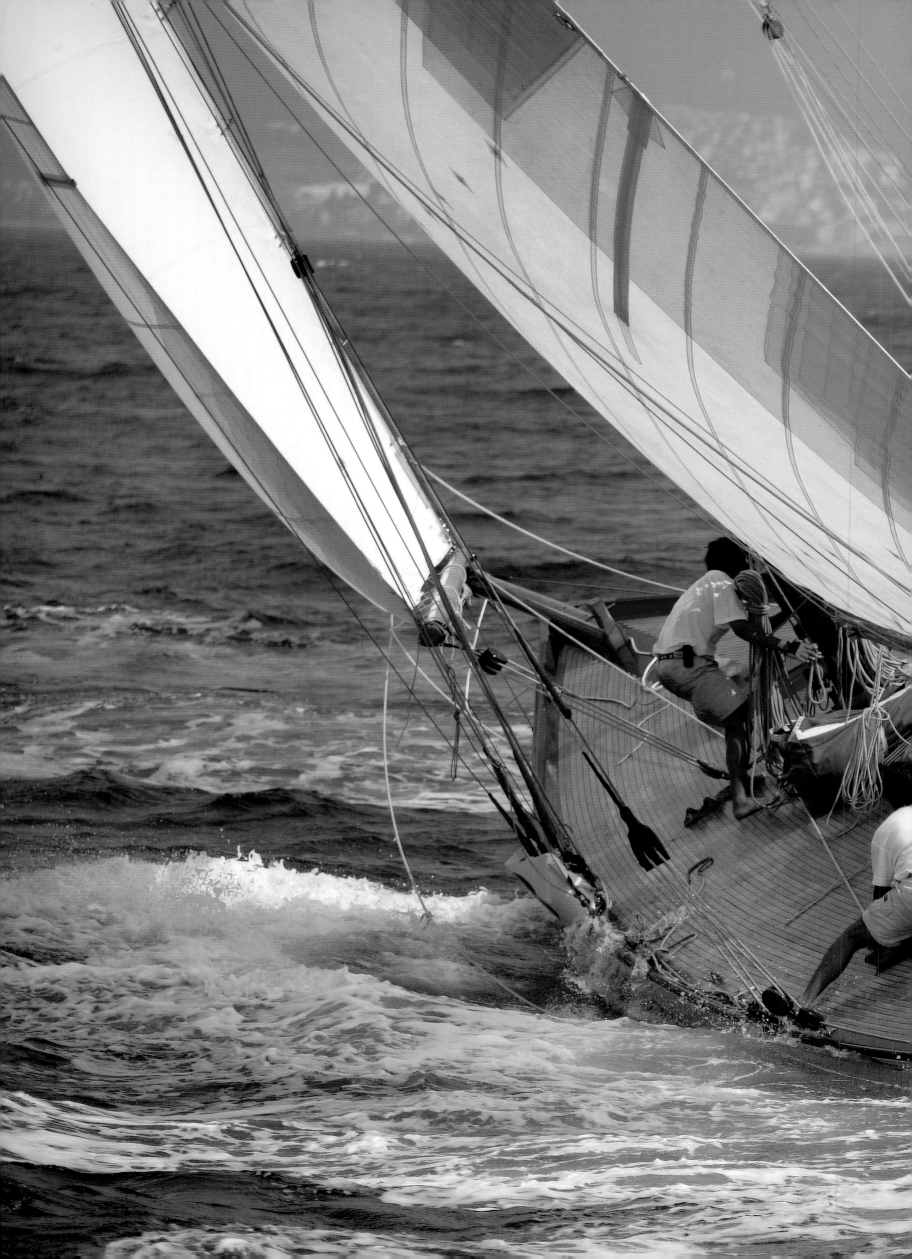

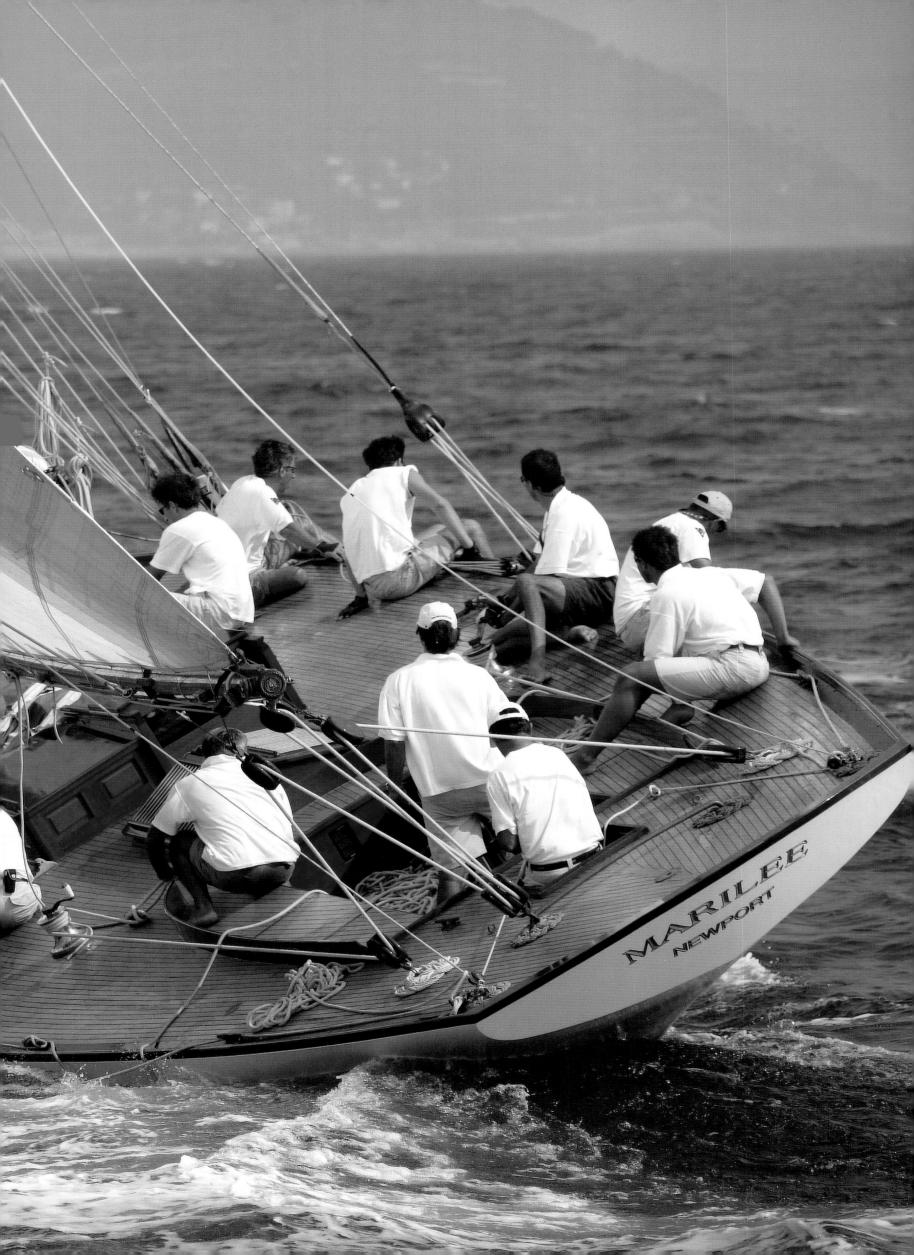

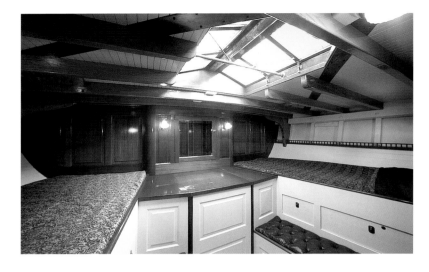

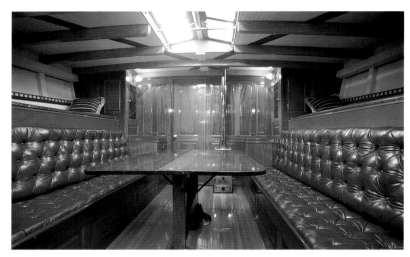

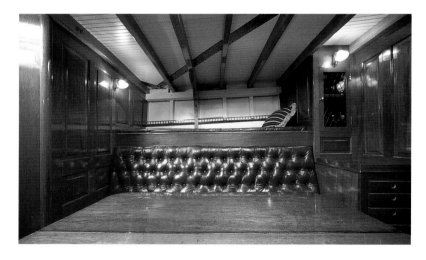

THIS PAGE *The millennium refit called for the complete restoration of the interior which included classic buttoned leather upholstery and a stove in the saloon.*

PRECEDING DOUBLE PAGE *Since relaunching in May 2001, MARILEE has sailed very successfully in the America's Cup Jubilee races off Cowes, and in the Mediterranean.*

OPPOSITE PAGE *Herreshoff delivered twelve NY 40s for the NYYC in 1916 and two more in 1926. One of these last two was MARILEE, sail number NY 50.*

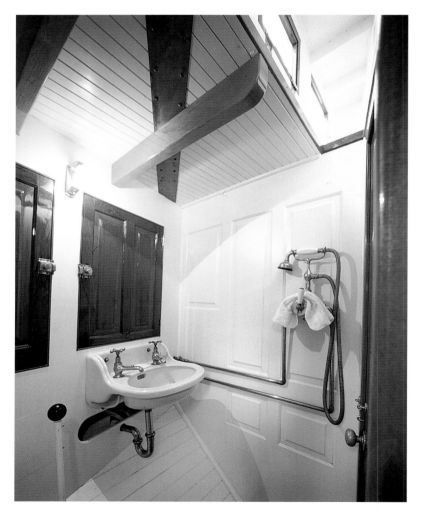

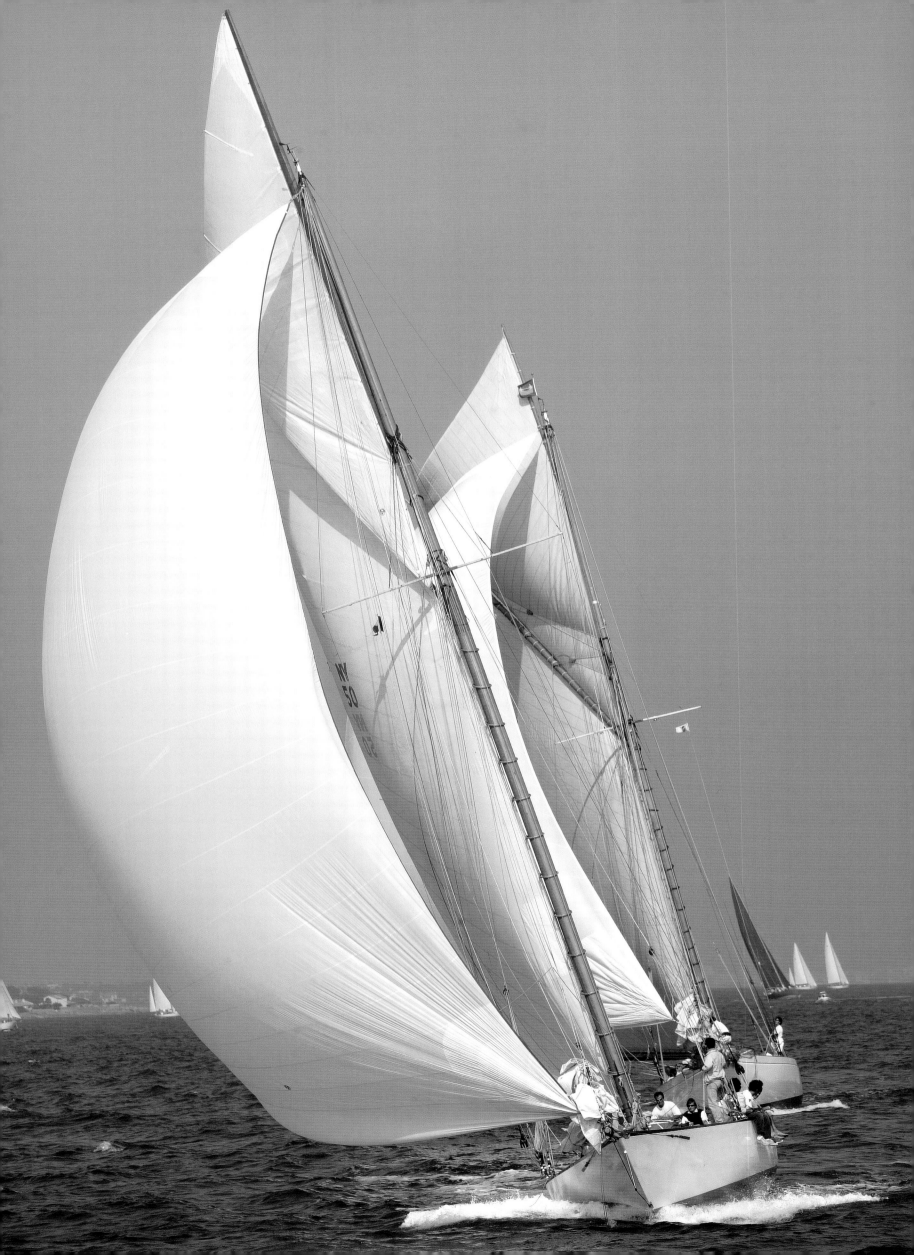

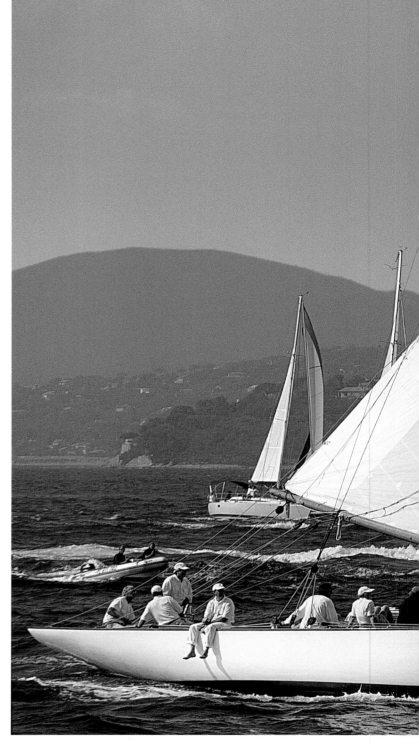

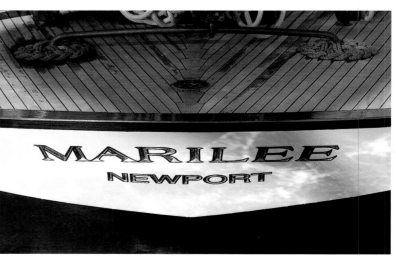

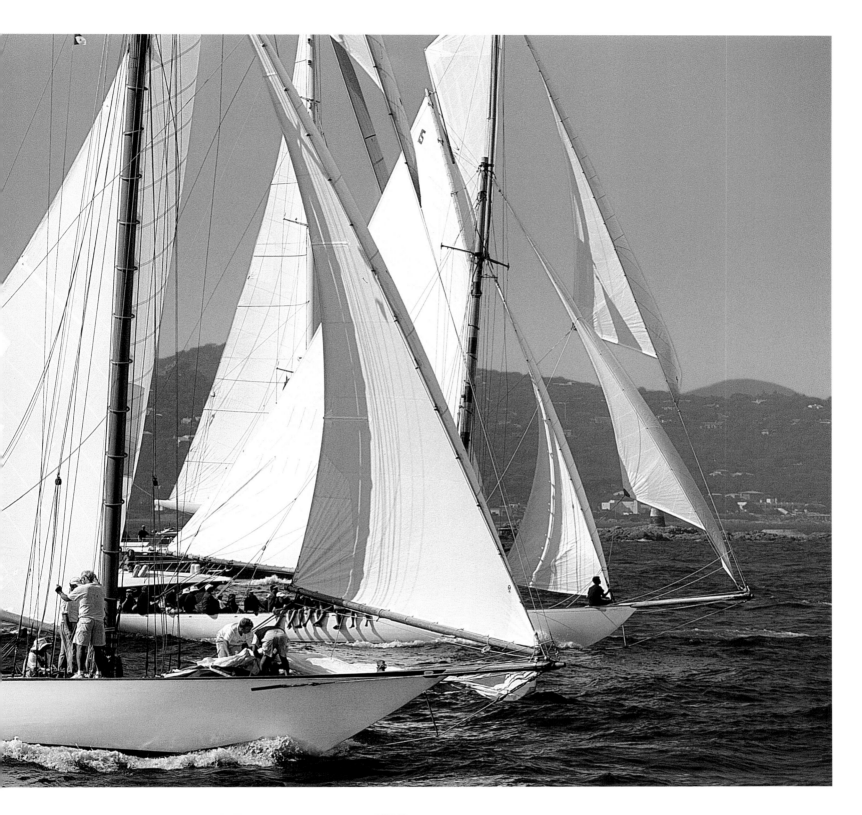

ABOVE *Today it's hard to believe that during the 1960s,* MARILEE*'s owner had her hull sheathed with fibreglass.*

LEFT *Once again the deck fittings look as they did in 1926. During the renovation,* MARILEE *was also returned to her original gaff rig. She won the Prix de'Élégance at the Antigua Classic Yacht Regatta in 2003.*

FOLLOWING DOUBLE PAGE *The NY 40s are far from being fair weather boats. According to observers at the time, none of the 40s was ever seen reefed.*

NEXT FOLLOWING DOUBLE PAGE *Under the Claiborne Pell Bridge at Newport are NY 30s No 14* CARA MIA, *No 11* ORIOLE *and No 1* ALERA.

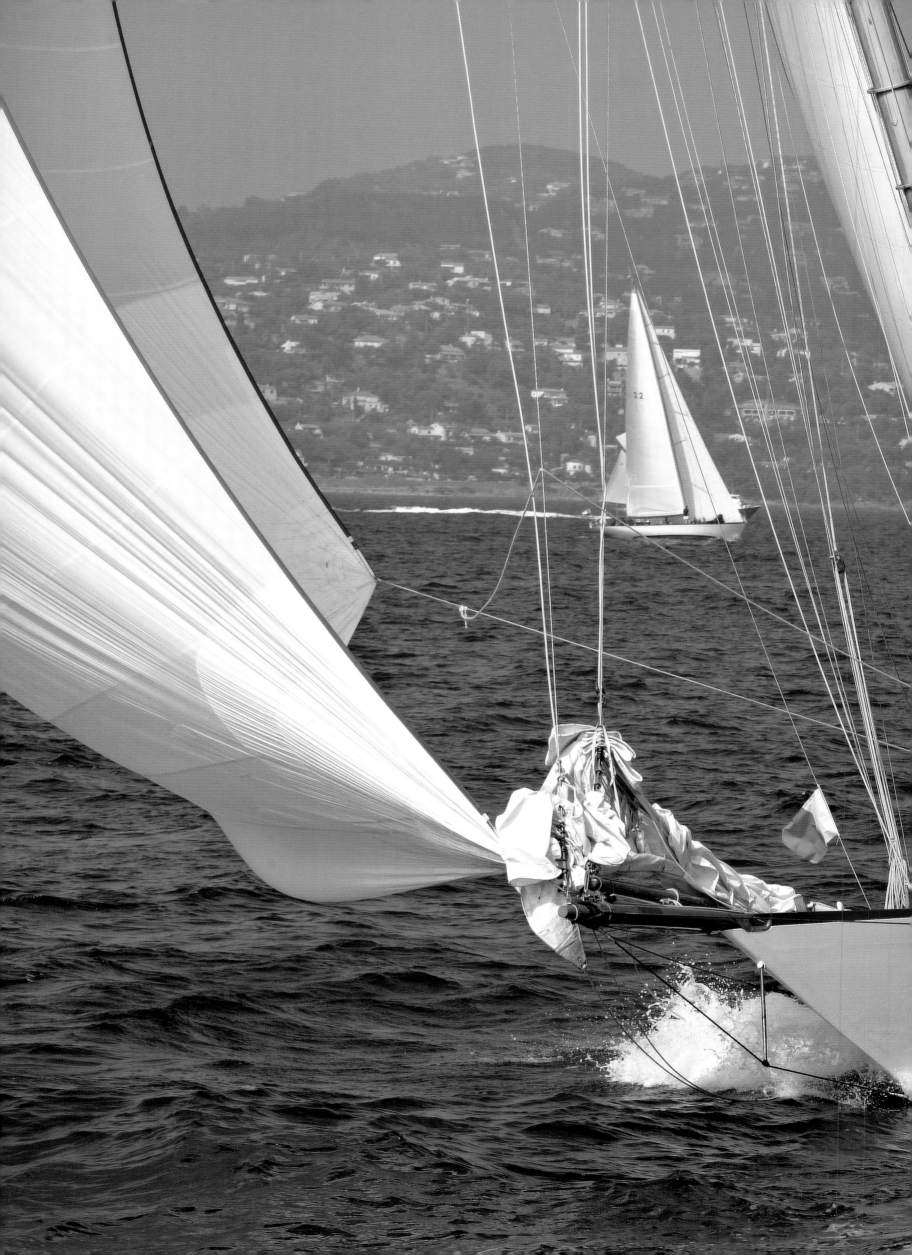

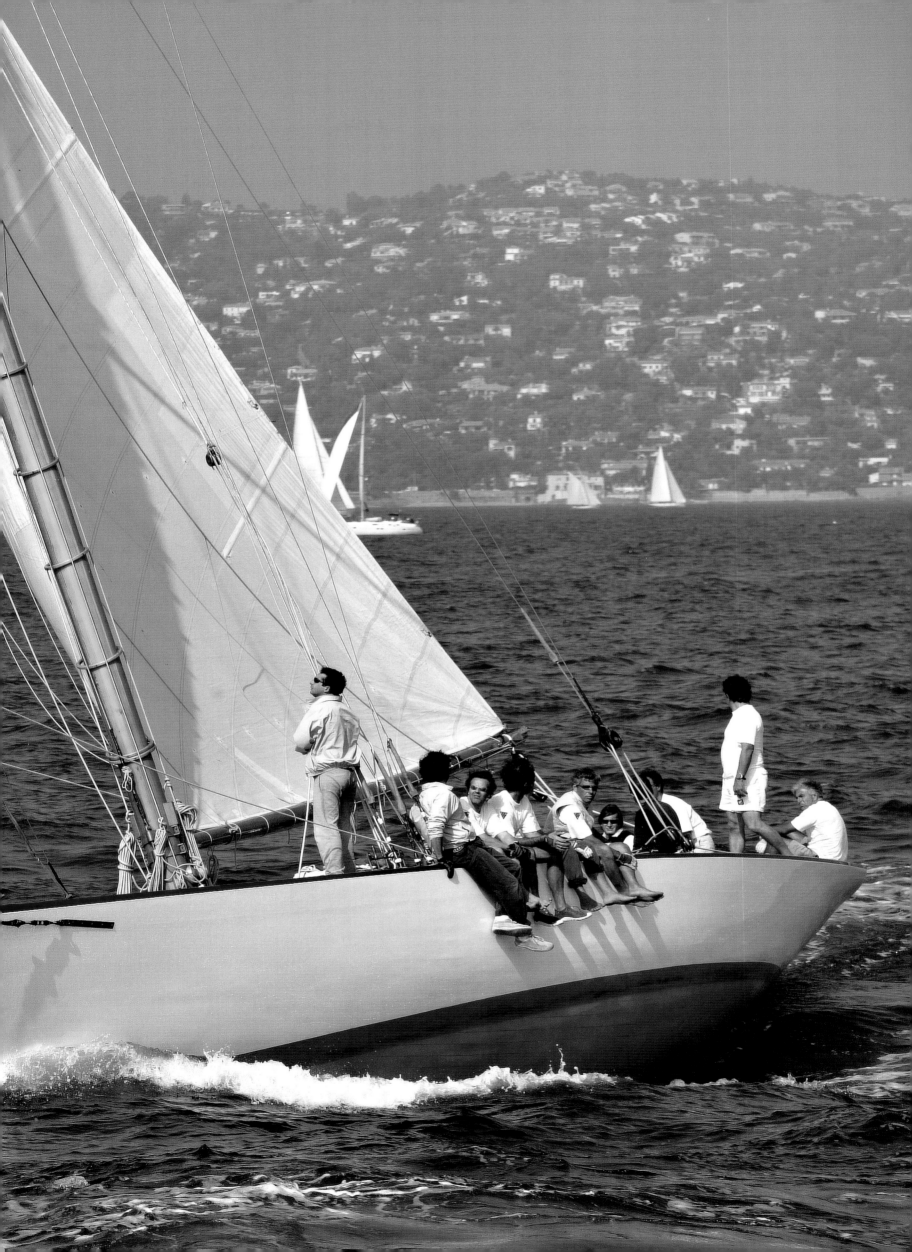

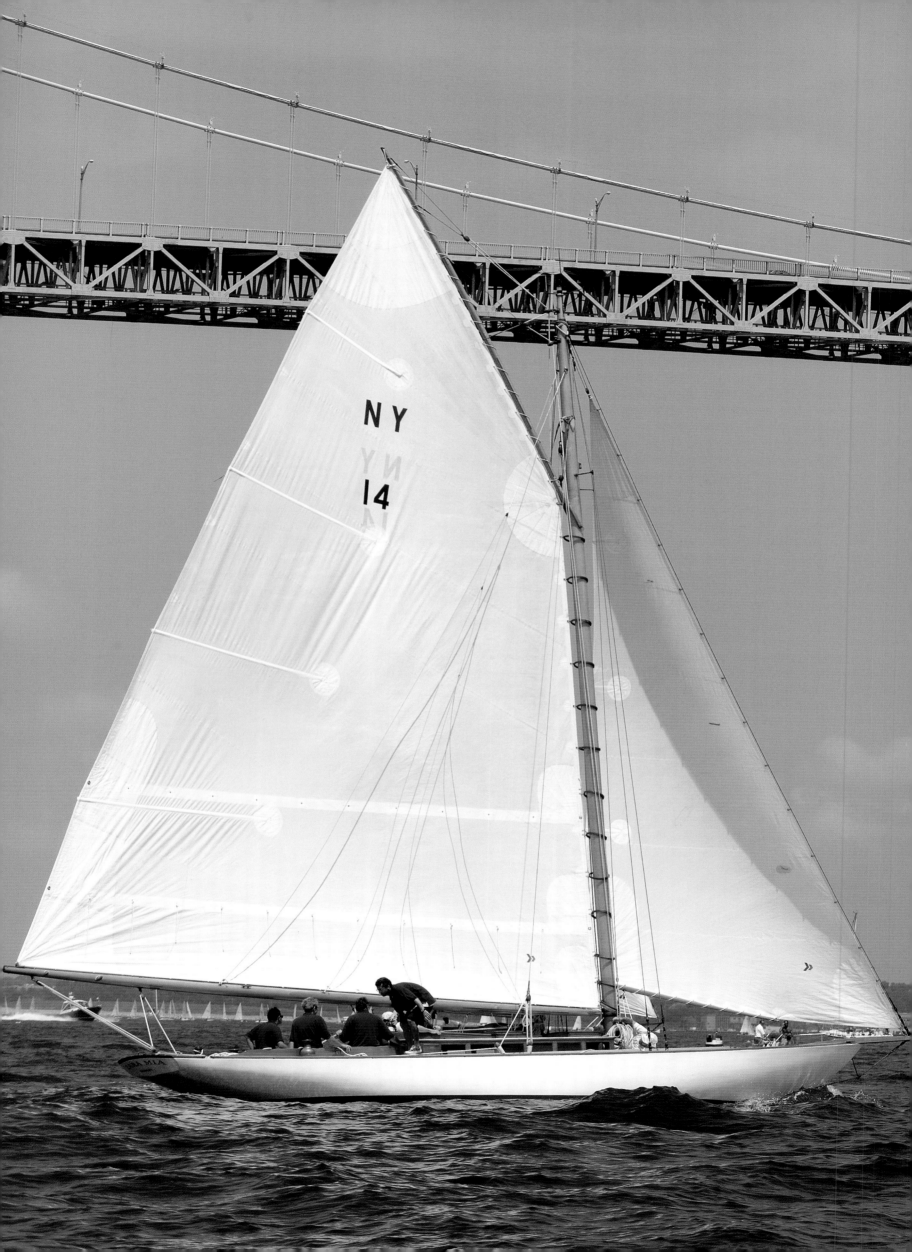

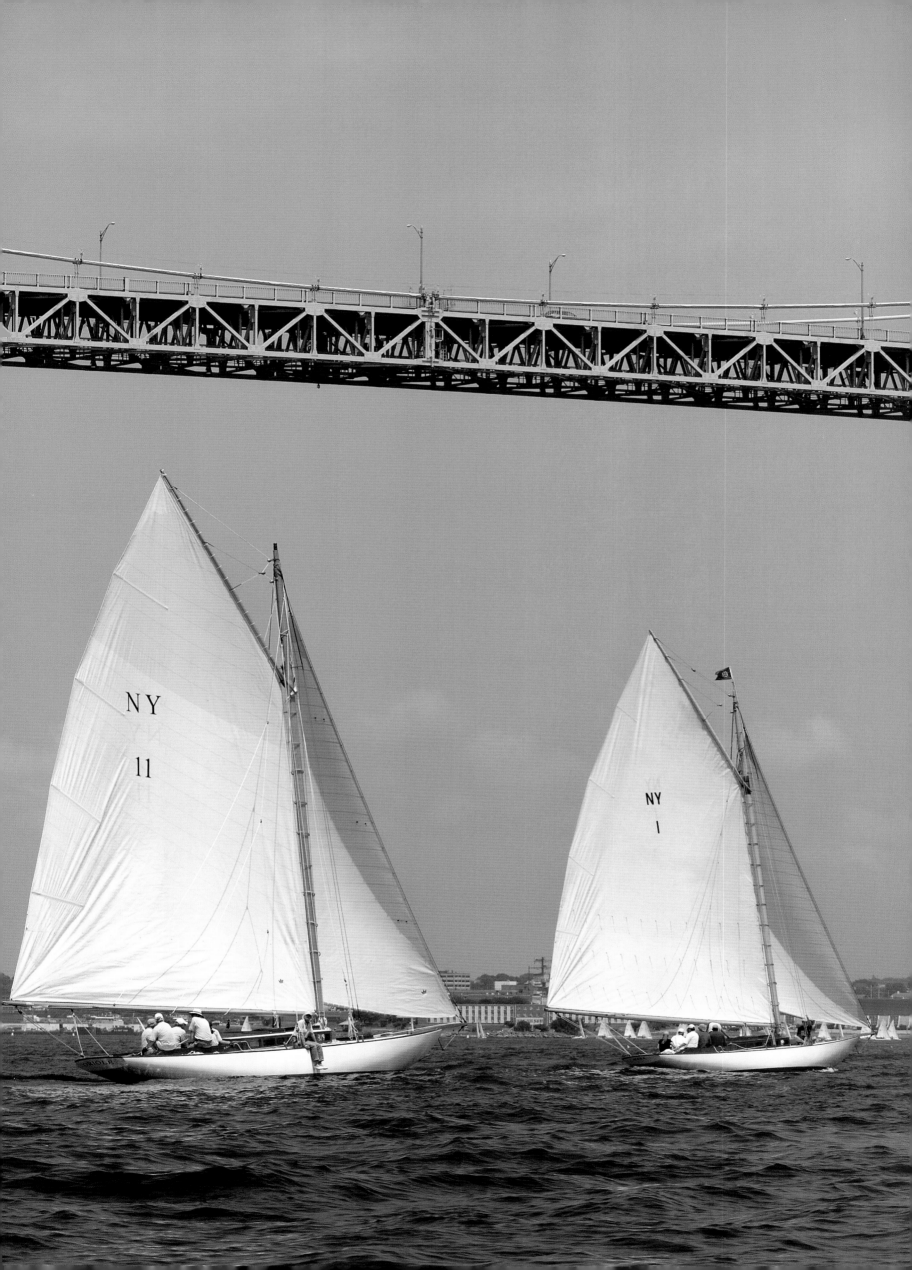

100 Years of the NY 30

Creating one-design yachts was a challenge because, in the case of large one-design boats, the owners had exacting demands. Once launched, a one-design either made its mark or disappeared. So he welcomed the opportunity of creating a successful, enduring one-design class for the New York Yacht Club.

With the New York 30 Herreshoff designed his fourth class to the 30 Foot Rule – their length is slightly less than that on the waterline – following the Newport 30 in 1896, the Buzzards Bay 30 in 1902 and the Bar

Year of construction	1904 & 1905	
Length on deck	43ft 6in	(13.25m)
Length of waterline	29ft 9in	(9.1m)
Beam	8ft 10in	(2.7m)
Draught	6ft 3in	(1.91m)
Sail area	1044sq ft	(97m²)
Designer	Nathanael Herreshoff	
Builder	Herreshoff Manufacturing Company	

In 1904, four members of the New York Yacht Club discussed the idea of a new boat design of reasonable dimensions for short passages and, in particular, suitable for competing in friendly races at the club. They confided their ideas to Herreshoff. Since the end of the 19th century the architect had been designing one-design class yachts as well as boats conceived solely for the purpose of competing in the America's Cup.

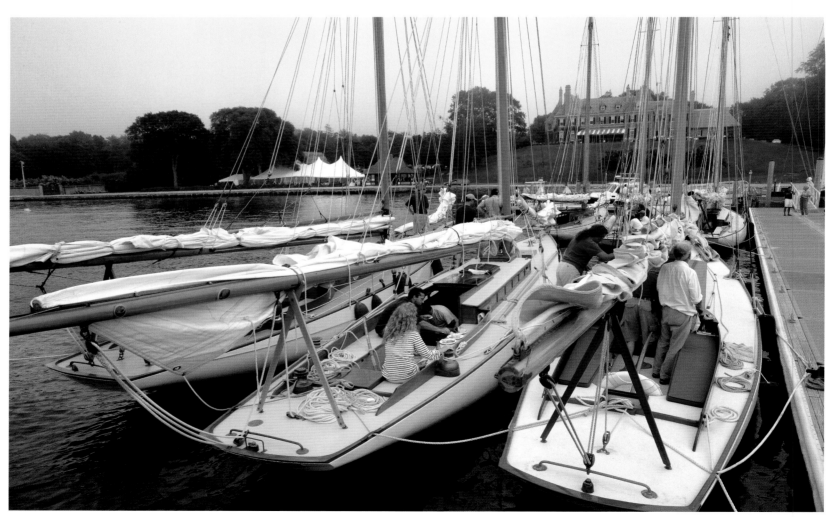

Harbor 30 in 1903. Members of the New York Yacht Club immediately ordered eighteen New York 30s, of which six have disappeared, six have been restored and six are awaiting restoration. Today, class racing takes place off Newport – in 2005 all the New York 30s still afloat took part in the design's centenary regatta.

THIS DOUBLE PAGE *For the centenary of the New York 30 Class, the New York Yacht Club organised a regatta off Newport, in front of its Harbor Court clubhouse. All the New York 30s still moor up at the club's landing stage.*

NEXT DOUBLE PAGE *No 11 ORIOLE (foreground) and No 16 NAUTILUS and No 15 BANZAI (behind) at close-quarters.*

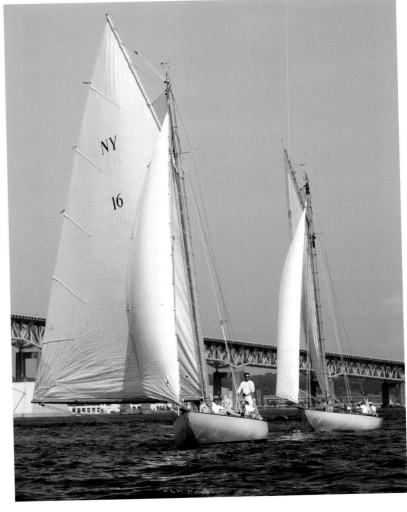

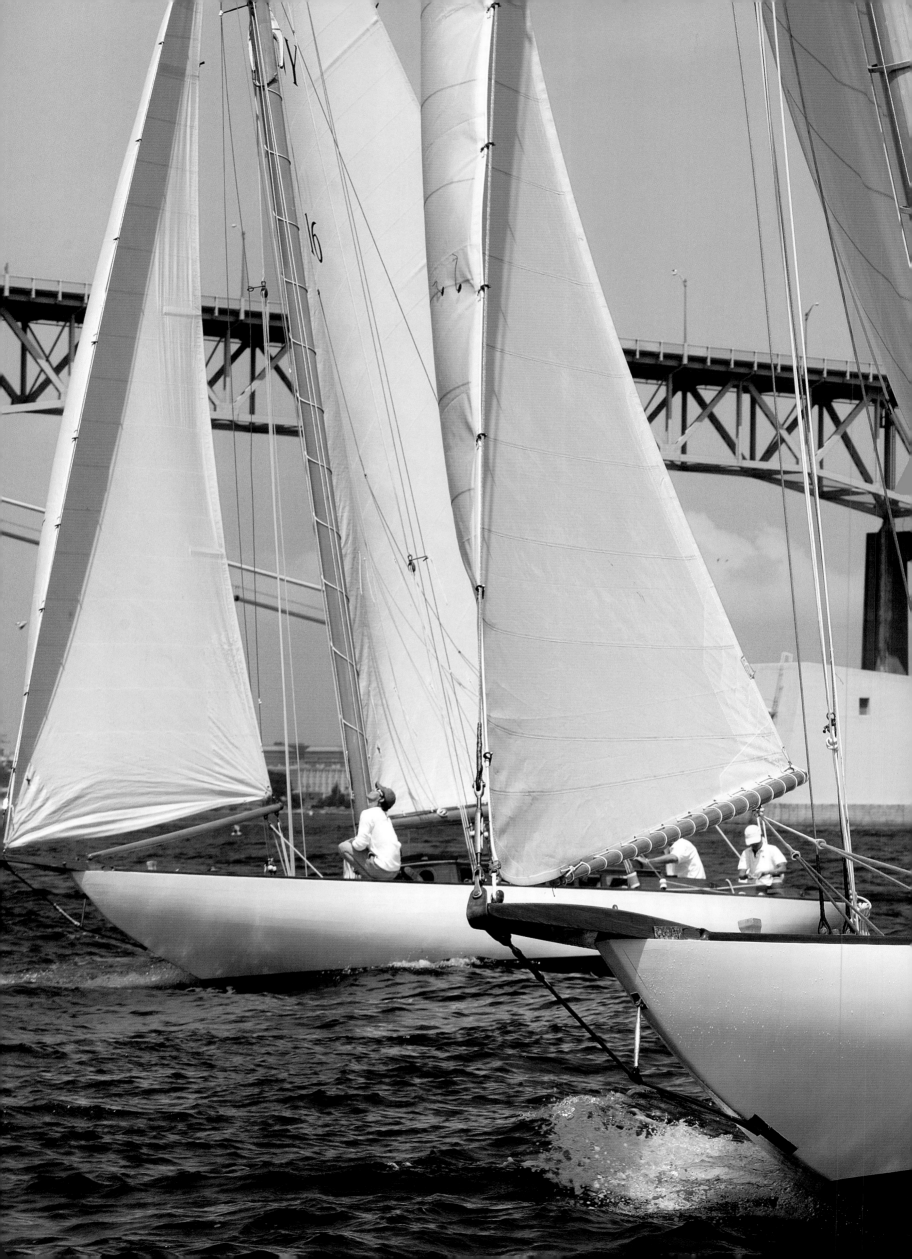

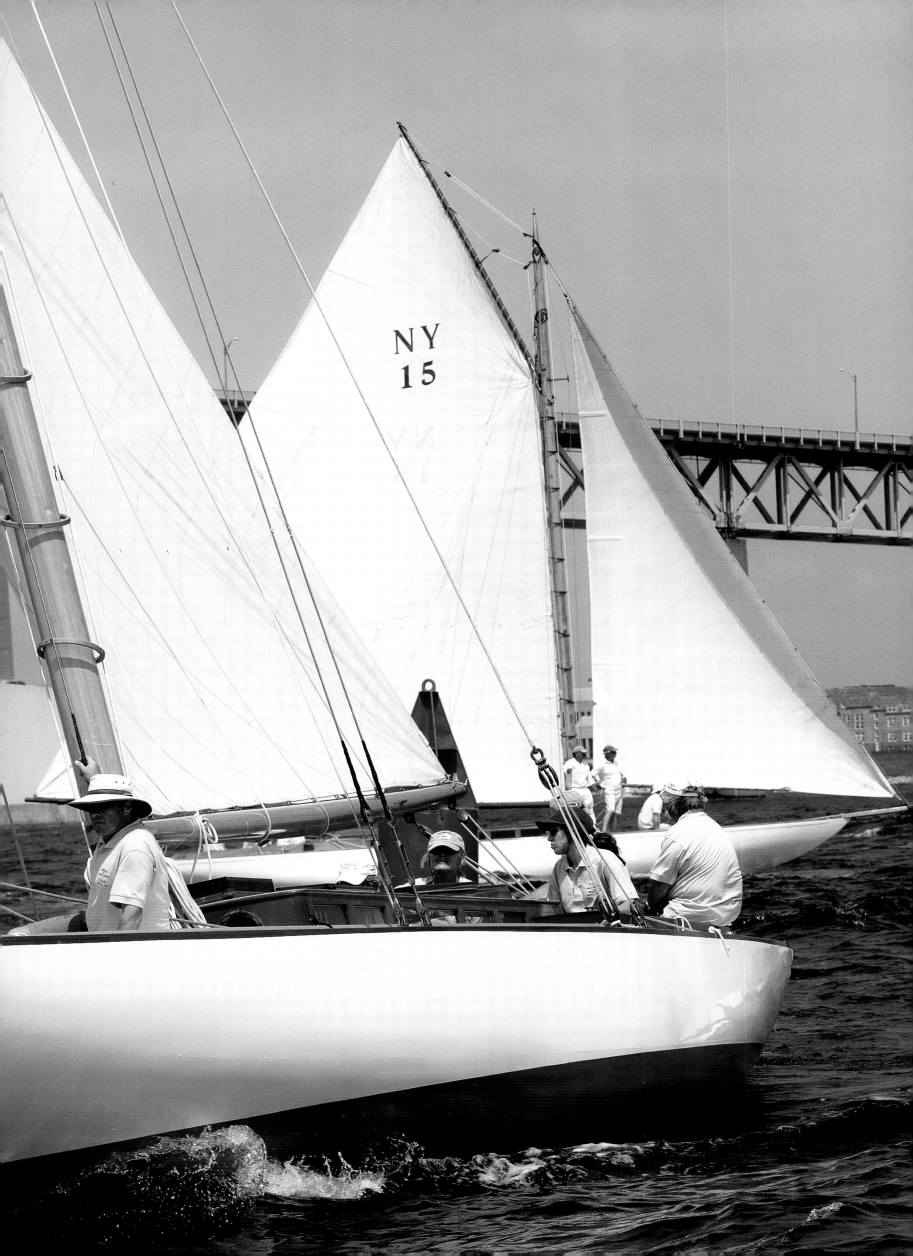

Oriole

The New York 30 performs well in wind and waves – it is amongst the most seaworthy of Herreshoff's one-designs. Furthermore, the NYYC members wanted a cruiser/racer, so the Wizard of Bristol created a very slim, fast boat. No 11's first owner Lyman Delano named his yacht *Oriole*. When her end seemed inevitable after decades of trusty service, she was saved by William Cannell Boatbuilding in Camden, Maine and received an extensive refit. Following several modifications in the early 1950s, neither the original deck nor her internal fittings remained. After her refit, she again sailed with a gaff rig, an authentic interior and a lime-washed deck made of Weymouth pine which the shipyard – like Herreshoff in his day – covered with canvas and waterproof paint. Only winches, made of polished bronze according to Herreshoff's drawings, were fitted on deck. Today the class rules allow an engine beneath the cockpit, and *Oriole* is powered with a light Yanmar diesel but the electrical system is kept to the minimum. *Oriole* is currently based on the French Mediterranean coast.

Year of construction	1904	
Length on deck	43ft 6in	(13.25m)
Length of waterline	29ft 9in	(9.1m)
Beam	8ft 10in	(2.7m)
Draught	6ft 3in	(1.91m)
Sail area	1044sq ft	(97m²)
Designer	Nathanael Herreshoff	
Builder	Herreshoff Manufacturing Company	

During Oriole's *restoration, the shipyard followed Herreshoff's original plans from the MIT collection exactly, from the rig to the interior.*

RIGHT *The New York Yacht Club wanted a racing class suitable for strong winds.* Oriole *demonstrates that Herreshoff fulfilled this wish.*

FOLLOWING DOUBLE PAGE *The shipyard renewed the deck with Weymouth pine, covered with canvas and waterproof paint.*

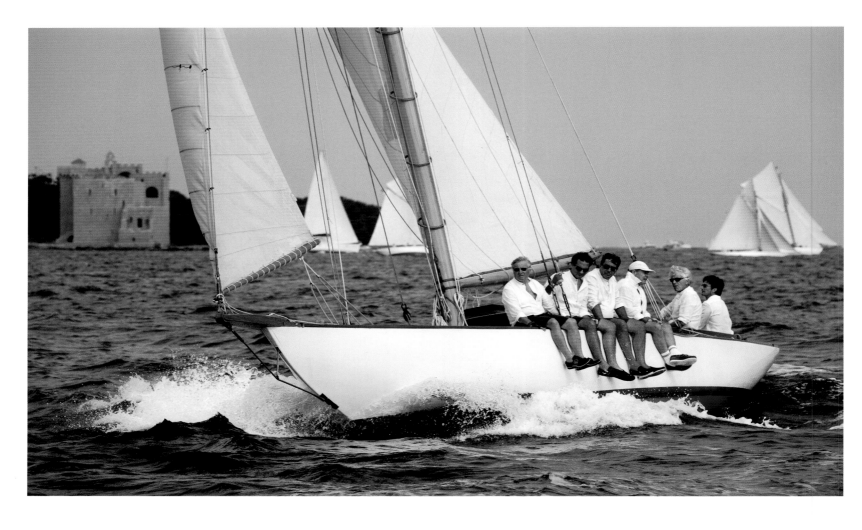

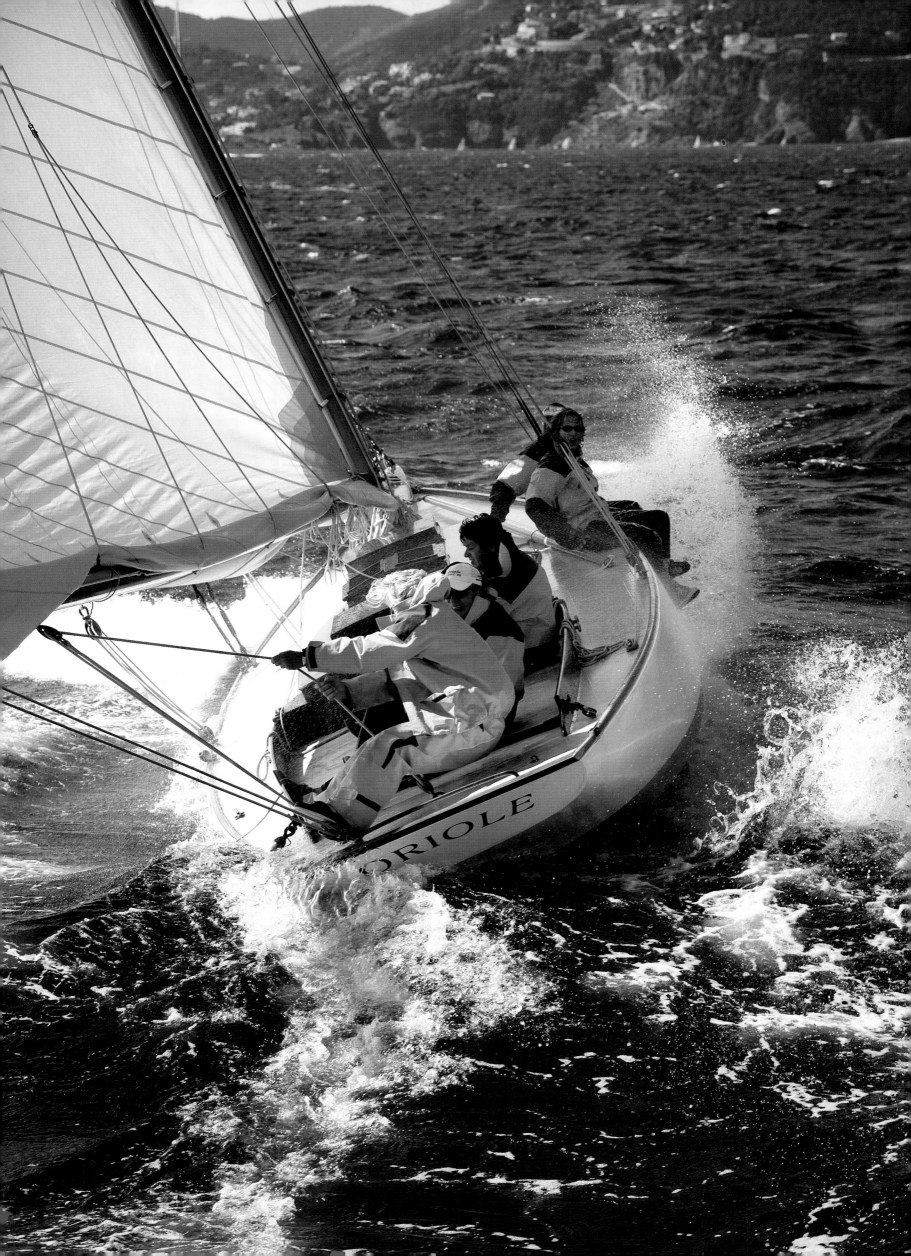

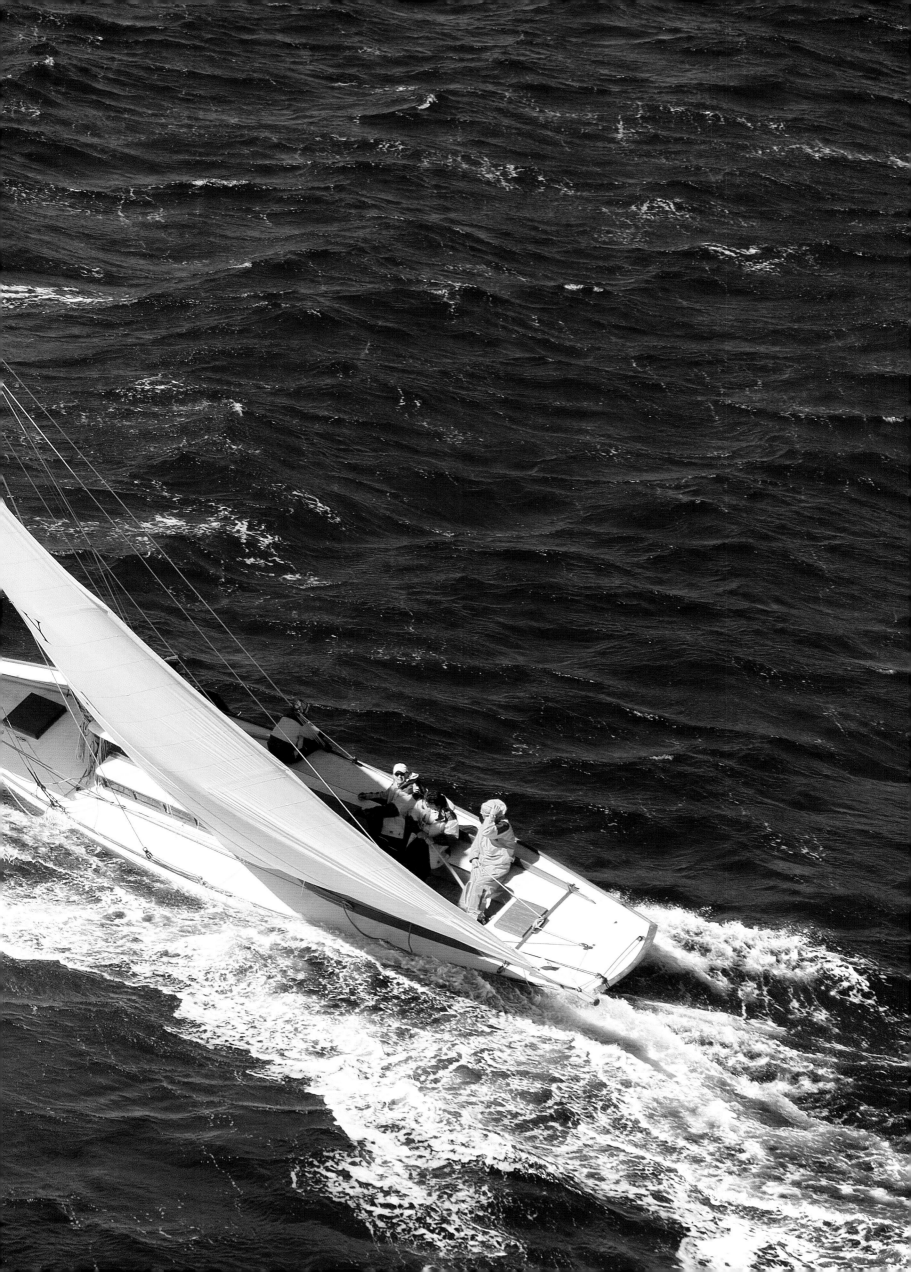

THIS PAGE *NY 30 ORIOLE left the refit yard just in time for the 100th anniversary of the class in summer of 2005, complete with authentic gaff rig.*

RIGHT *According to legend, NY 30 owners sailed under full canvas even in 40 knots of wind (force 8 on the Beaufort Scale). Nowadays, they sometimes shorten sail.*

FOLLOWING DOUBLE PAGE *The newly-created class association allows owners to use synthetic sailcloth.*

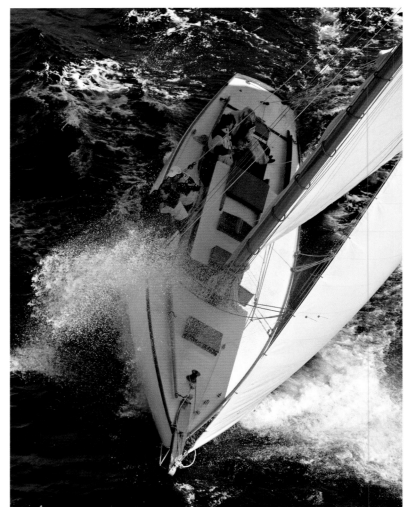

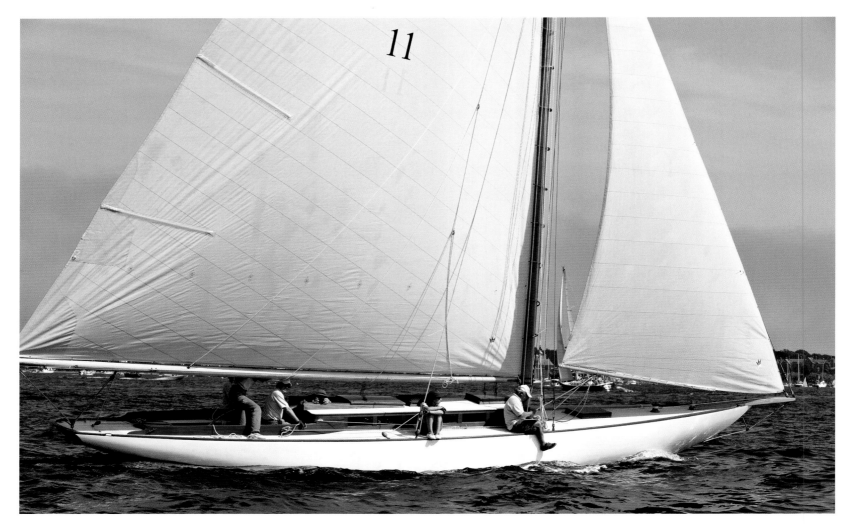

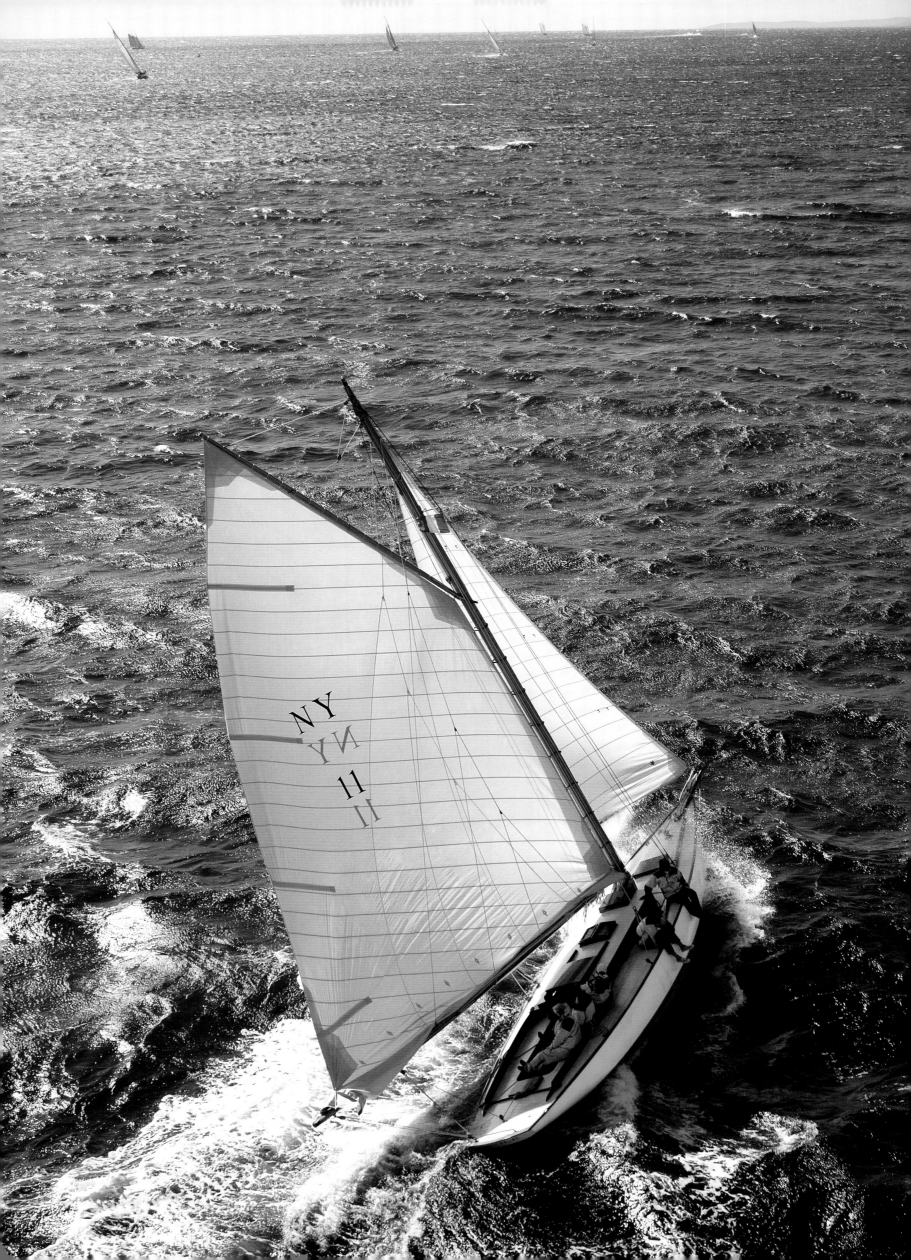

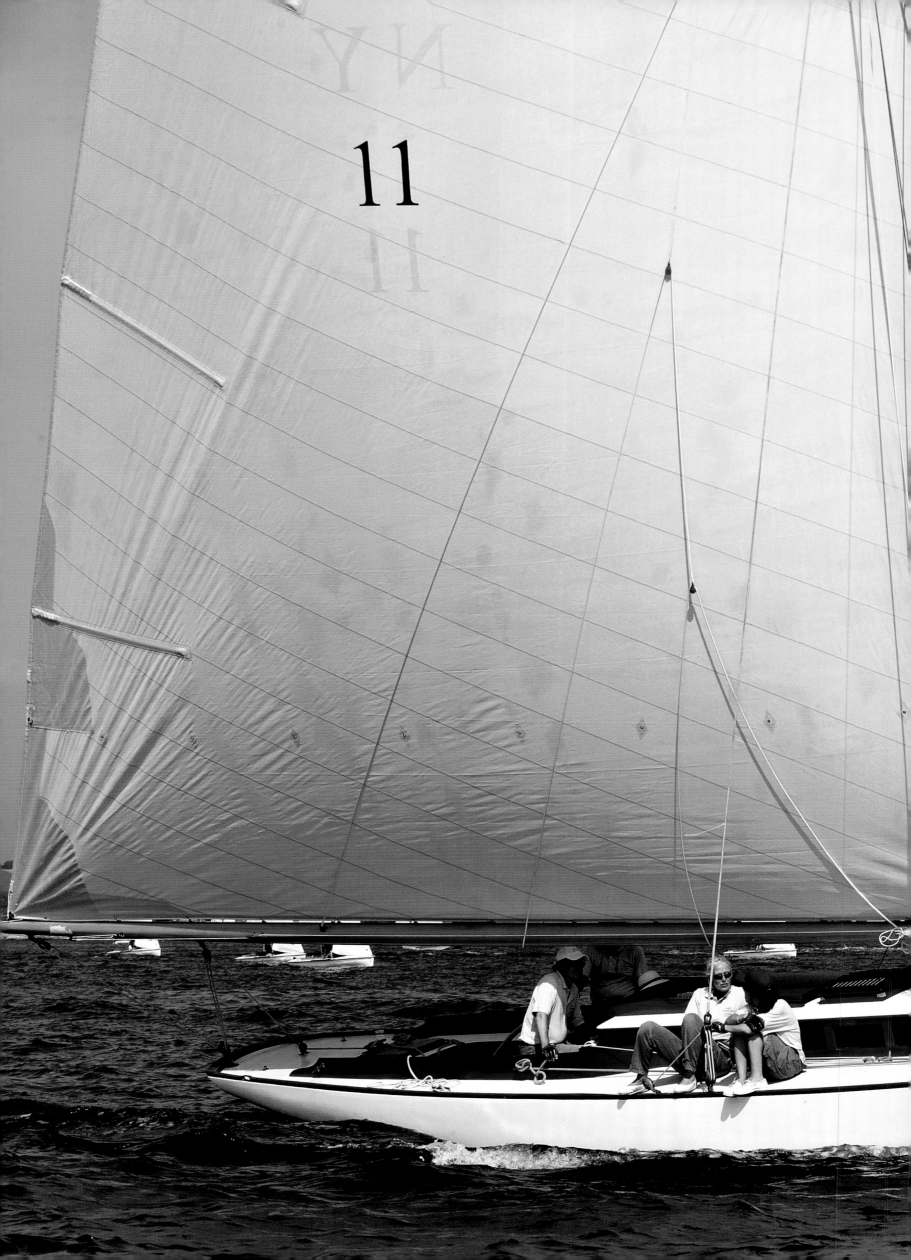

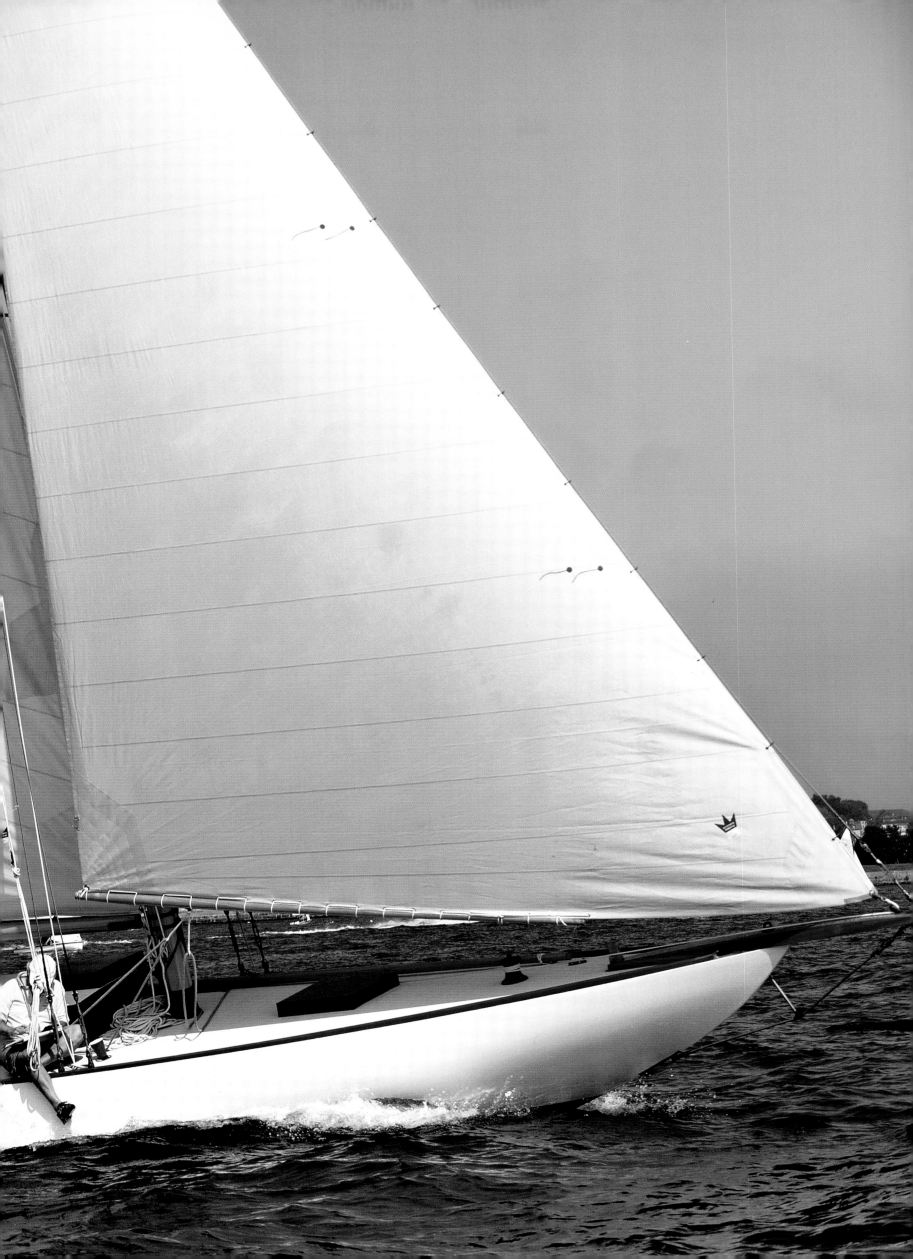

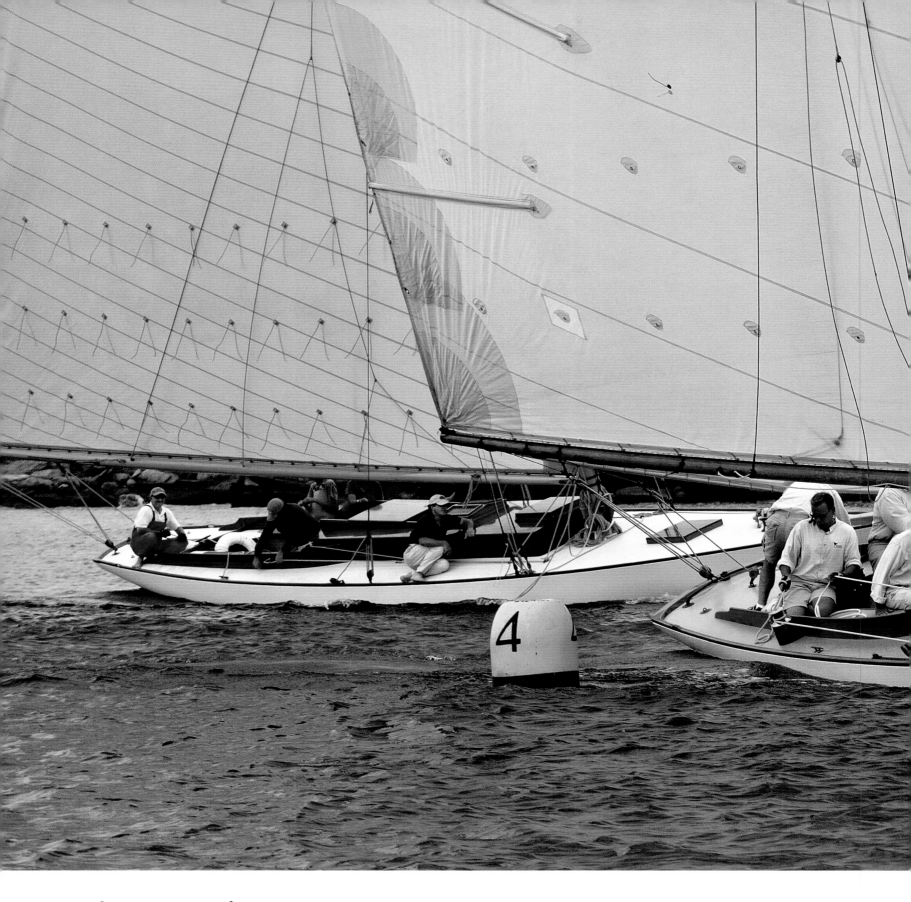

Amorita

Year of construction	1904	
Length on deck	43ft 6in	(13.25m)
Length of waterline	29ft 9in	(9.1m)
Beam	8ft 10in	(2.7m)
Draught	6ft 3in	(1.91m)
Sail area	1044sq ft	(97m²)
Designer	Nathanael Herreshoff	
Builder	Herreshoff Manufacturing Company	

George and Philip Adee, the first owners of NY 30 No 9, gave her the name *Adelaide II*. Her second owner, FB Bragdon, renamed her *Amorita*. In 1937, with the help of an outboard motor, she left New England bound for the Great Lakes. After several changes of owner in the far north, and alterations to the rig and interior accommodation in 1960, she started to deteriorate in the late 1960s. She lay in the courtyard of the Cleveland Yacht Club, the storage costs to be paid with the lead of her keel. Then in 1975 a surveyor saw her real value and, with financial help from an investor,

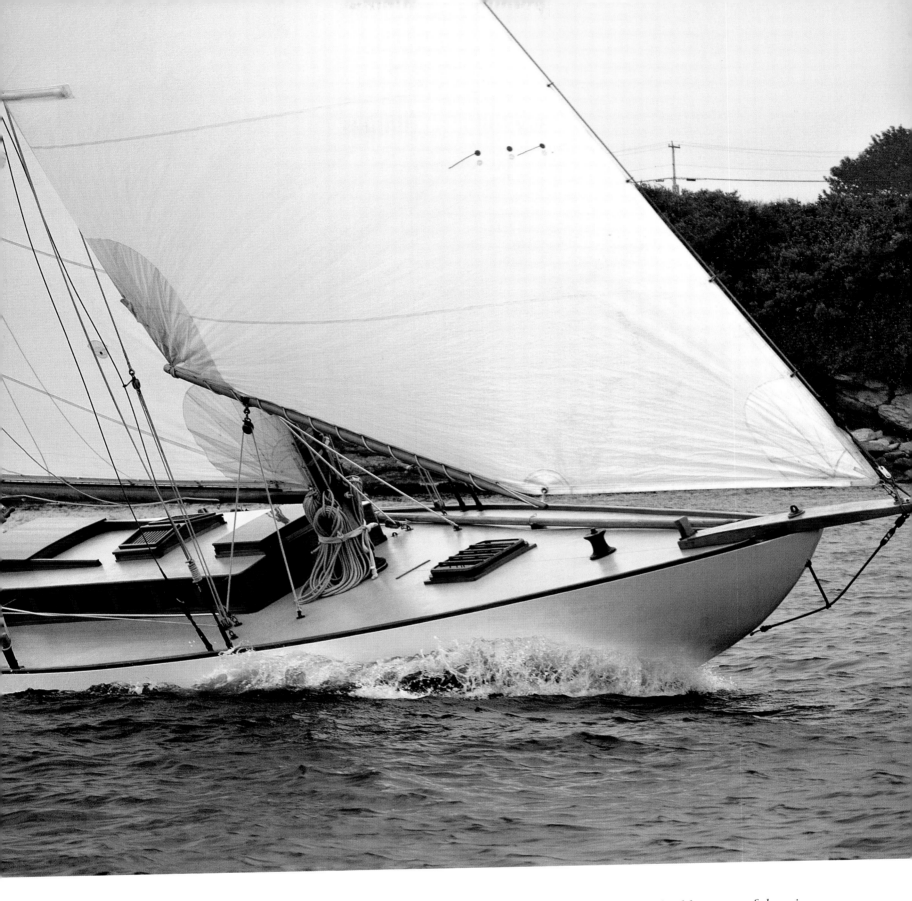

After a very varied history, the highly successful racing yacht AMORITA, *NY 30 No 9, again sails off Newport.*

When the restoration of AMORITA *began in 1981 the boat was almost past saving.*

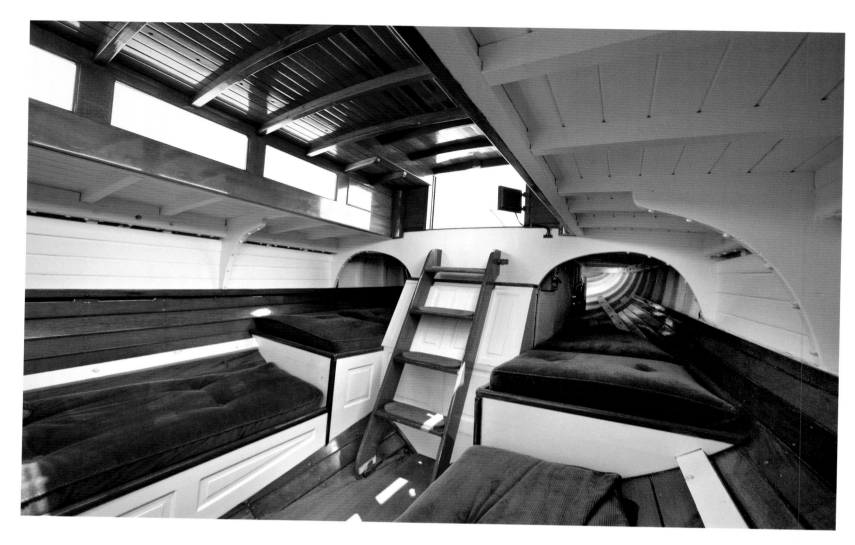

made her seaworthy again and offered her for sale. In 1979 her next guardian, NY 30 enthusiast David Kiremijian, received her as a gift. He sold her to Adrian and Jed Pearsall who, between 1981 and 1993, restored to her original state. Since then, *Amorita* has been known not only for her looks but also for her excellent racing results. In 1995 she returned to the New York Yacht Club fleet and to Rhode Island, where she was much photographed for yachting magazines and today represents the purist element among the NY 30s, despite being fitted with a diesel engine. During the summer *Amorita* is kept in Newport, moving to winter quarters in Mystic, Connecticut.

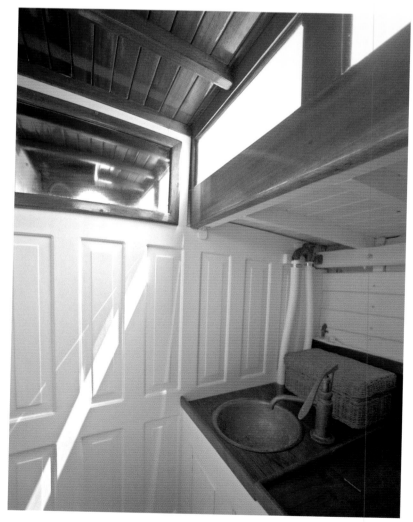

THIS PAGE *Amorita's interior represents the purist style within the NY 30 Class. The berths are never used as she is only sailed by day.*

OPPOSITE PAGE *The forepeak serves only as a sail locker. Thanks partly to her spartan interior, *Amorita* often leads the field during her numerous races.*

FOLLOWING DOUBLE PAGE *Since her restoration to pristine condition, *Amorita* is very much admired and photographed.*

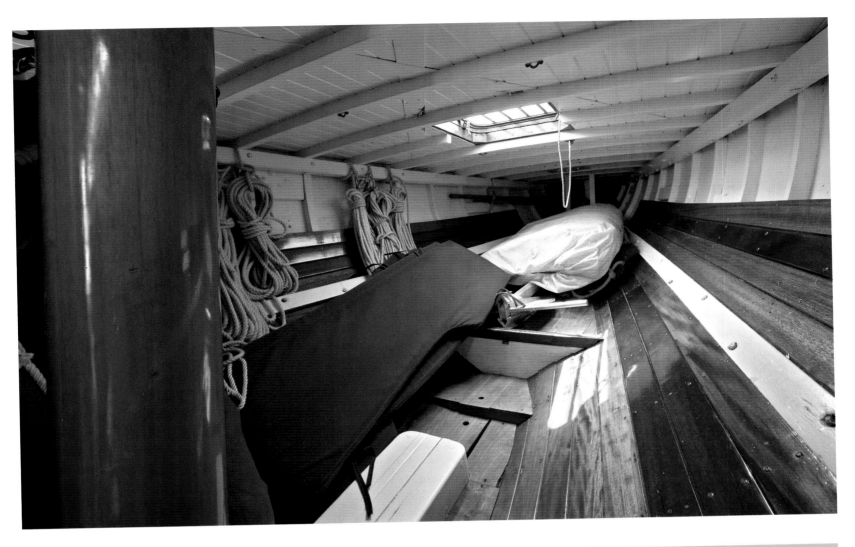

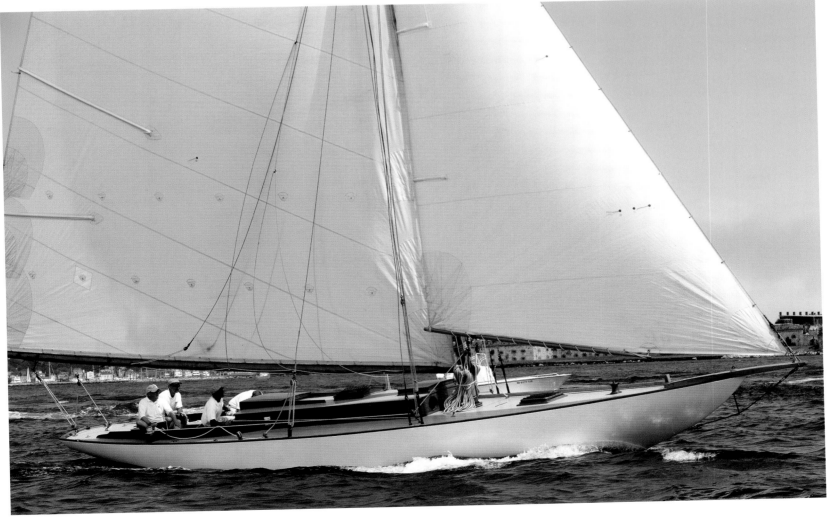

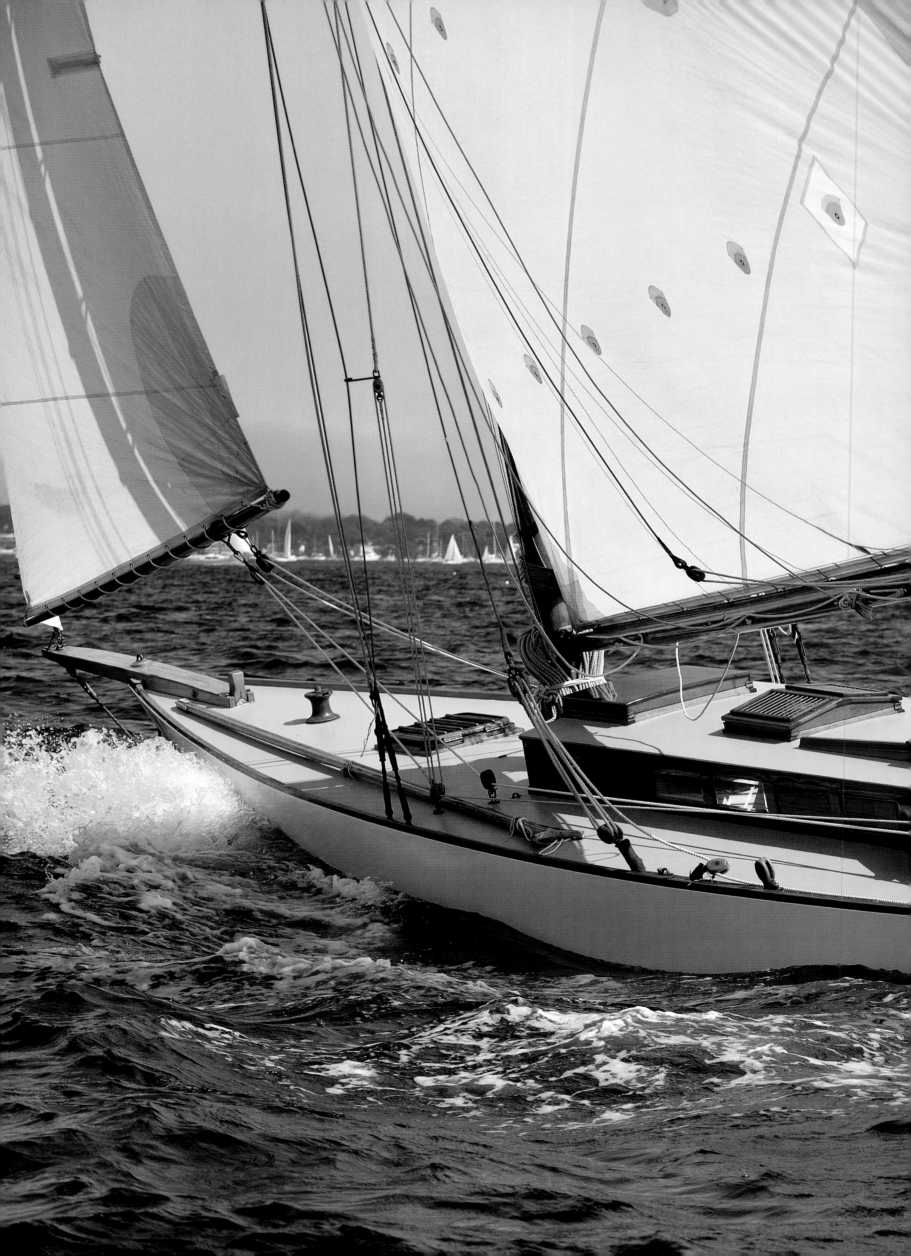

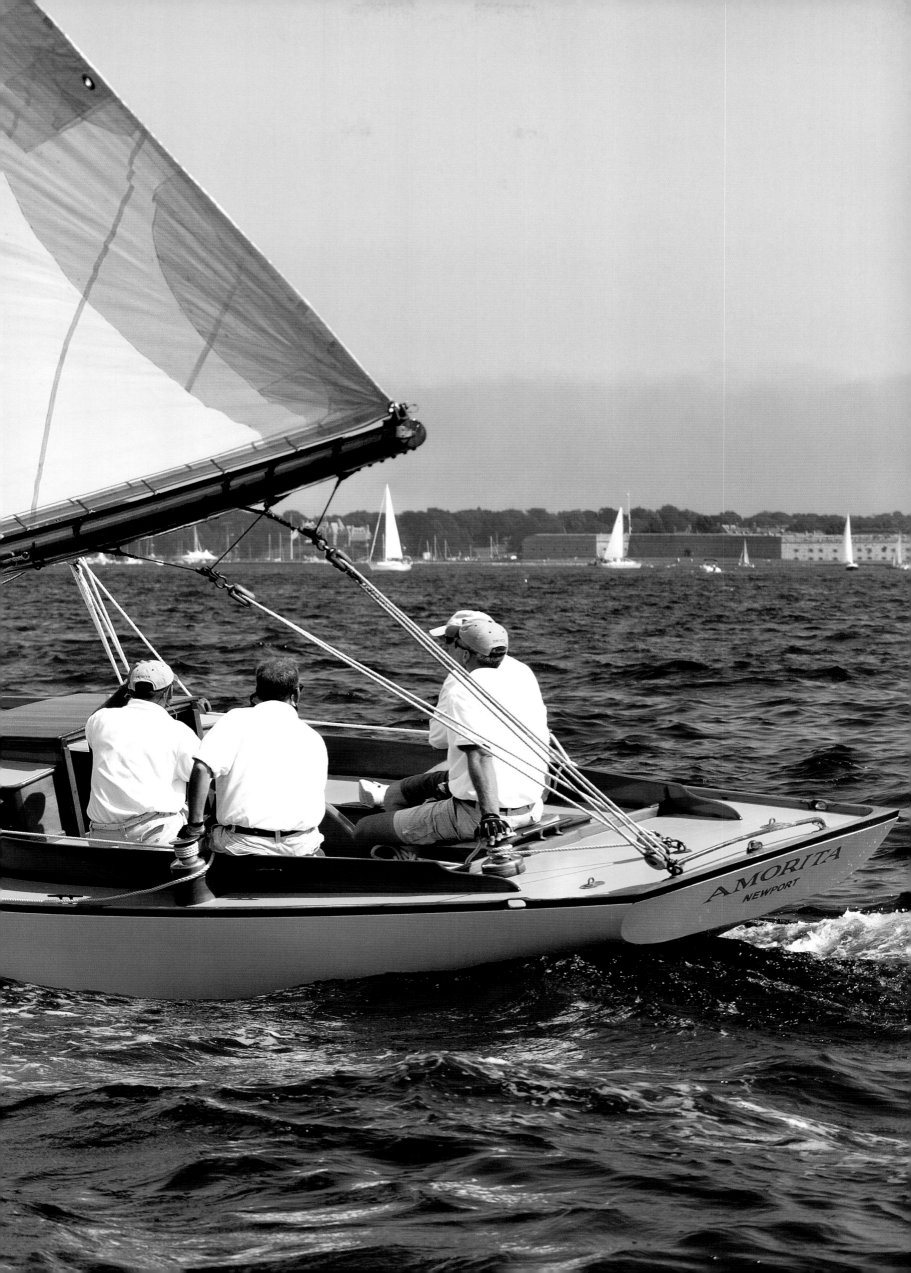

Alera

Year of construction	1904	
Length on deck	43ft 6in	(13.25m)
Length of waterline	29ft 9in	(9.1m)
Beam	8ft 10in	(2.7m)
Draught	6ft 3in	(1.91m)
Sail area	1044sq ft	(97m²)
Designer	Nathanael Herreshoff	
Builder	Herreshoff Manufacturing Company	

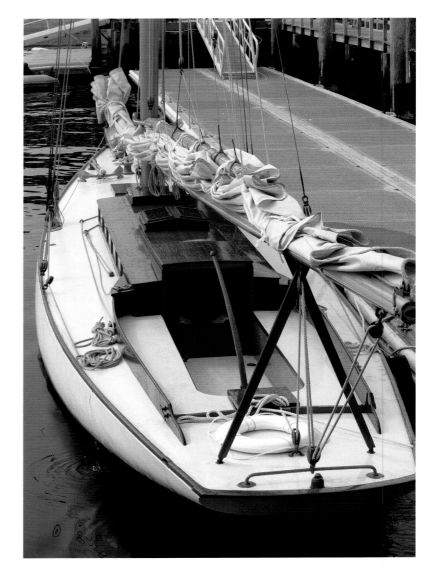

AH Alker was not pleased – his *Alera*, hull No 1 of the new NY 30 one-design class, carried serious weather helm. Herreshoff compensated by lengthening the bowsprit from 40cm to one metre.

Alera was thought to have been lost since the early 1920s, but in 2004 she reappeared in Toronto. She was bought by the Boothbay Harbor Shipyard in Maine who restored her.

THESE PAGES *The refit of this NY 30 took only six months; the yard was able to reuse the rudder and much of the planking.*

FOLLOWING DOUBLE PAGE *Alera was the winner of the NY 30 Centenary Regatta in 2005.*

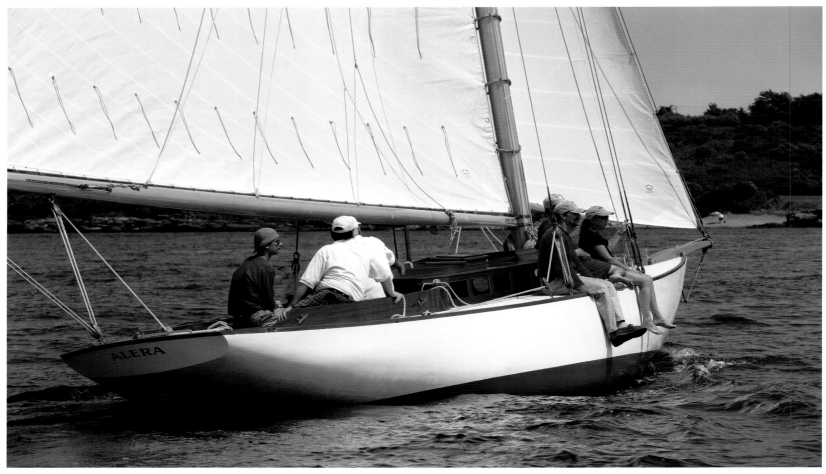

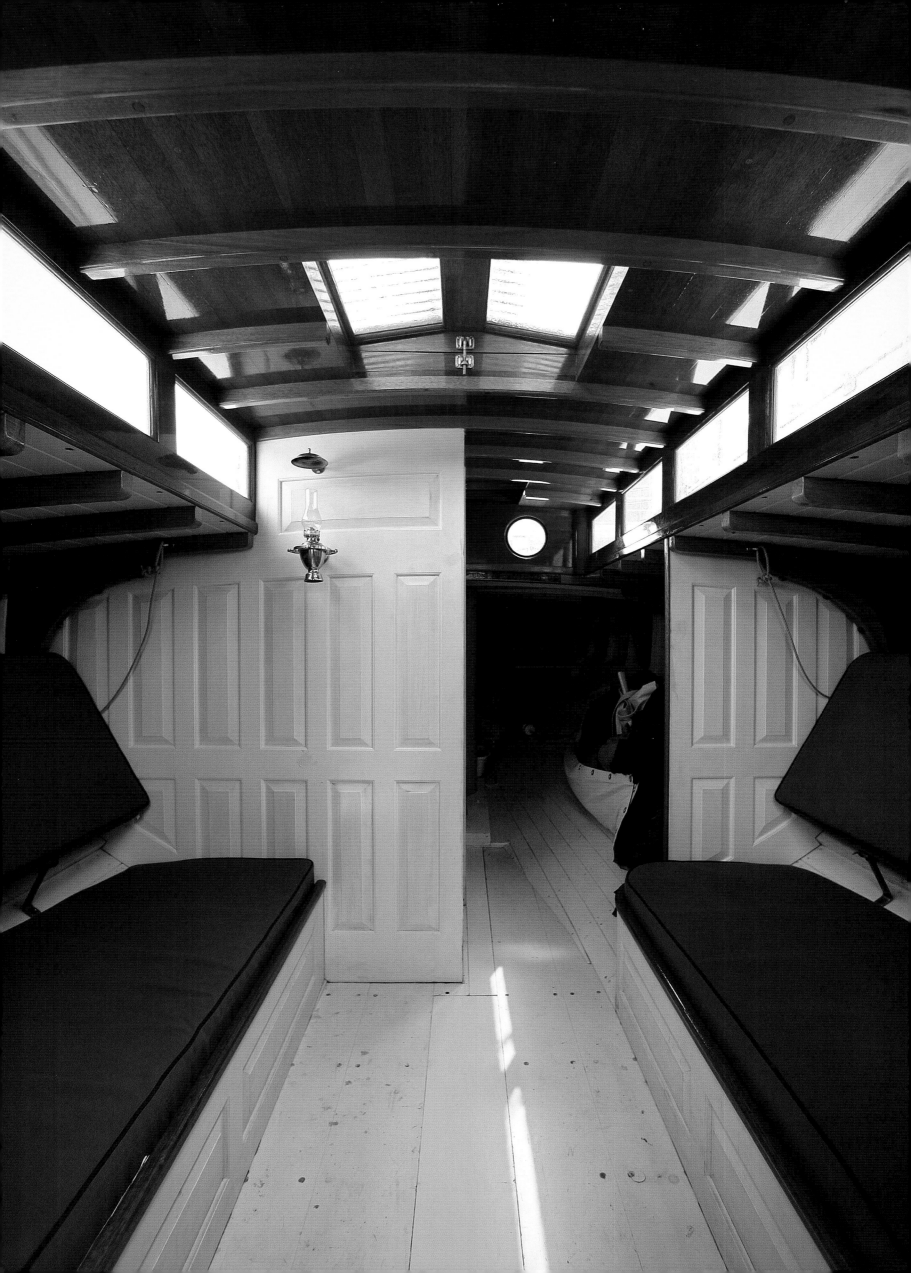

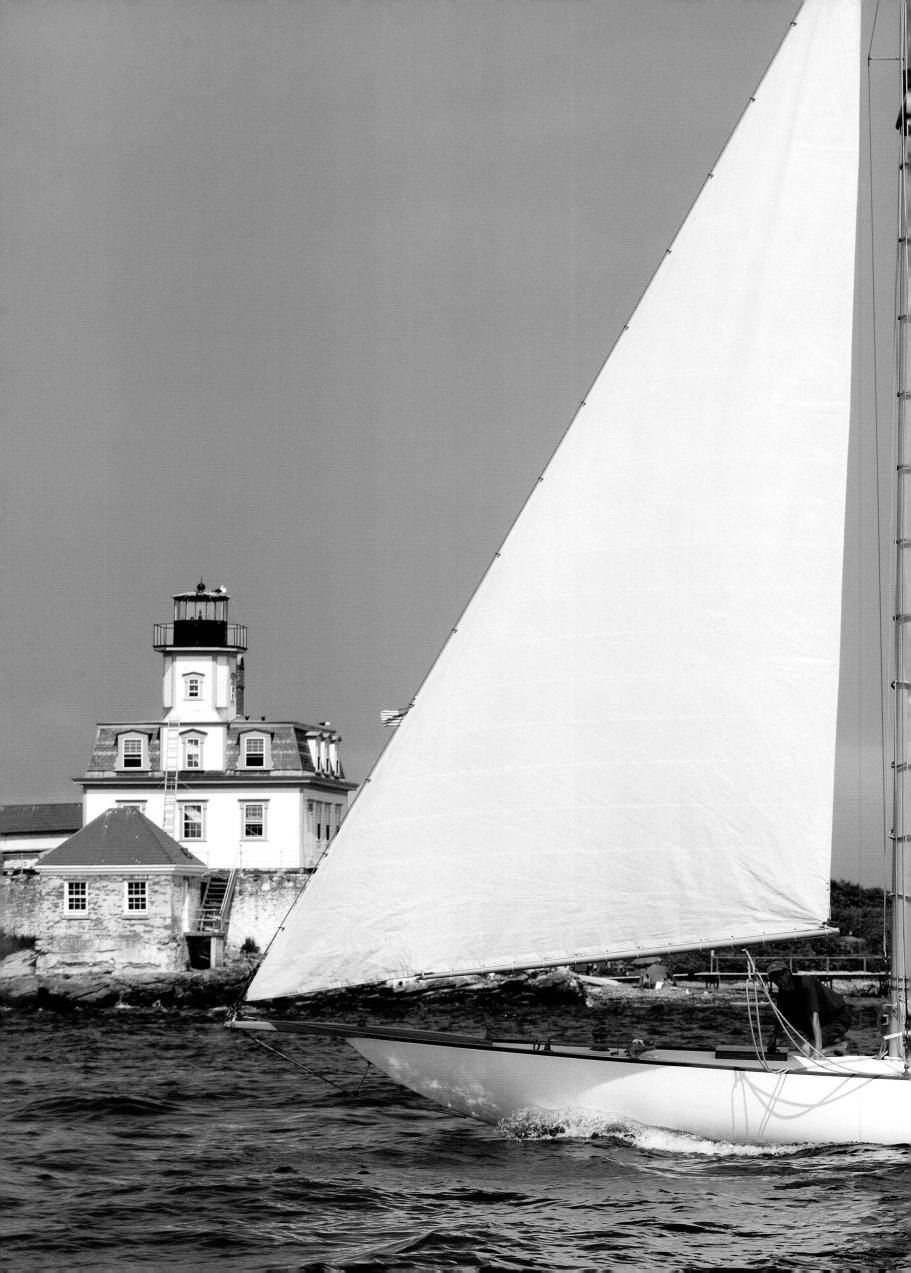

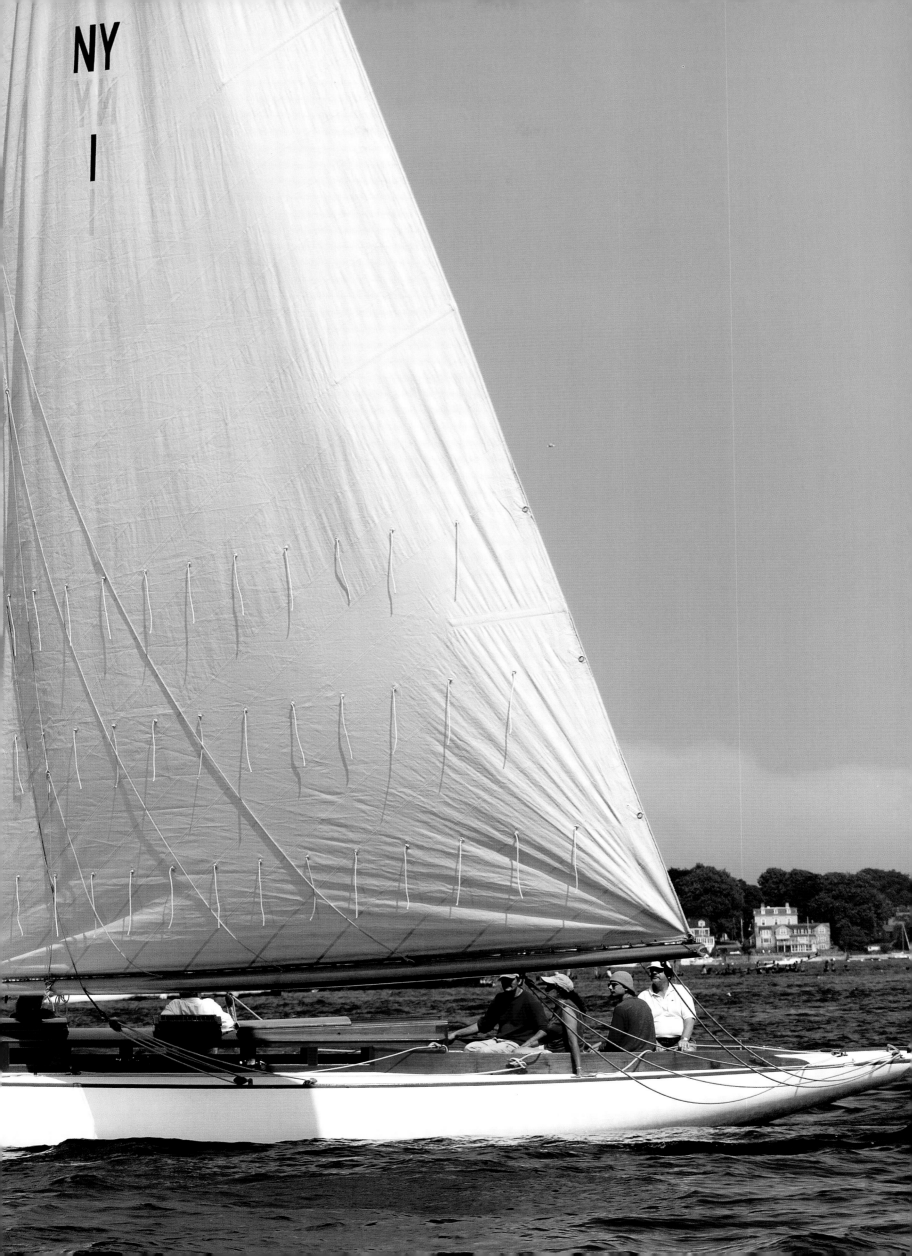

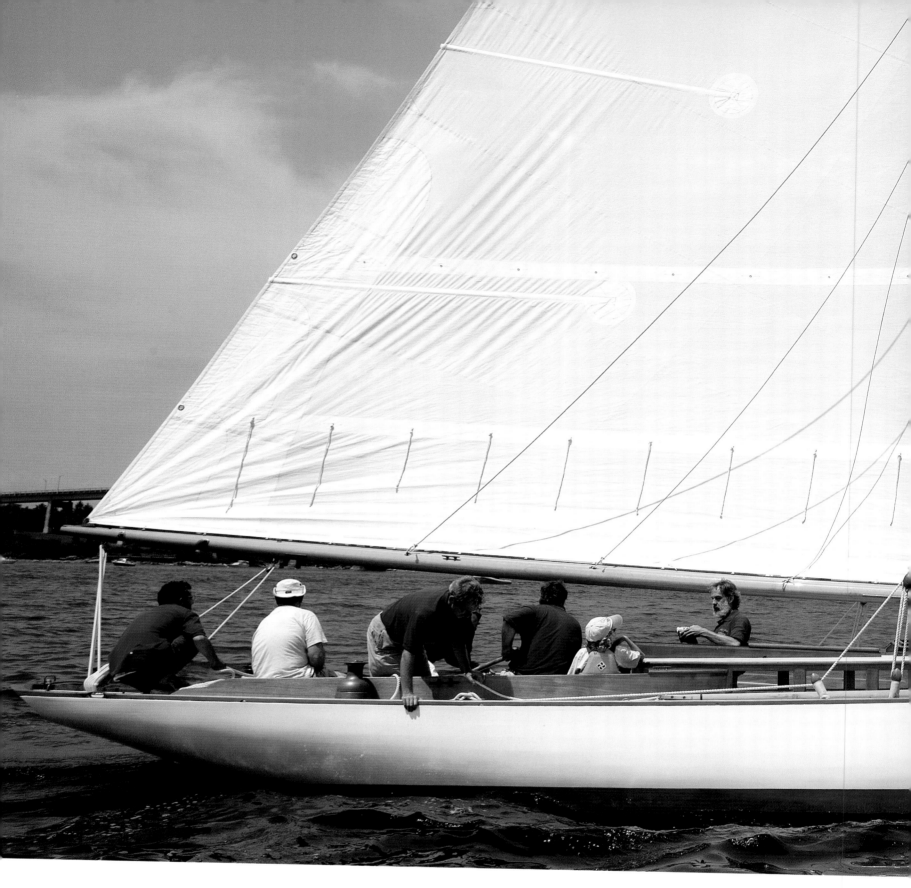

Cara Mia

CARA MIA's first owner paid $4000 for her. The shipyard delivered her 'ready to sail', including sails and a complete set of porcelain tableware.

Year of construction	1904	
Length on deck	43ft 6in	(13.25m)
Length of waterline	29ft 9in	(9.1m)
Beam	8ft 10in	(2.7m)
Draught	6ft 3in	(1.91m)
Sail area	1044sq ft	(97m²)
Designer	Nathanael Herreshoff	
Builder	Herreshoff Manufacturing Company	

It took a bit longer to restore *Cara Mia* to her prime than *Alera*. NY 30 No 14 needed eight years of work before she could return to the one-design fleet in 2001. Her first owner, Stuyvesant Wainwright, would probably never have dreamt that, nearly a hundred years after launching, *Cara Mia* would again be sailing off the New York Yacht Club, with a restored hull and under her original gaff rig. The quality of workmanship

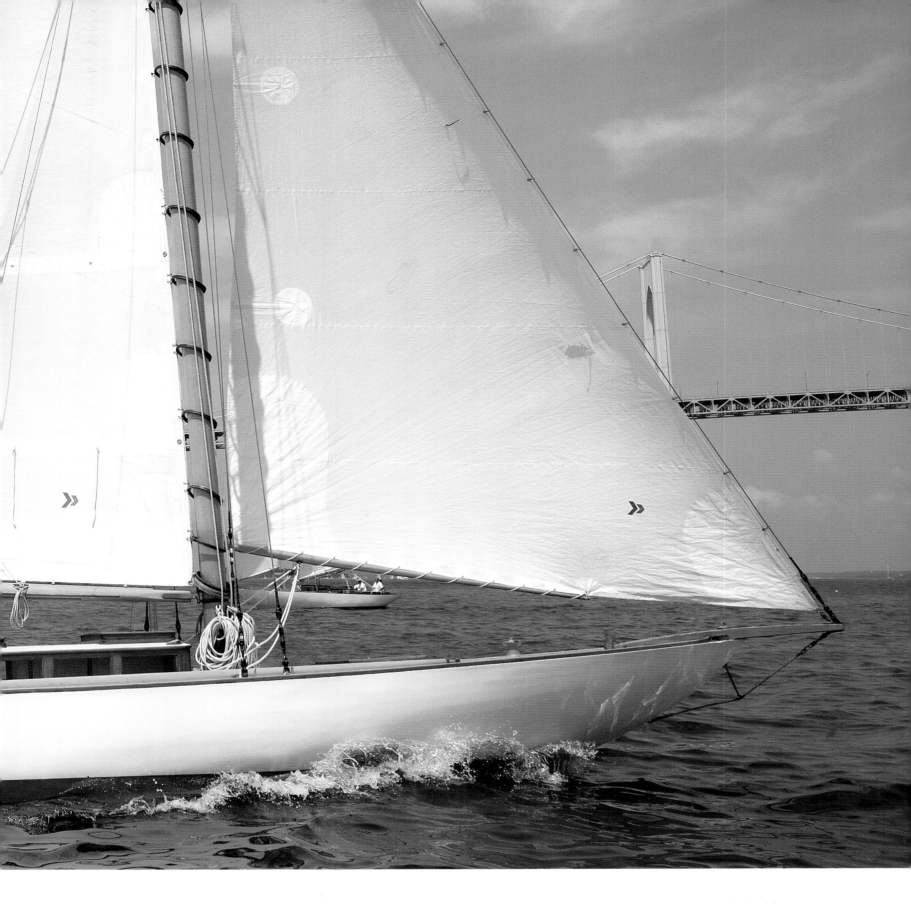

The Herreshoff shipyard built the NY 30 with double planking – cypress for the interior, southern yellow pine for the exterior – sealed with shellac.

FOLLOWING DOUBLE PAGE *The true size of the rig becomes apparent when seen from astern. Above all else, NY 30s should be fast.*

is remarkable, and her interior joinery and fittings must far surpass the expectations of her first owner. Today *Cara Mia* is owned by Alfred Slanetz, and is moored for racing in Newport in front of the Museum of Yachting. During the winter she is kept in Mystic, Connecticut.

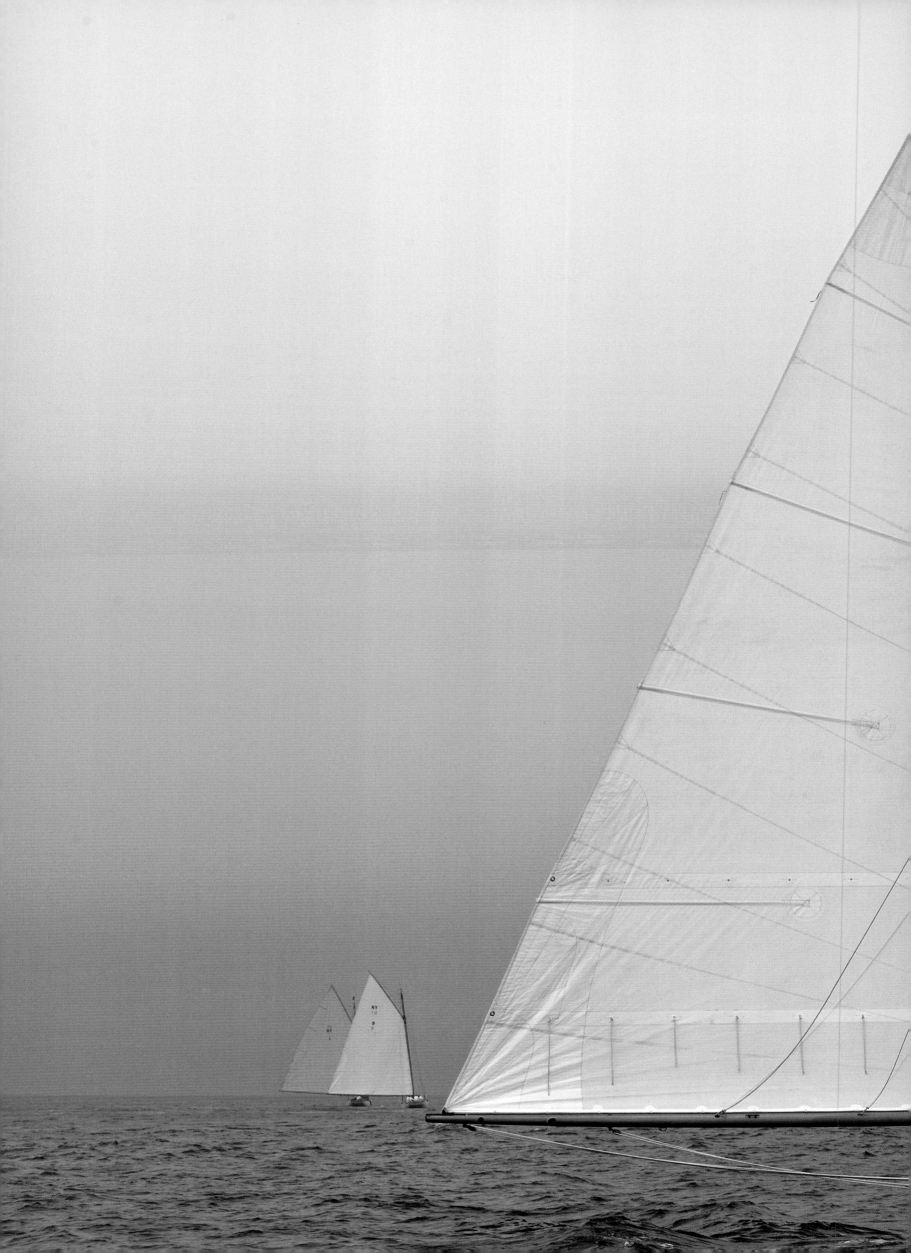

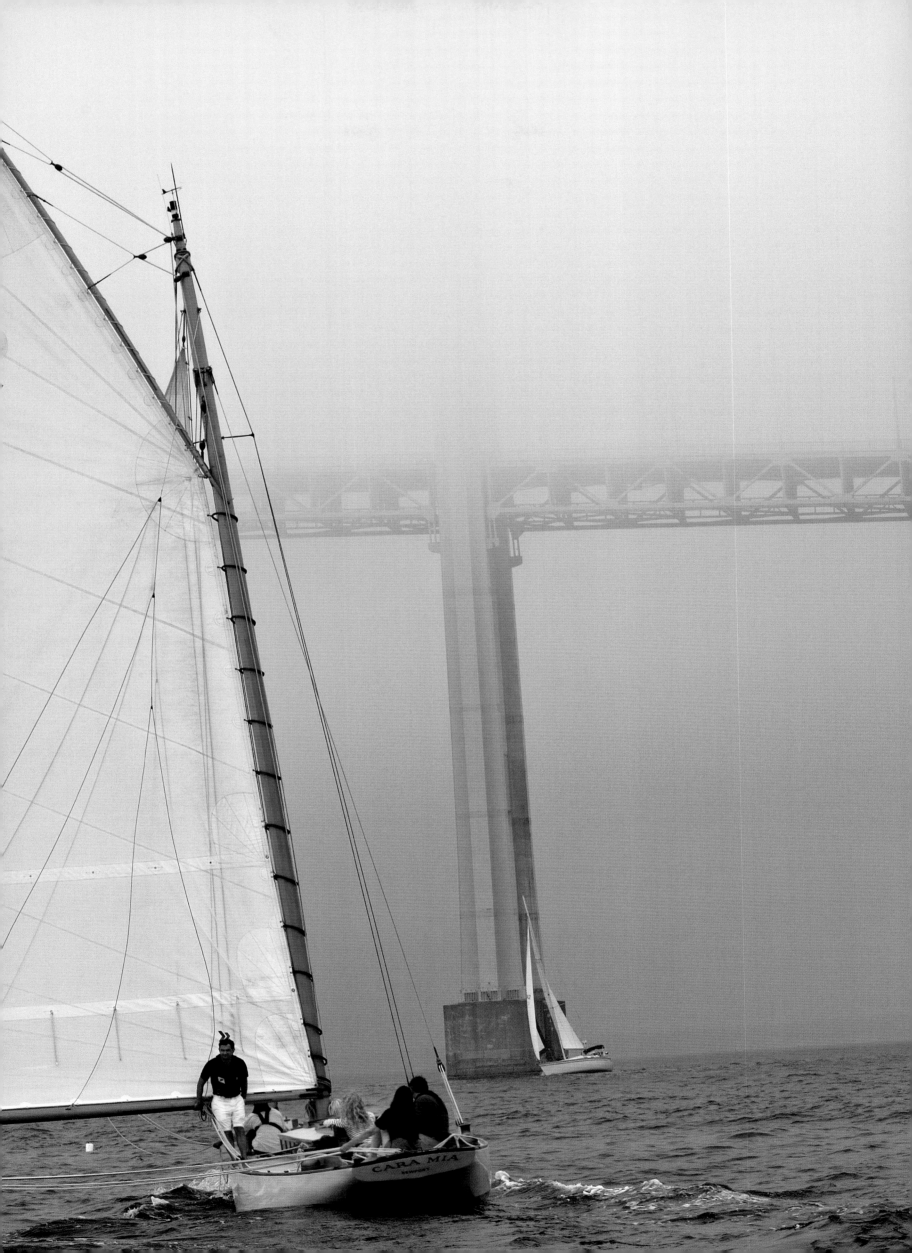

Nautilus

Year of construction	1905	
Length on deck	43ft 6in	(13.25m)
Length of waterline	29ft 9in	(9.1m)
Beam	8ft 10in	(2.7m)
Draught	6ft 3in	(1.91m)
Sail area	1044sq ft	(97m²)
Designer	Nathanael Herreshoff	
Builder	Herreshoff Manufacturing Company	

It was the spring of 1905 when Addison G Hanan took delivery of his gleaming new gaff sloop *Nautilus*. After a long and chequered history, the renaissance for NY 30 No 16 came in 1988. Her enthusiastic owner worked for more than 15 years to restore her. But he was unable to complete the work and her present owner, architect Bill Pedersen, finished the restoration.

ABOVE *The compass binnacle rests atop a pedestal in the cockpit.*

BELOW *Nautilus once again sails under her original 1905 gaff rig.*

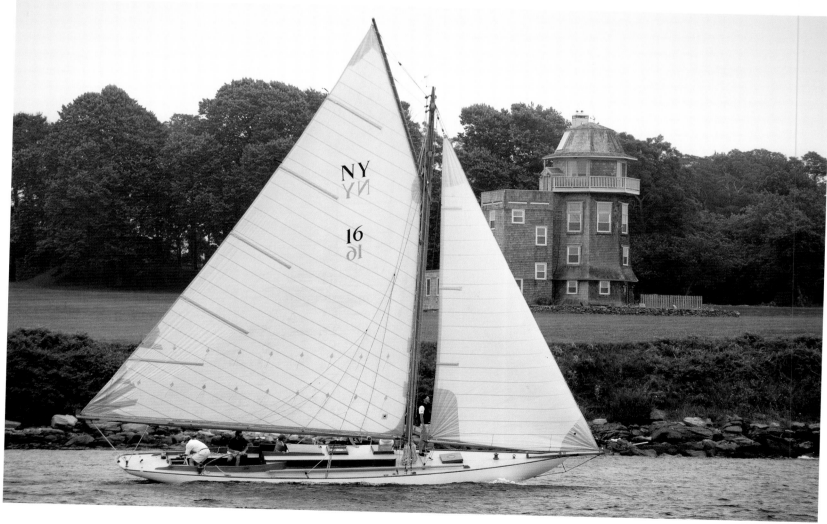

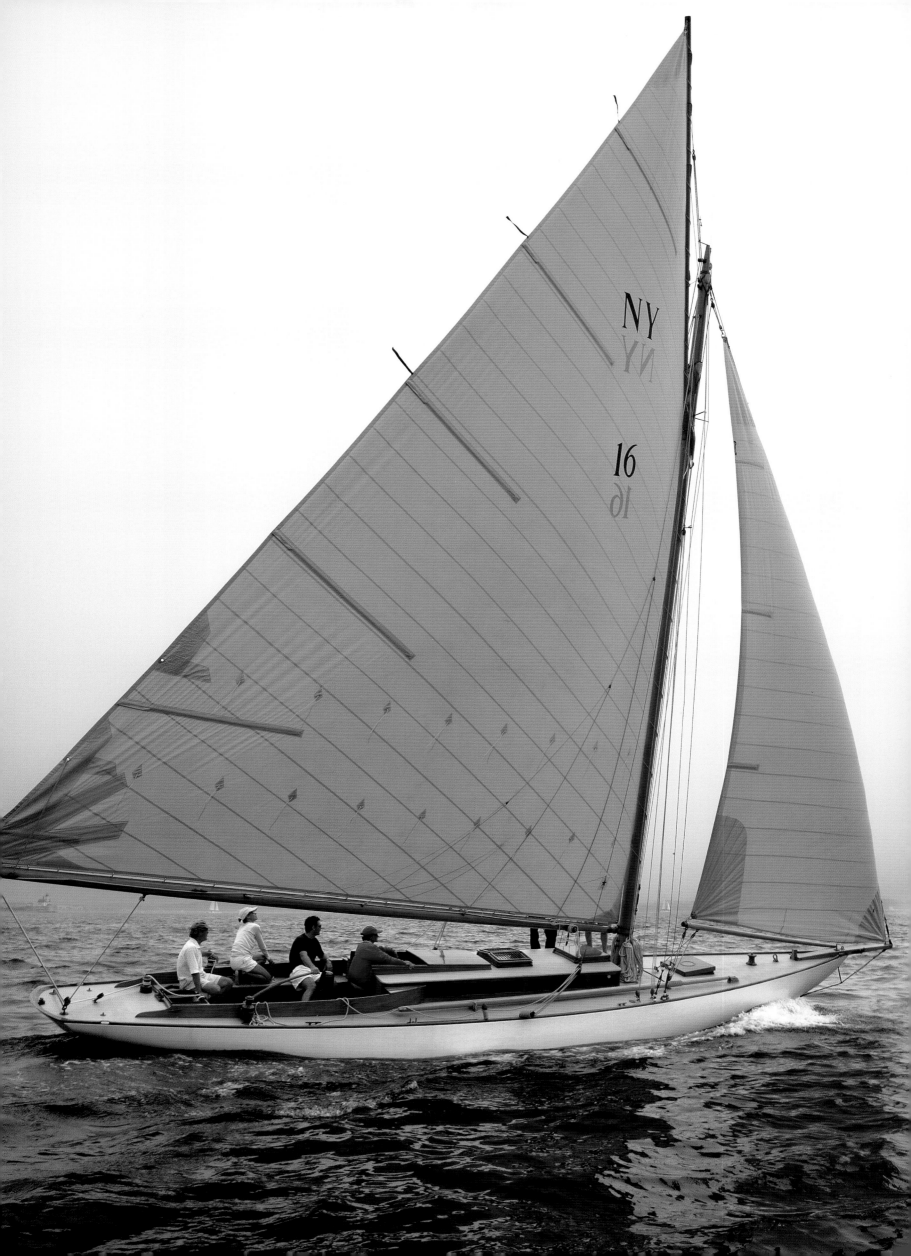

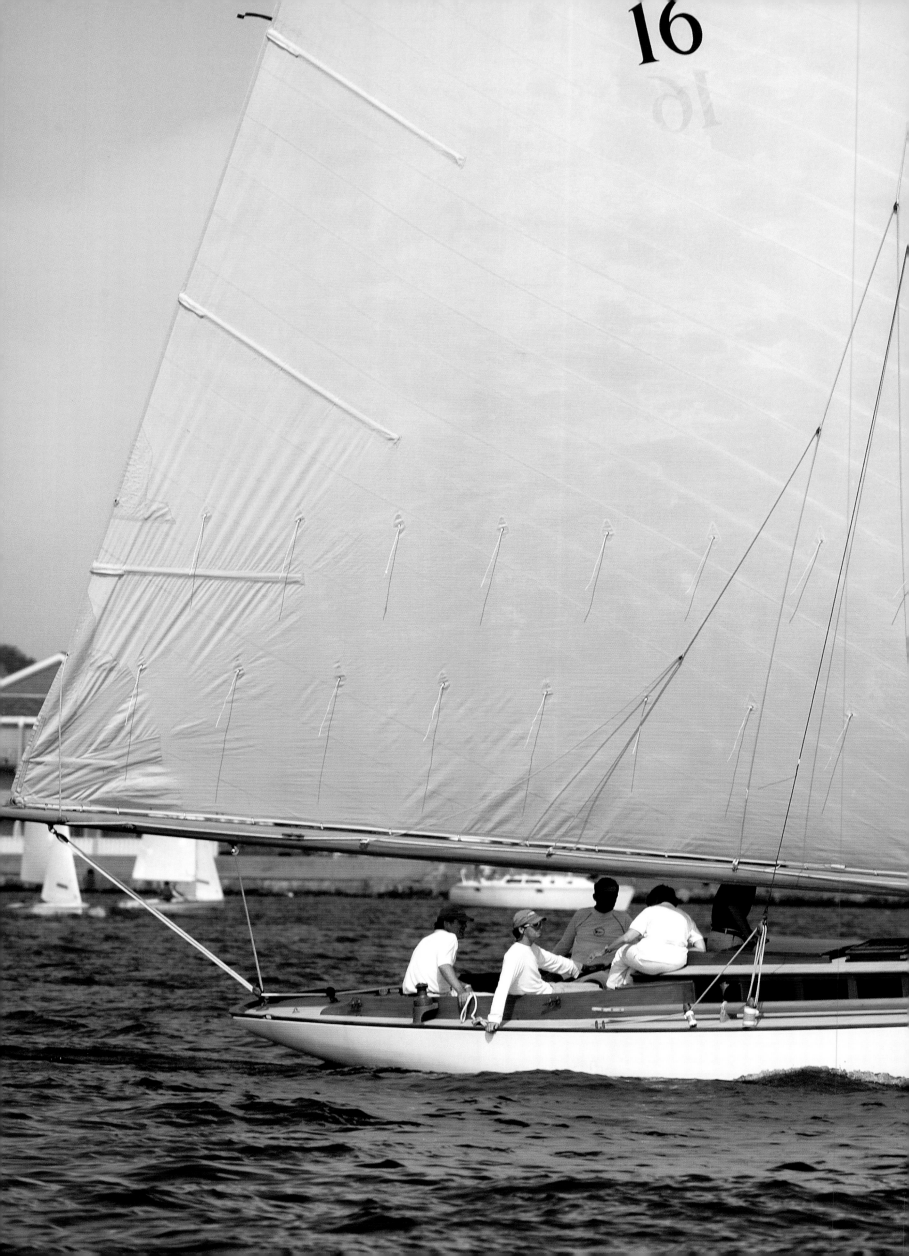

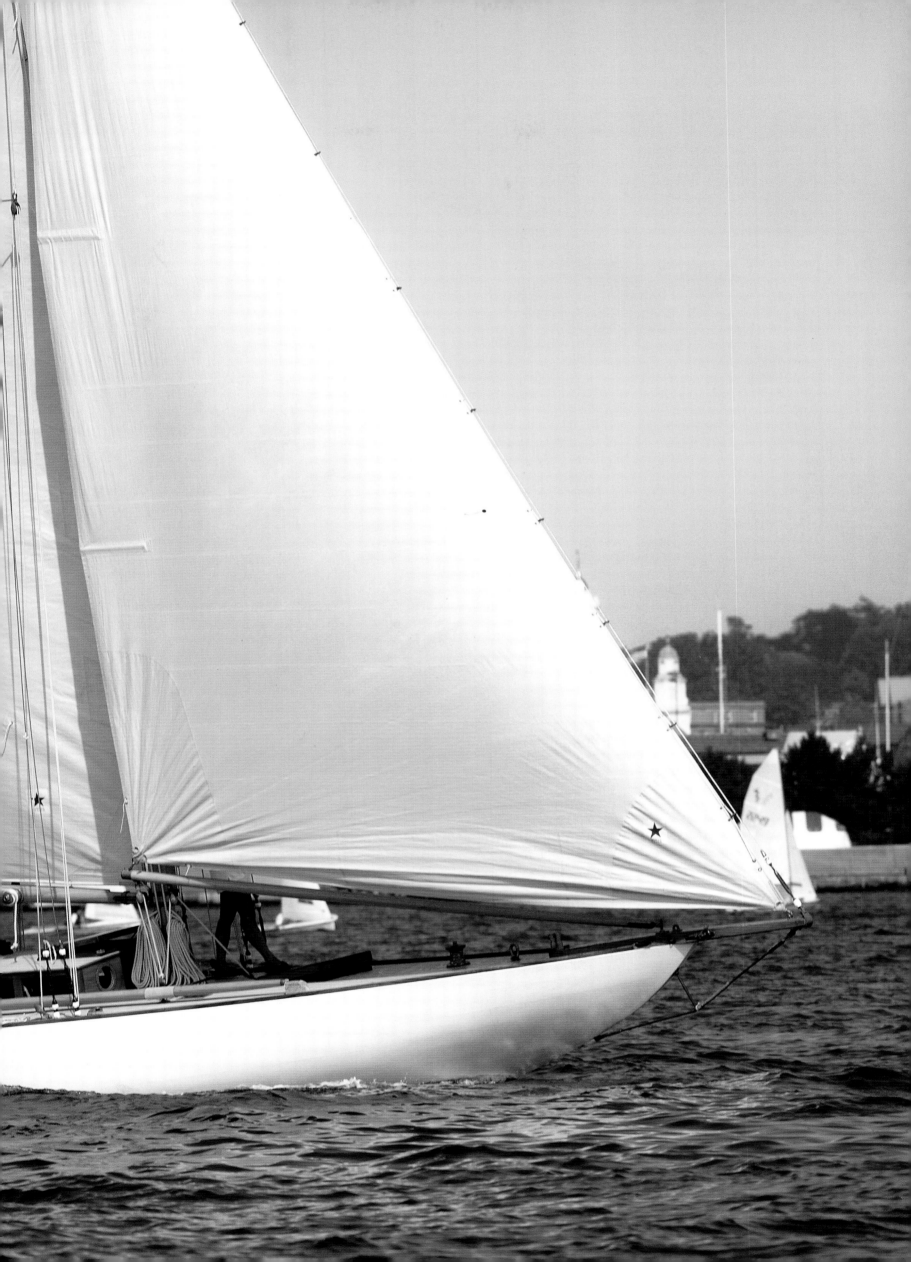

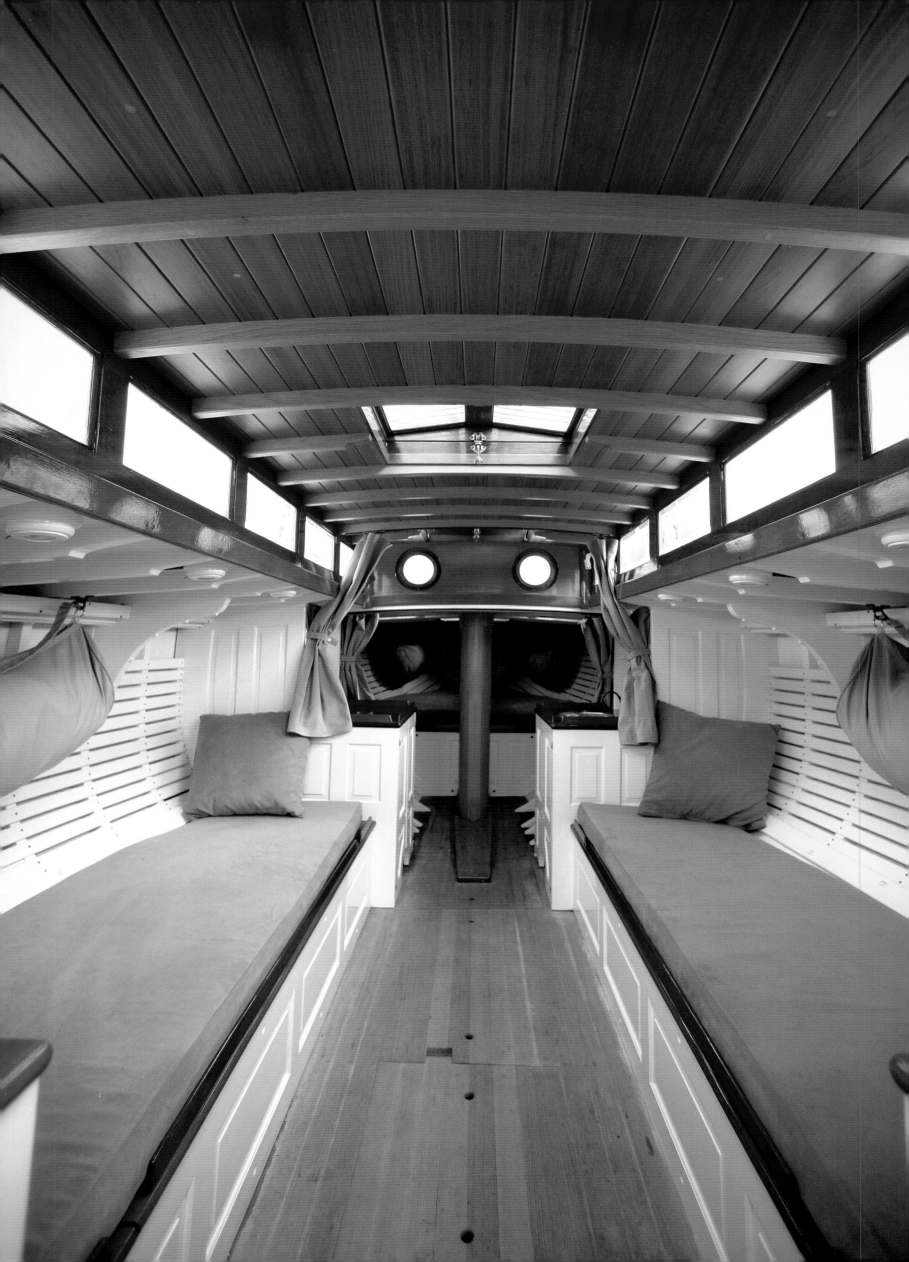

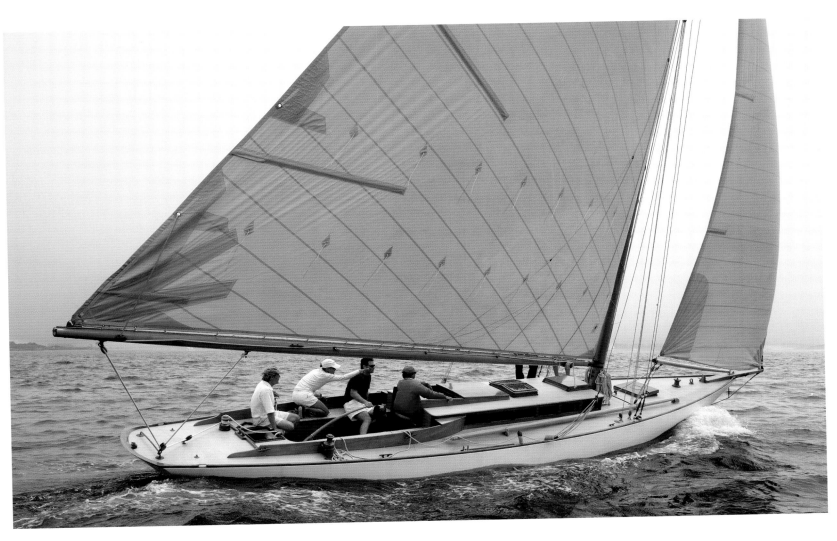

PREVIOUS DOUBLE PAGE *It is a credit to the design and build-quality of the NY 30, and to her restorers, that NAUTILUS has survived over 100 years of seas and weather and is still sailing today.*

THIS DOUBLE PAGE

ABOVE *Changes made to the deck layout over the past decades were reversed during her long restoration. The class rules were also complied with.*

LEFT *The owner of NAUTILUS spared no expense and effort for the centenary celebrations to make her an excellent example of her class.*

FAR LEFT *The accurate restoration featured a minimalist interior and reflected Nautilus' racing spirit even down below.*

FOLLOWING DOUBLE PAGE *NY 30 No 15 at Newport from Massachusetts for the 100th Anniversary celebrations. Her first owner, Newbury D Lawton, named her BANZAI and she still carries this name today, sailing off Nantucket and Martha's Vineyard. Both rig and interior are original, and the sloop's structural condition is good. BANZAI is kept in Vineyard Haven, Massachusetts.*

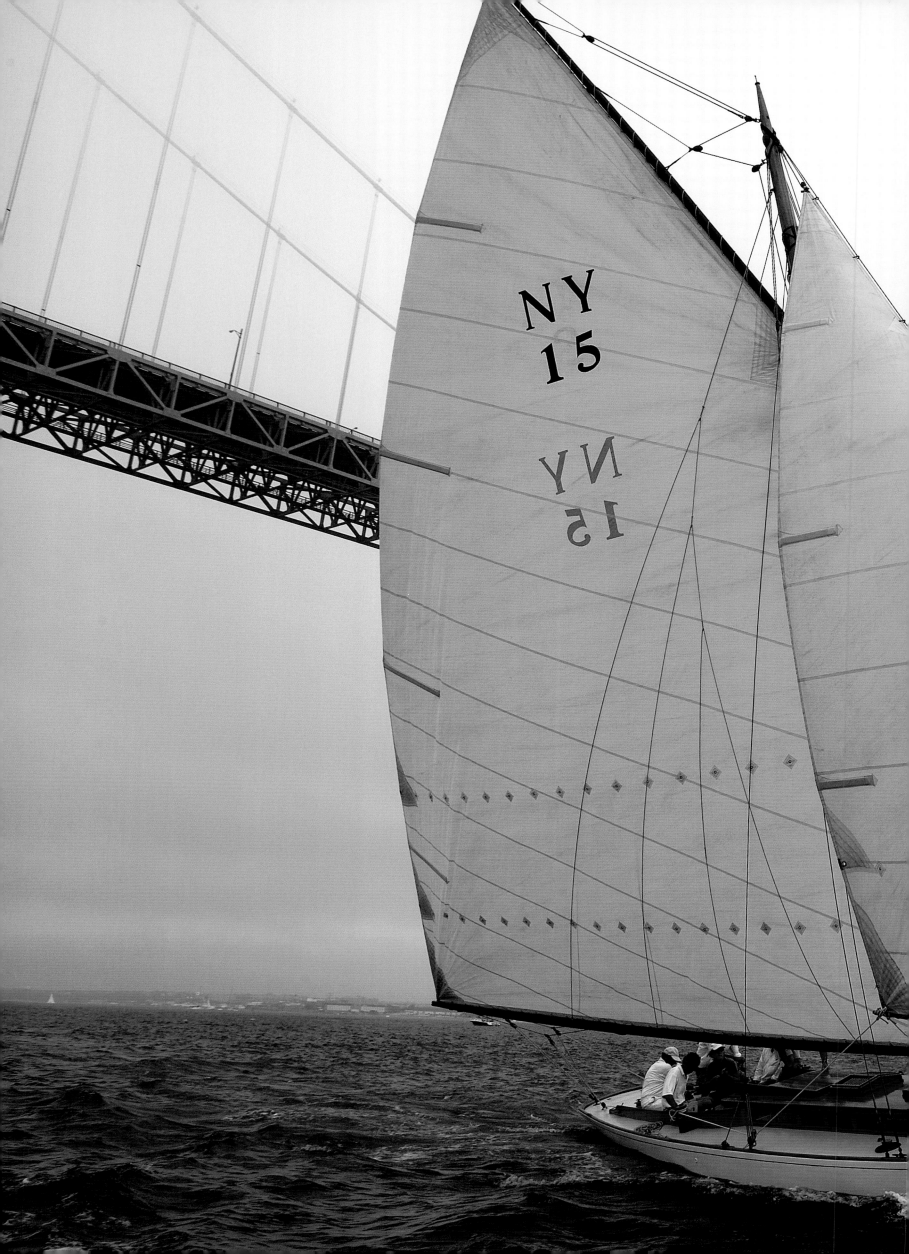

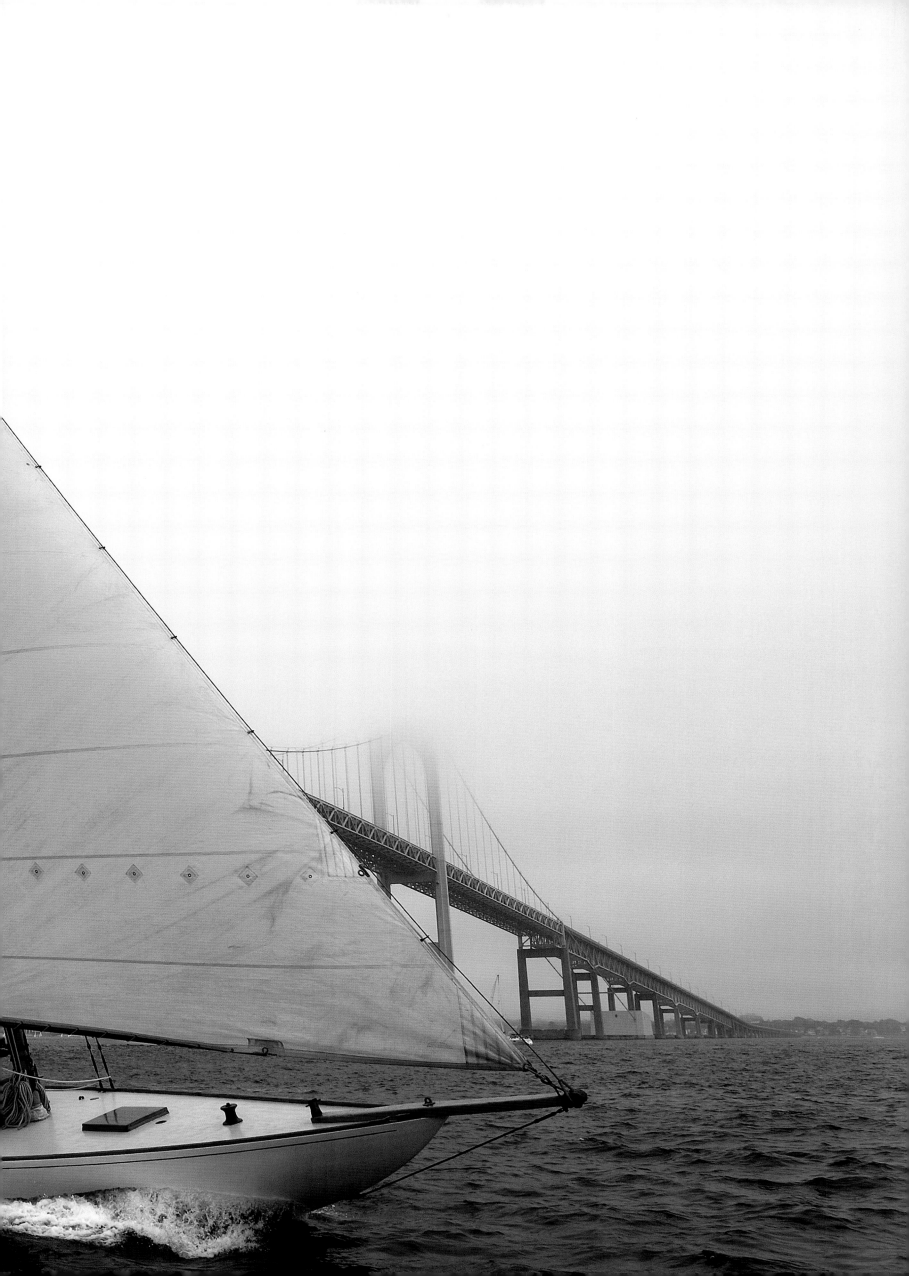

Linnet

Year of construction	1905	
Length on deck	43ft 6in	(13.25m)
Length of waterline	29ft 9in	(9.1m)
Beam	8ft 10in	(2.7m)
Draught	6ft 3in	(1.91m)
Sail area	1044sq ft	(97m²)
Designer	Nathanael Herreshoff	
Builder	Herreshoff Manufacturing Company	

Hull No 10 of the NY 30 one-design was ordered by New York Yacht Club member Amos T French. The Herreshoff Manufacturing Company delivered *Linnet* in 1905, complete with the class's standard suit of sails comprising mainsail, two staysails, one balloon fore-staysail and spinnaker. Herreshoff's design was intended to carry a considerable amount of sail, but even so a crew of five could handle this 43ft 6in (13.25m) racing yacht in all conditions. Two paid crew were permitted but the helmsman had to be amateur. The paid hands got $1 starting bonus and $4 for a win.

Patrizio Bertelli, the husband of Prada heiress Miuccia Prada, deserves the credit for rescuing NY 30 No 10 and giving her a top quality restoration at the Nardi shipyard in Italy. He bought *Linnet* in 1998 and relaunched her two years later in perfect condition. From the first, *Linnet* achieved excellent racing results. Like her sister ships, she sails under gaff rig and retains her original layout below. However curtains, upholstery, carpets and cutlery are no longer aboard – in 1905 it was mandatory to carry these items while racing.

Bertelli's link with the Herreshoff class arose from his former America's Cup participation. He was owner of *Luna Rossa*, which challenged for the Cup in 2000 but lost to the New Zealand team. *Linnet* is one of the NY 30s to have found a new home in the Mediterranean. Her owner remains very keen and races her as often as possible.

BELOW *Patrizio Bertelli's* Linnet, *beautifully restored by the Italian Nardi shipyard. Her rigging and sails conform to original specifications.*

OPPOSITE PAGE *Carrying a large staysail on her forestay, New York 30 No 10 sets approximately 90 square metres of sail on her gaff spars when closehauled.*

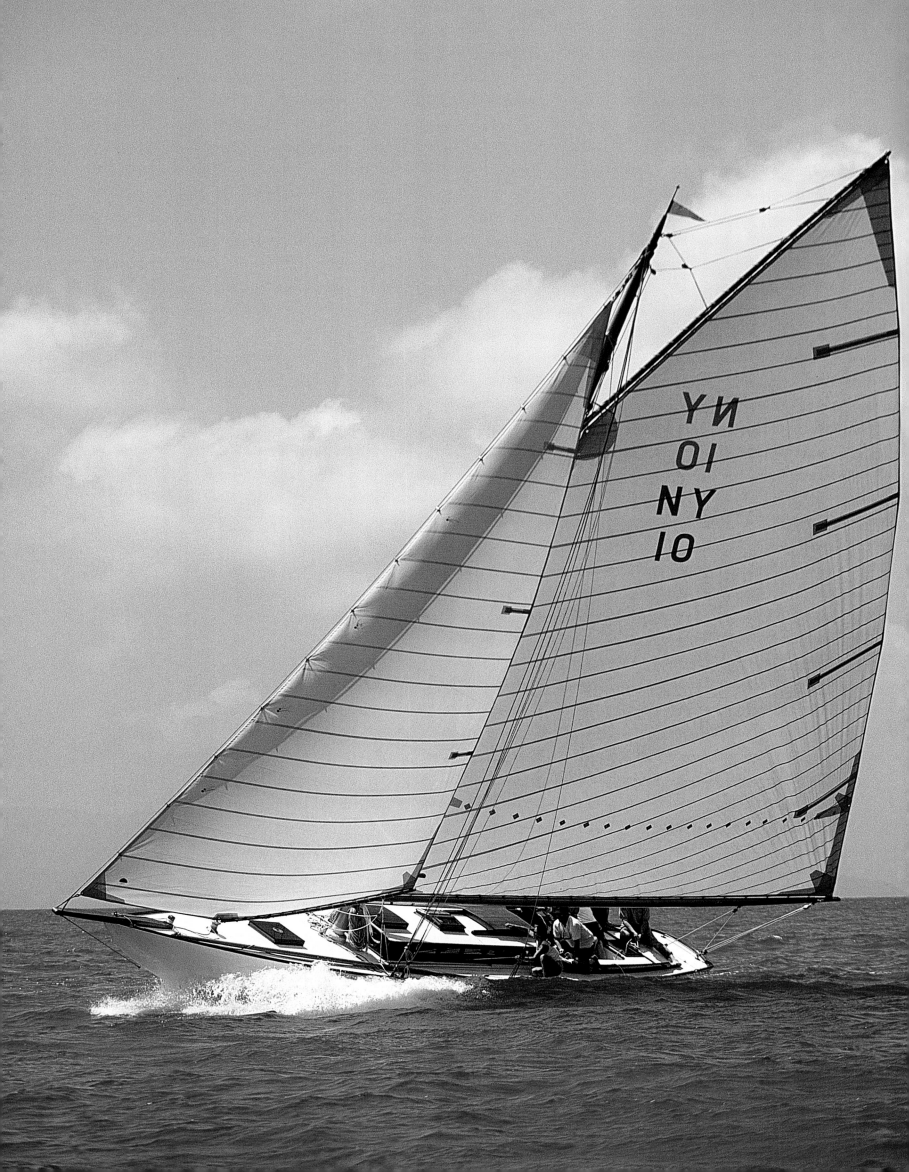

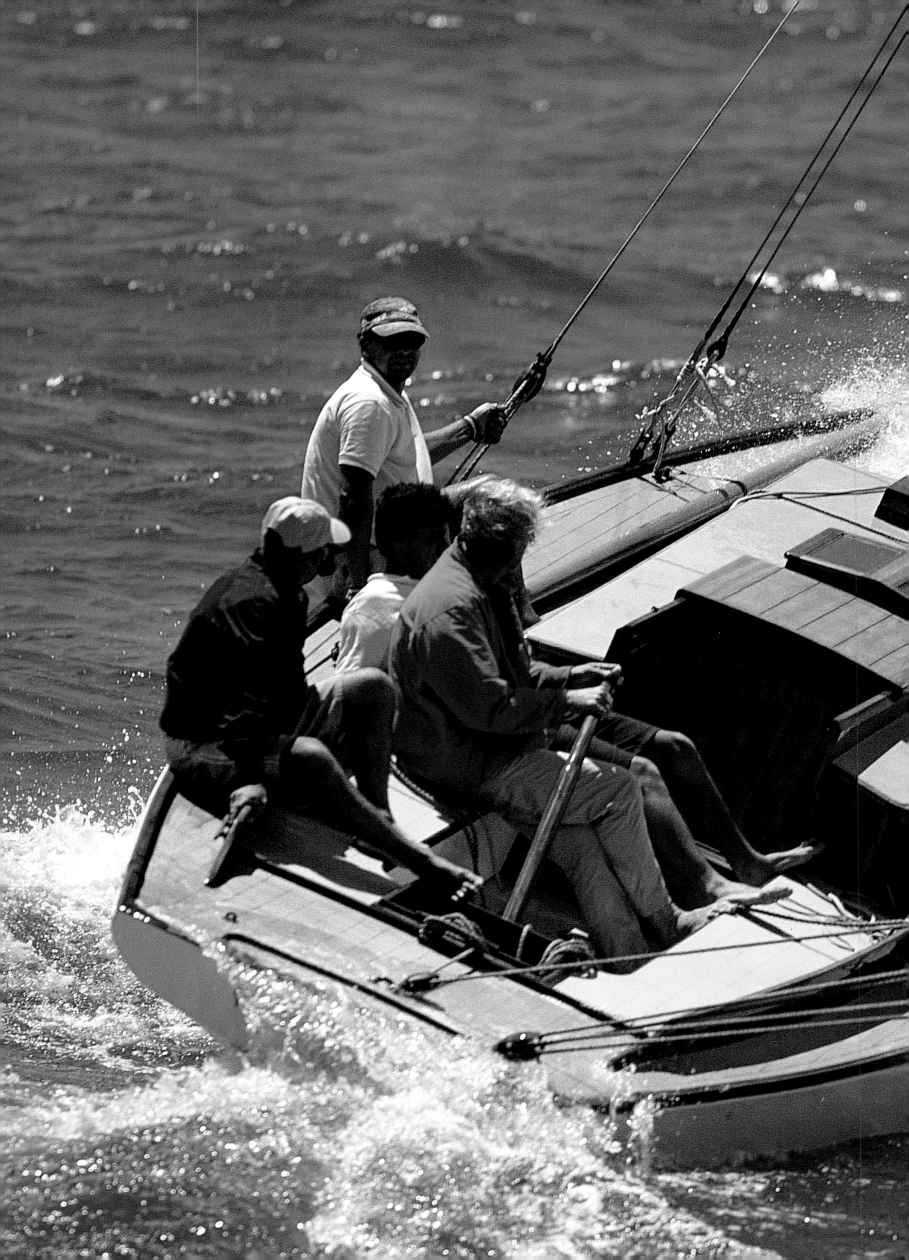

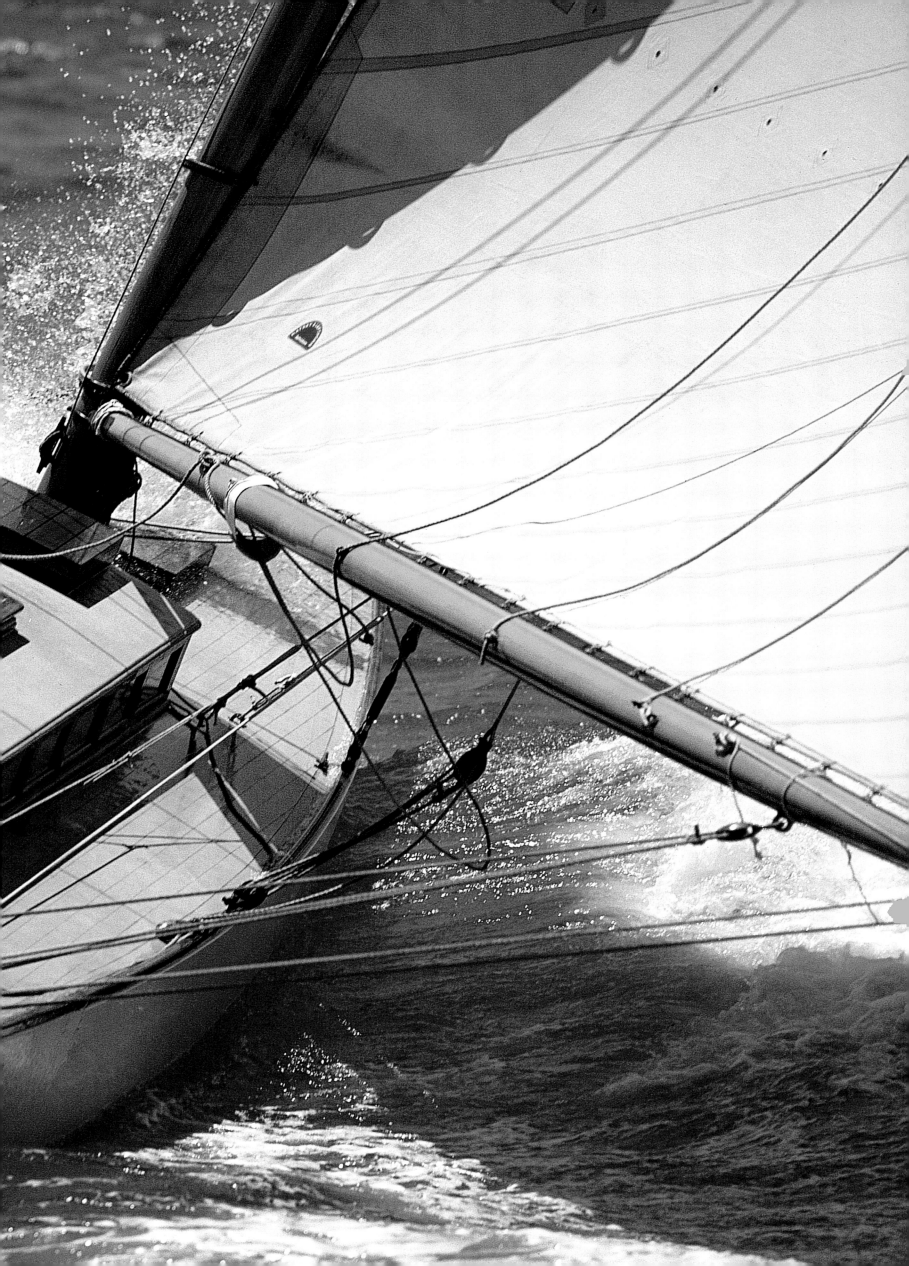

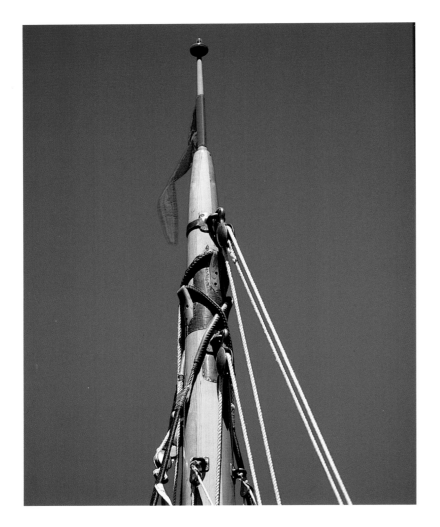

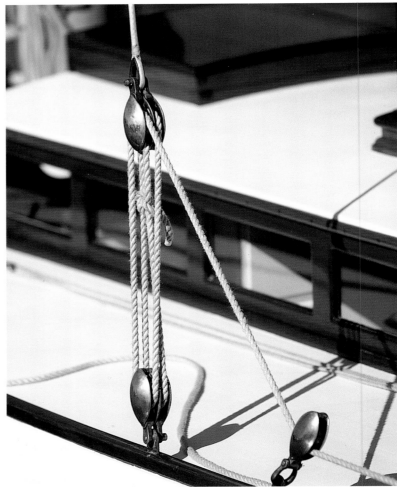

PRECEDING DOUBLE PAGE *Herreshoff's NY 30 design is not only fast but also very seaworthy.*

THIS PAGE *The owner's involvement in the fashion industry is reflected in the quality of* LINNET's *finish from the masthead to the wash basin.*

OPPOSITE PAGE *The combination of white paint and lacquered wood below is very elegant. The bronze blocks have seen service for many years.*

FOLLOWING DOUBLE PAGE *Owner Patrizio Bertelli bought* LINNET *in 1998. Soon after completion of her two-year refit, Bertelli started racing her in Classic events.*

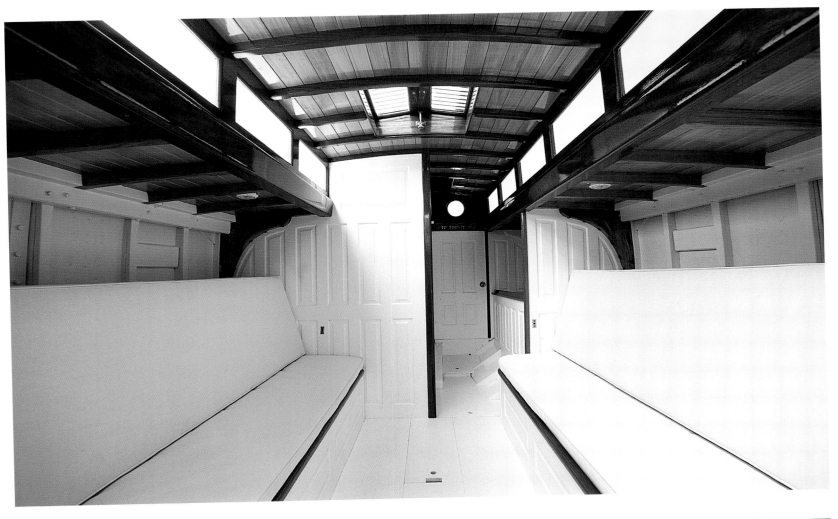

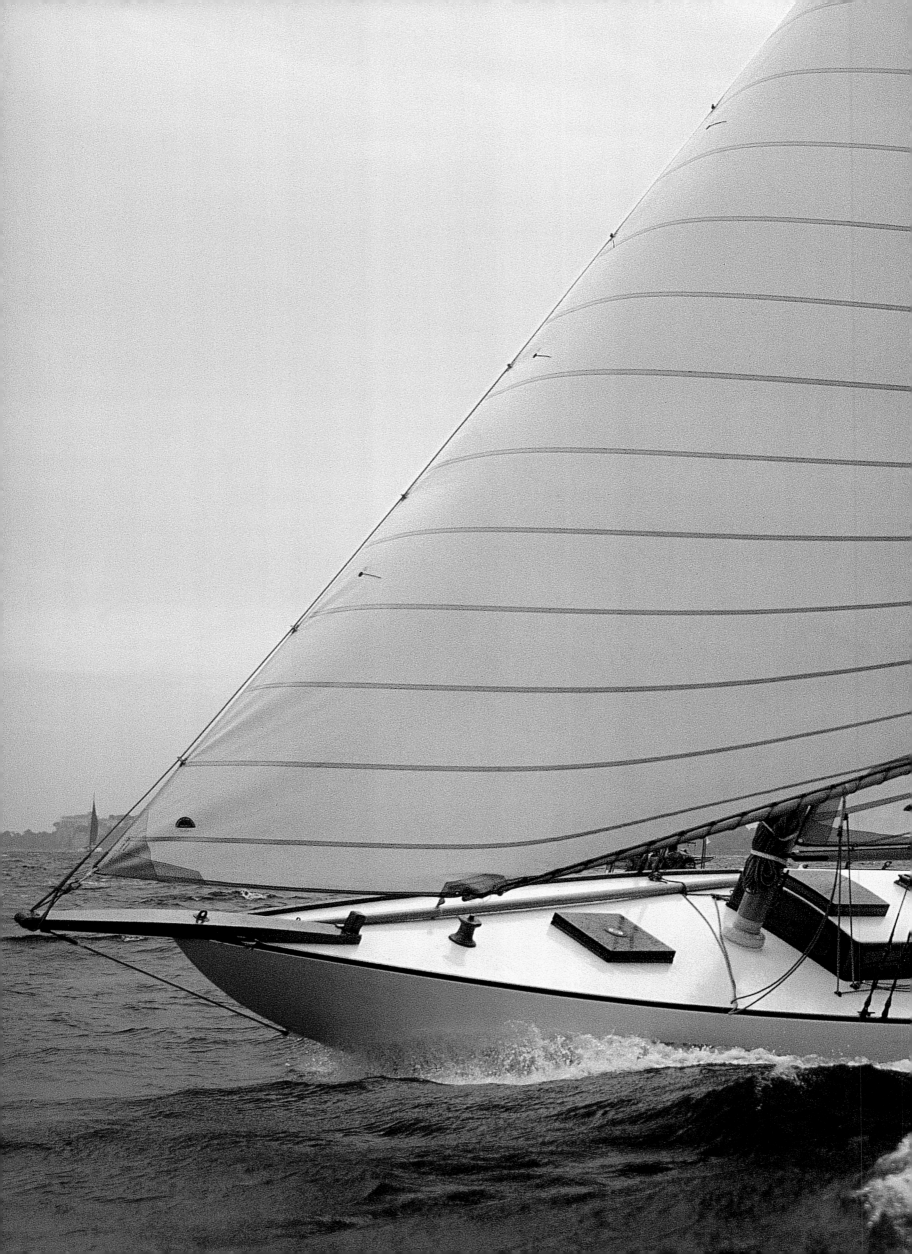

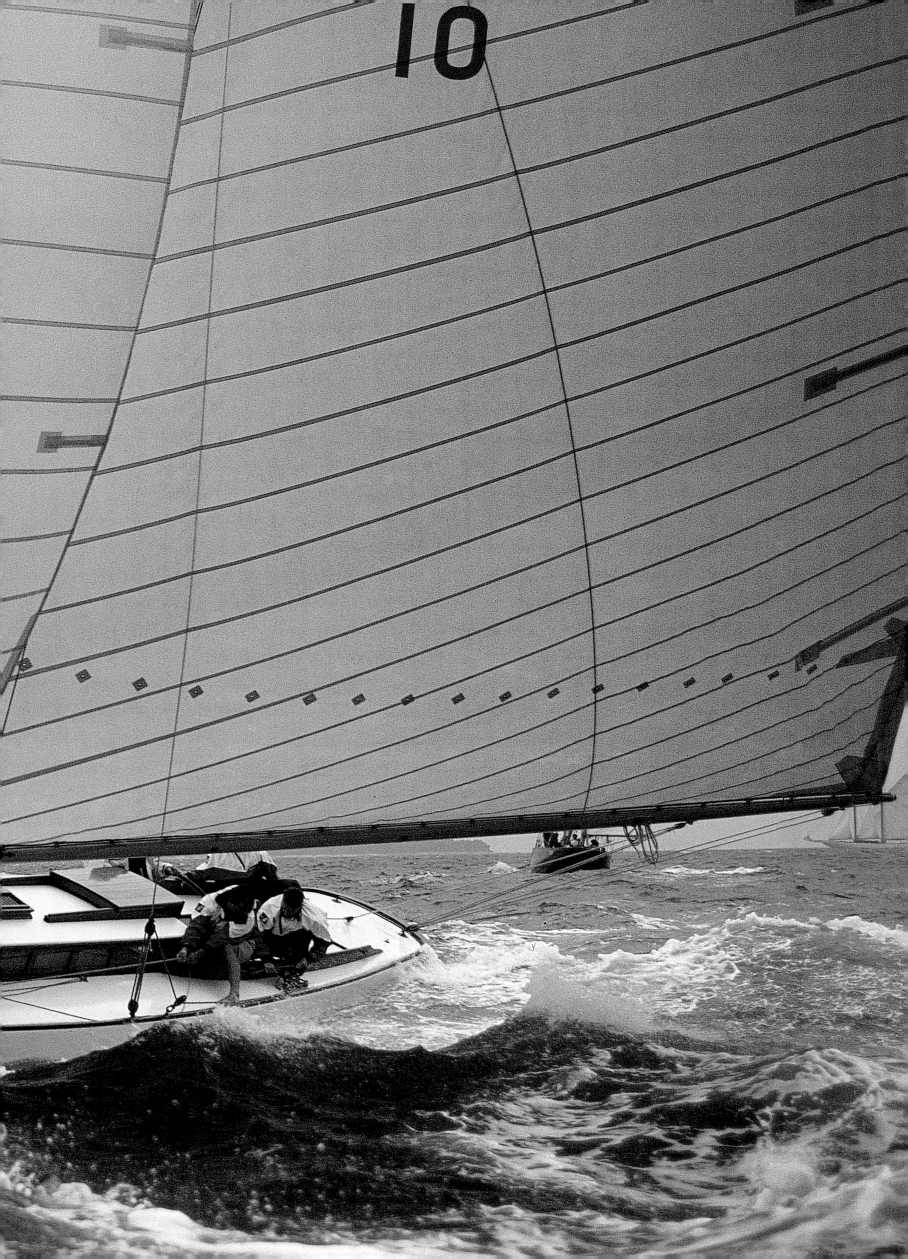

The MP&G Boatyard

Three craftsmen – Ed McClave, Ben Philbrick and Andy Giblin – exercise their skills in Mystic, Connecticut, where they run a small boatyard known as MP&G. All three are passionate about Herreshoff-designed boats.

The origins of this partnership began near the workshop of the Mystic Seaport Museum, which was founded in 1929. Ed and Andy were roaming around on boats, while Ben was helping to build replicas of Herreshoff dinghies. All were boatbuilders; in addition, Ed and Ben were both engineers and Andy – the last to join the team, in the mid 1980s – was a designer. They favour Herreshoff boats because the simplicity of the design makes them relatively easy to restore; there are plenty of restoration projects available in New England. MP&G's motto is 'Better to make a cut and build again rather than botch'. They prefer to use traditional boatbuilding methods to determine lines and curves than to use modern technology and computer software.

RIGHT *Here Andy chooses to replace a plank in a stripped down hull rather than to repair it.*

BELOW *Andy Giblin has a great love of wooden boats, particularly those of Herreshoff, the doyen of boatbuilders. At the beginning of the 1990s he helped the Herreshoff Marine Museum with the conservation of its exhibits, which probably led to some of their restoration commissions.*

OPPOSITE PAGE BAGATELLE, *one of four Buzzards Bay 25s built in 1914, in the process of restoration at the MP&G yard.*

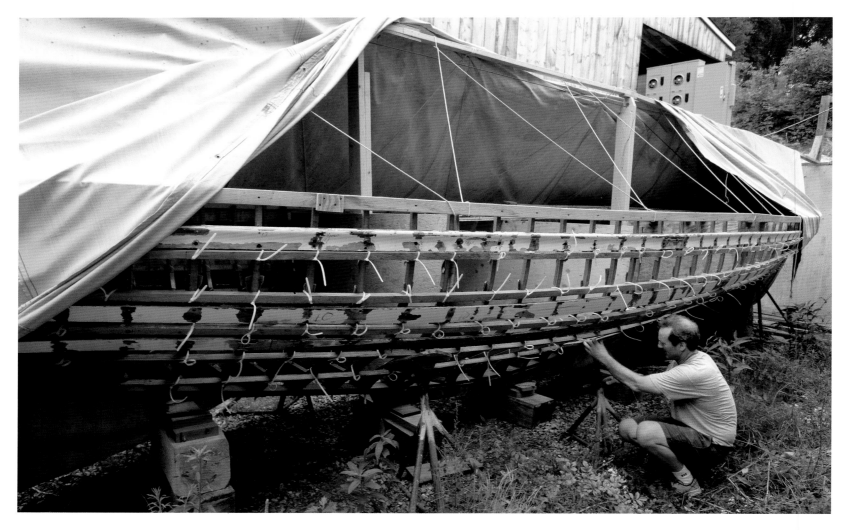

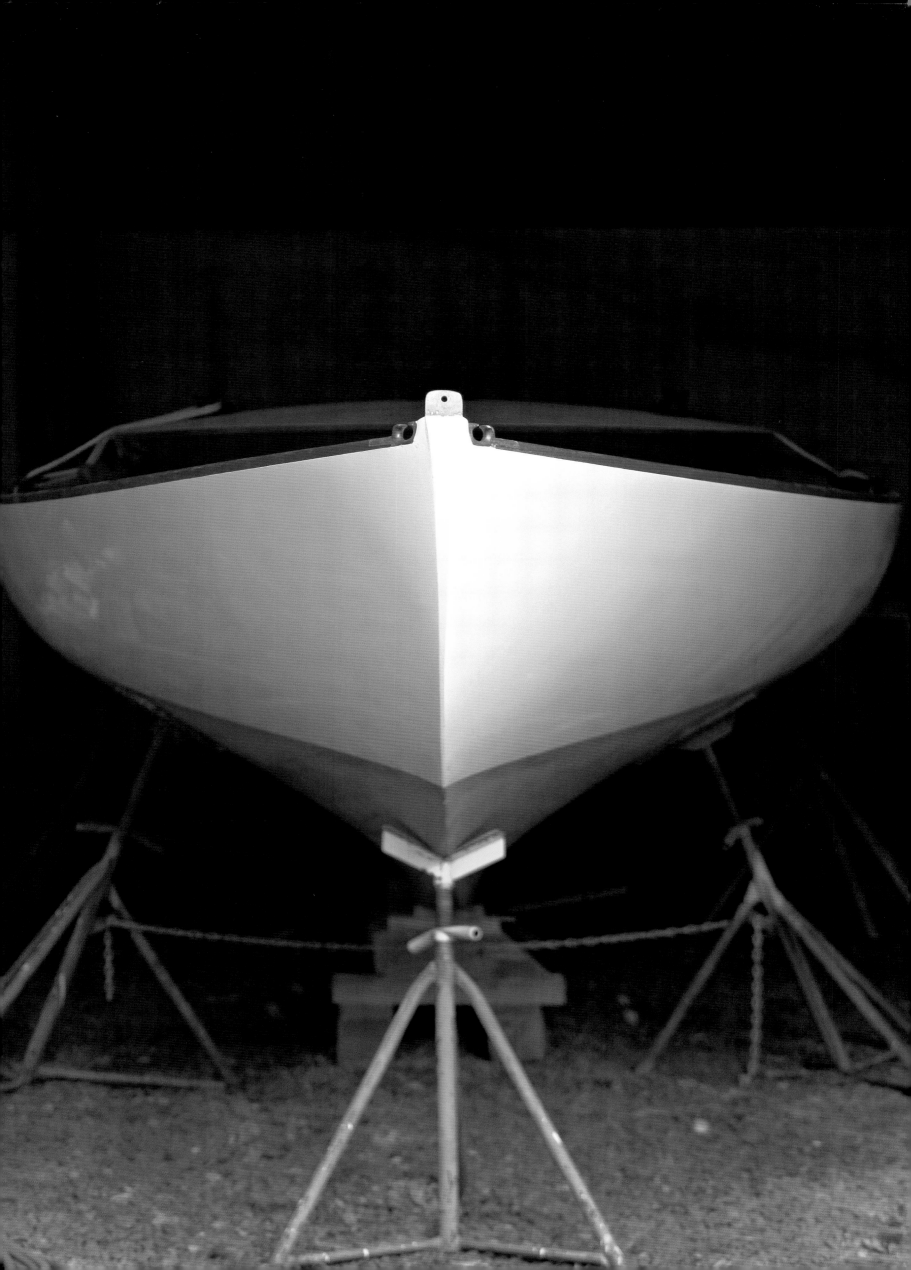

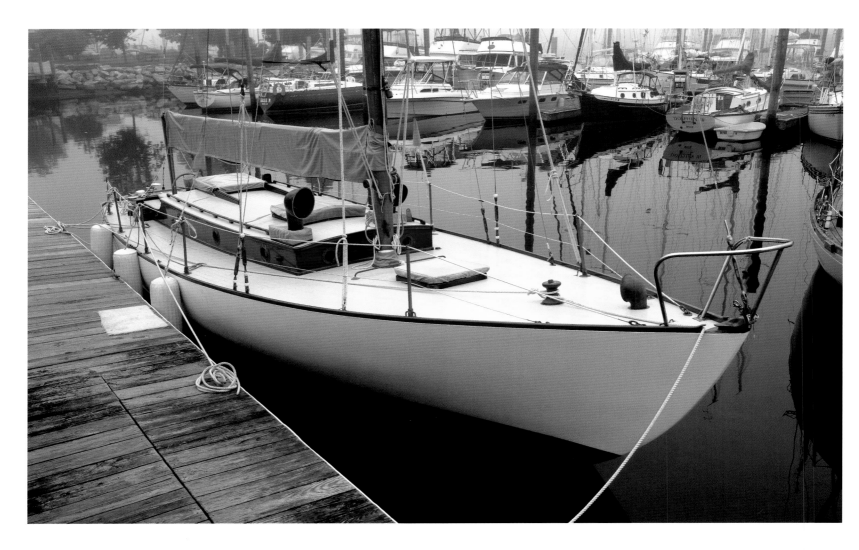

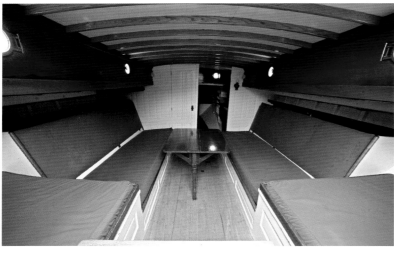

TOP *Following her restoration by MP&G, DOLPHIN, a Newport 29, looks as pristine as if she had just been delivered by Herreshoff. The shipyard renewed the decks in the spirit of the original, using canvas coated in waterproof paint.*

ABOVE *The interior provides spartan saloon bunks and quarter berths.*

FAR RIGHT *It can be seen from this bow-on view of DOLPHIN, moored at a pontoon, that the attention to detail has been faithful and as many original fittings as possible have been reused.*

FOLLOWING DOUBLE PAGE *CORINTHIAN, a P Class boat like JOYANT (page 120) waits in the yard for her restoration by MP&G.*

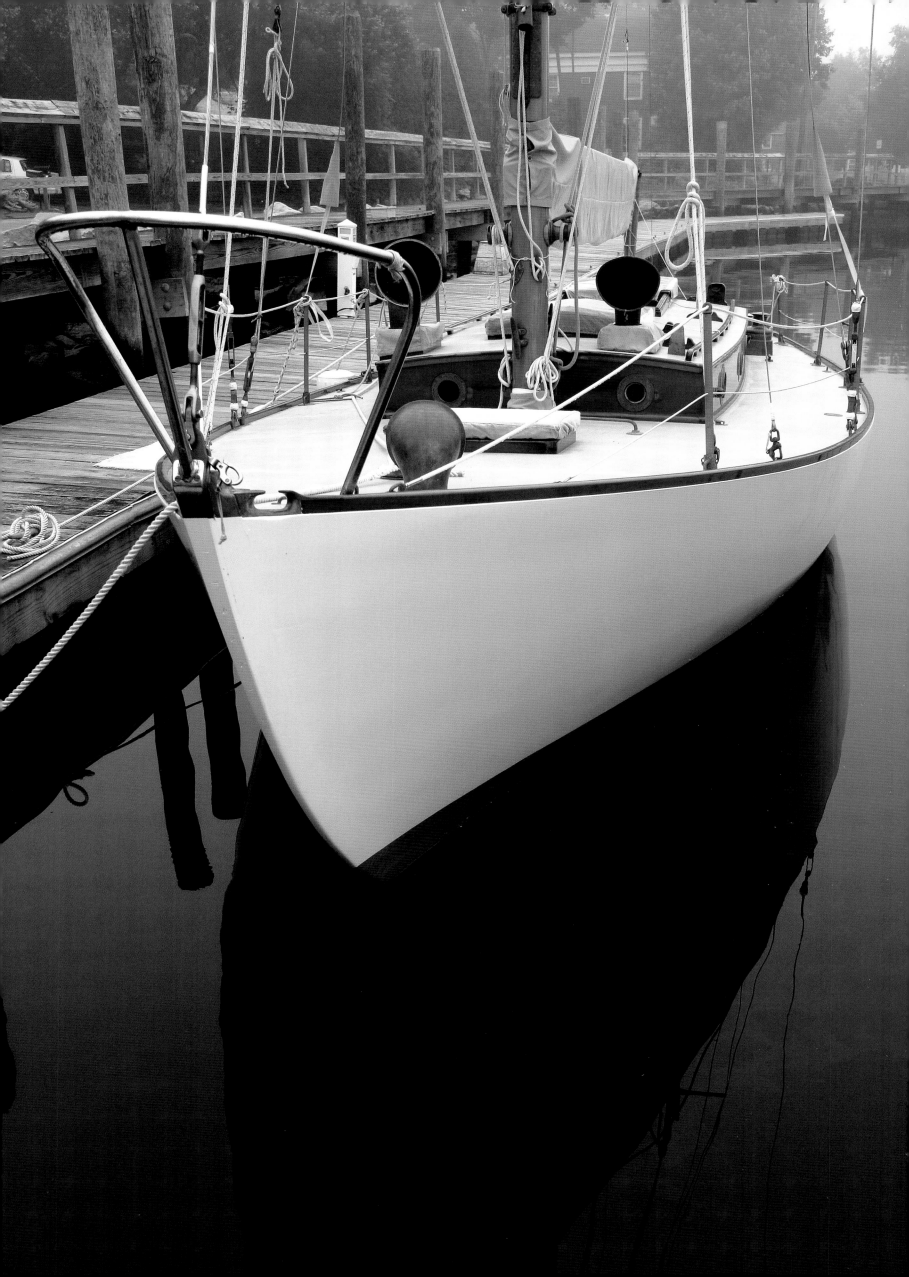

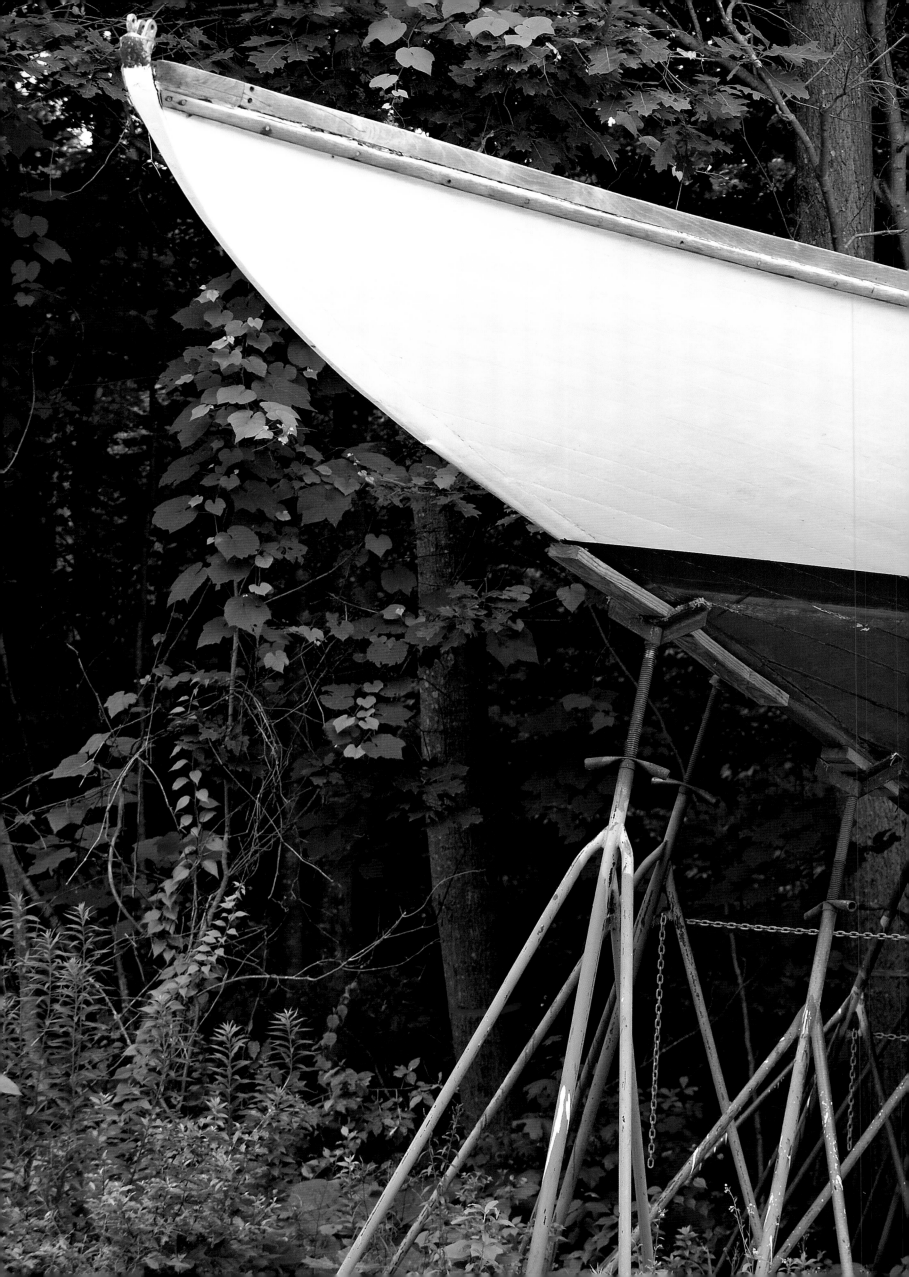

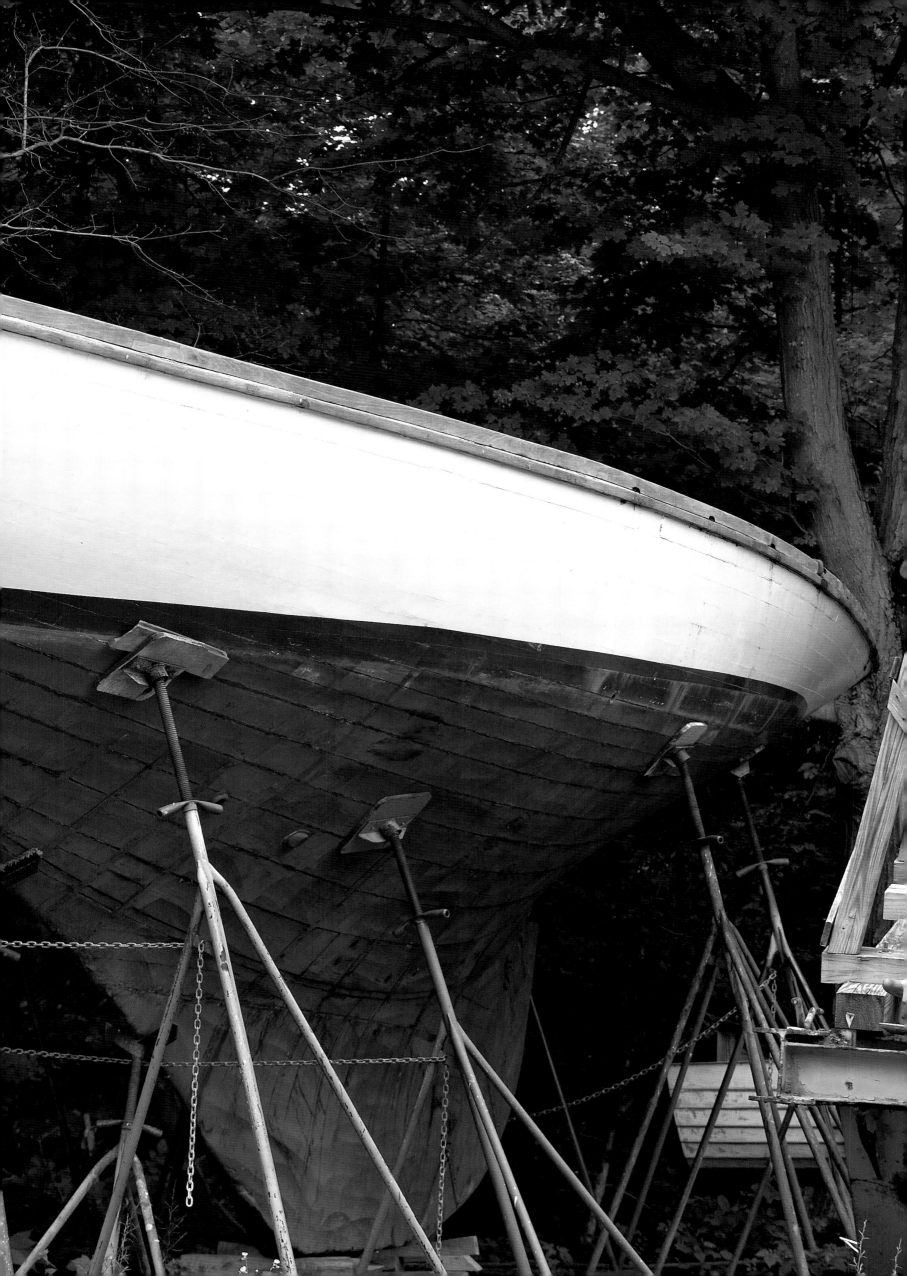

Mischief

Year of construction	1914	
Length on deck	35ft 6in	(10.82m)
Length of waterline	30ft	(9.14m)
Beam	10ft 6in	(3.2m)
Draught	5ft 6in	(1.68m)
Sail area	646sq ft	(60m²)
Designer	Nathanael Herreshoff	
Builder	Herreshoff Manufacturing Company	

In 1914, Hugh D Auchincloss was only 17 years old when his mother gave him a Newport 29. *Mischief* was the second boat of the class, which Herreshoff had based on his own sloop, *Aurelion*. The only modification was to replace the centreboard with a fixed keel.

The Newport 29, MISCHIEF is now equipped with modern winches and has navigation instruments above the sliding hatch.

OPPOSITE PAGE *Since 1929 MISCHIEF has carried a Bermudan rig. In the same year, the owner installed her first engine.*

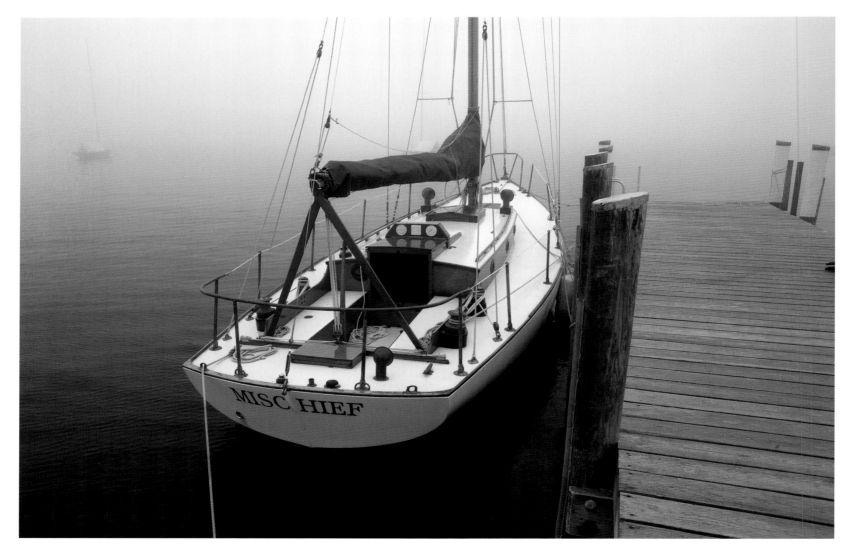

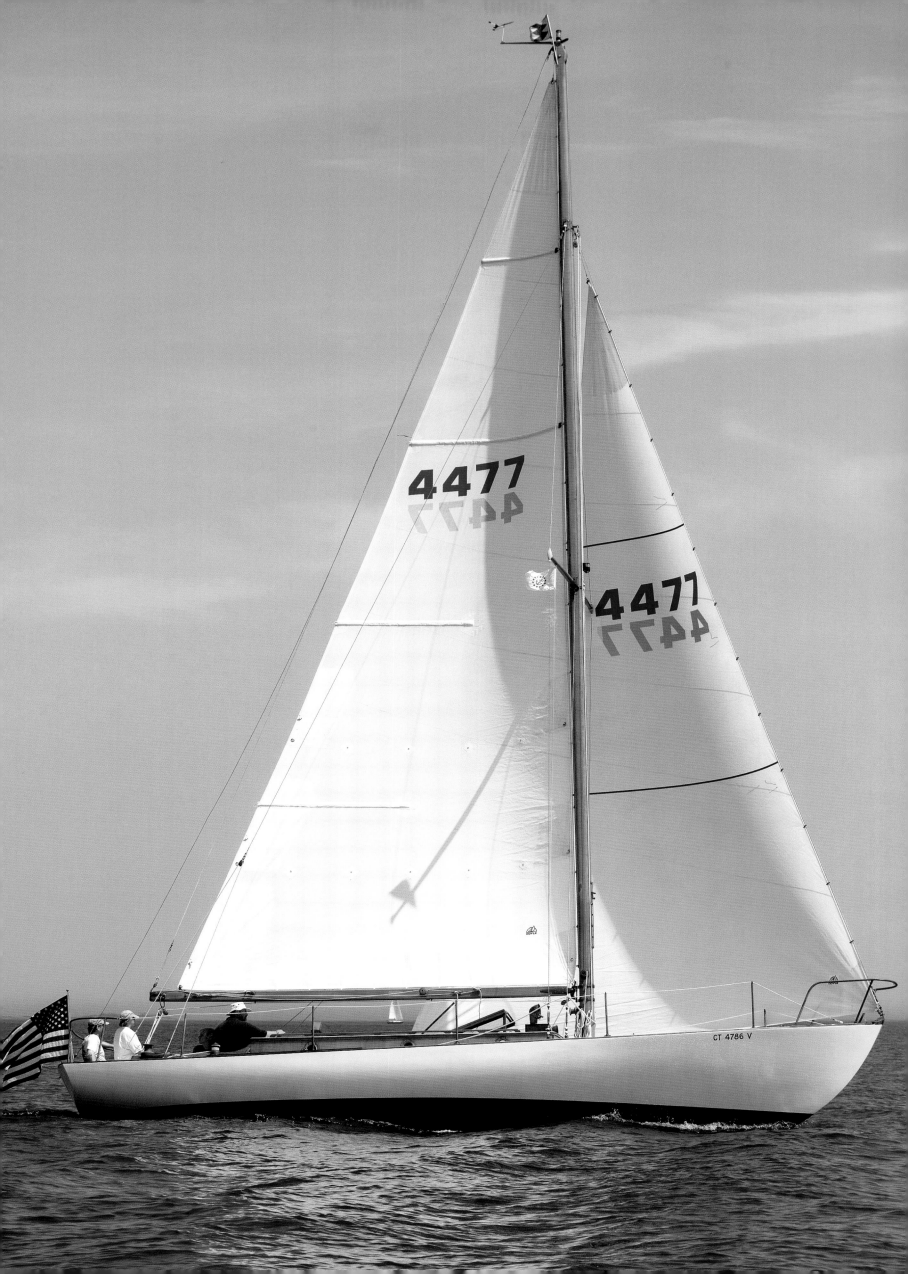

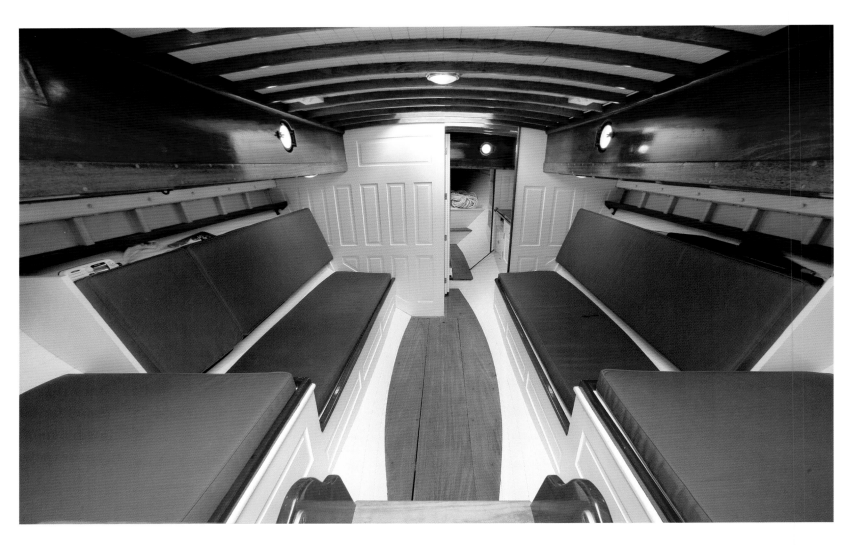

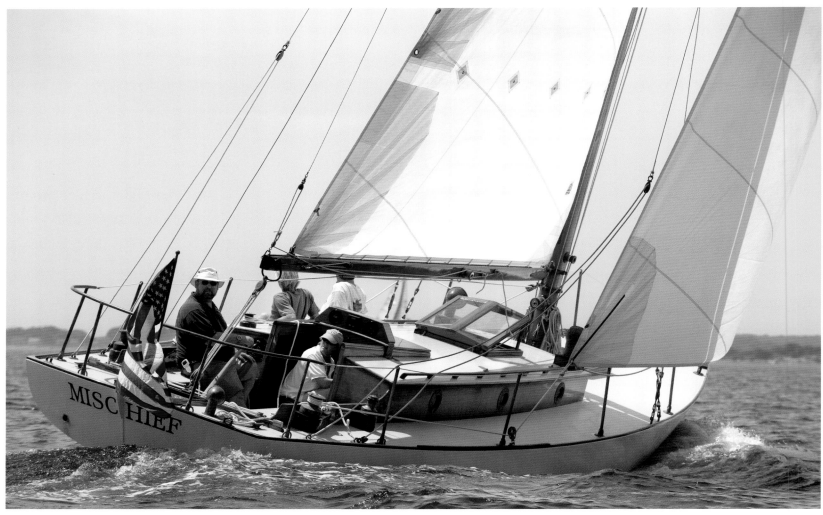

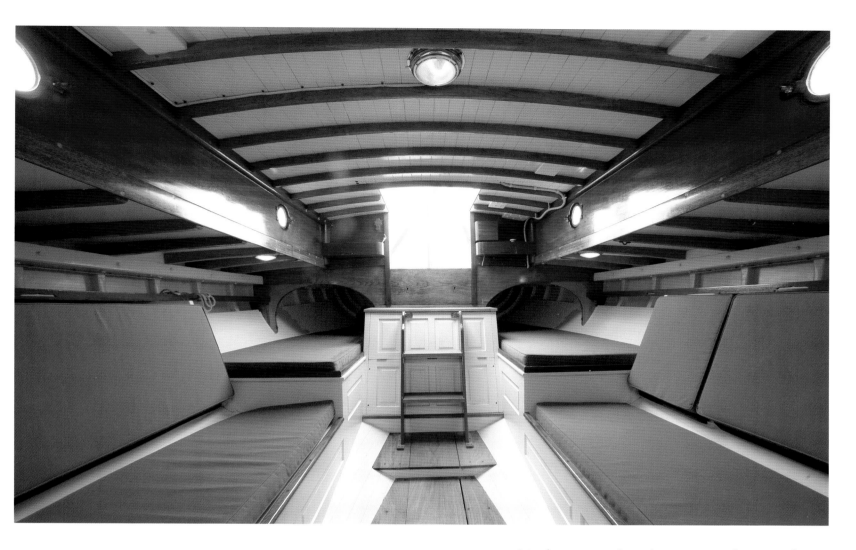

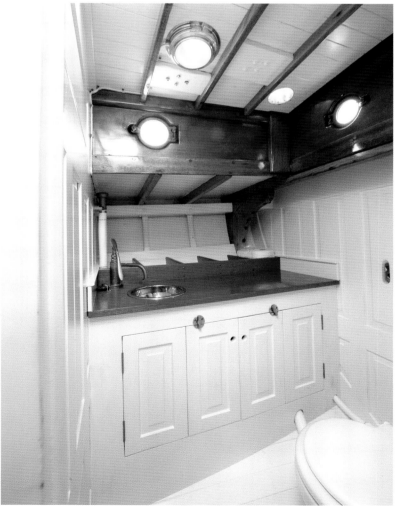

THESE PAGES *Much structural work was carried out on the hull during the two-year restoration by Mystic-based boatbuilders McClave, Philbrick and Giblin (MP&G). Jeff Hall of North Stonington rebuilt her much-modified interior.*

FOLLOWING DOUBLE PAGE *Owner Chris Wick enjoys sailing with his family but he has also won many awards racing* Mischief.

For five years Auchincloss sailed *Mischief* in the waters around Newport.

It was the third owner who, like many others, replaced the gaff rig of his boat with a Bermudan. In the same year, 1929, *Mischief* received her first engine. In the 1950s she went to new owners who moved her south to the Chesapeake Bay, where they made further alterations to the rig. They felt that *Mischief* was over-canvassed, and shortened the mast by two metres.

In 1967 her new owner David Cabot took *Mischief* to New England, off Rhode Island and Connecticut. In 1973, she was bought by Chris Wick, then a student. He lengthened her mast, undertook several repairs including replacing the deck with plywood, and sailed her constantly for almost 30 years before deciding on a complete restoration. Today *Mischief* looks much as she did when first built by Herreshoff in 1914.

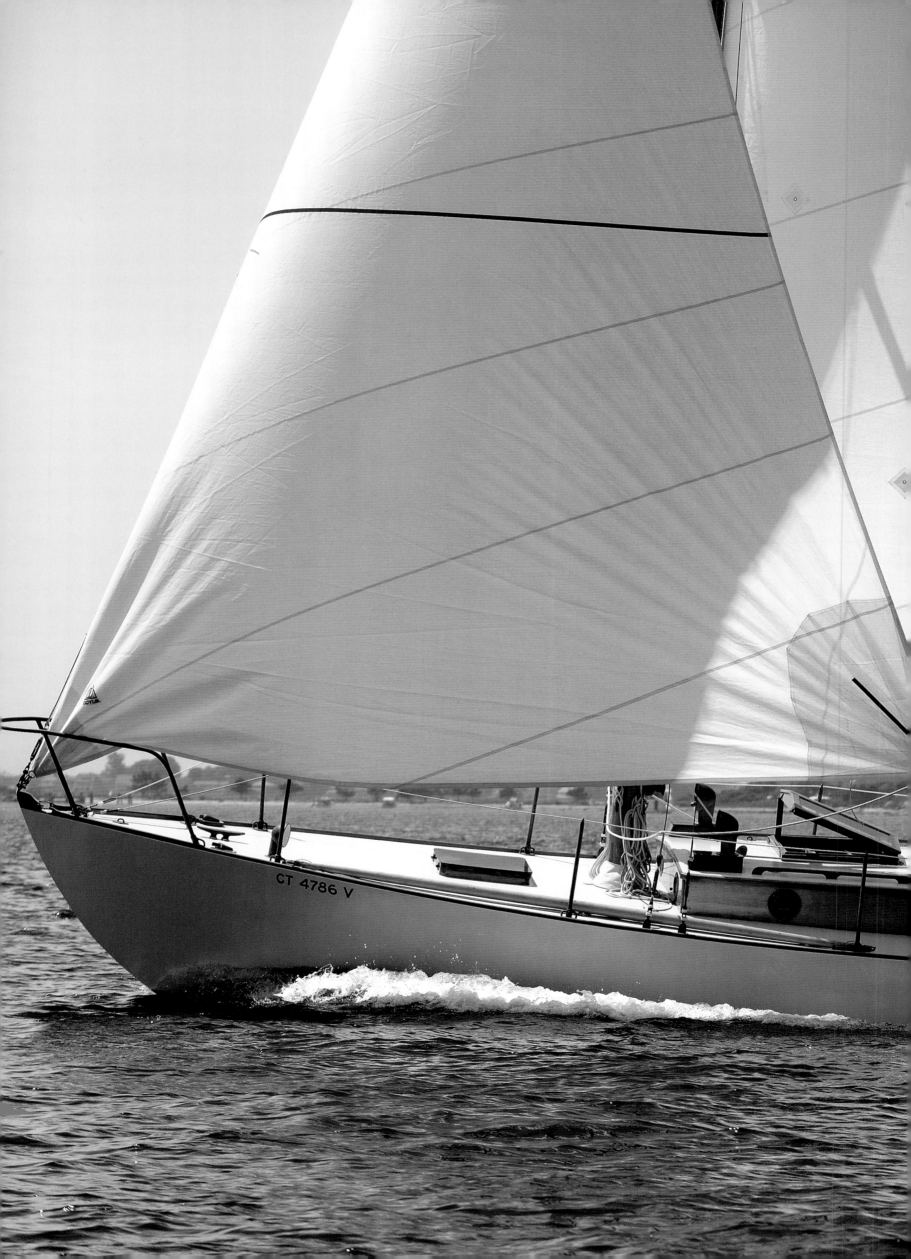

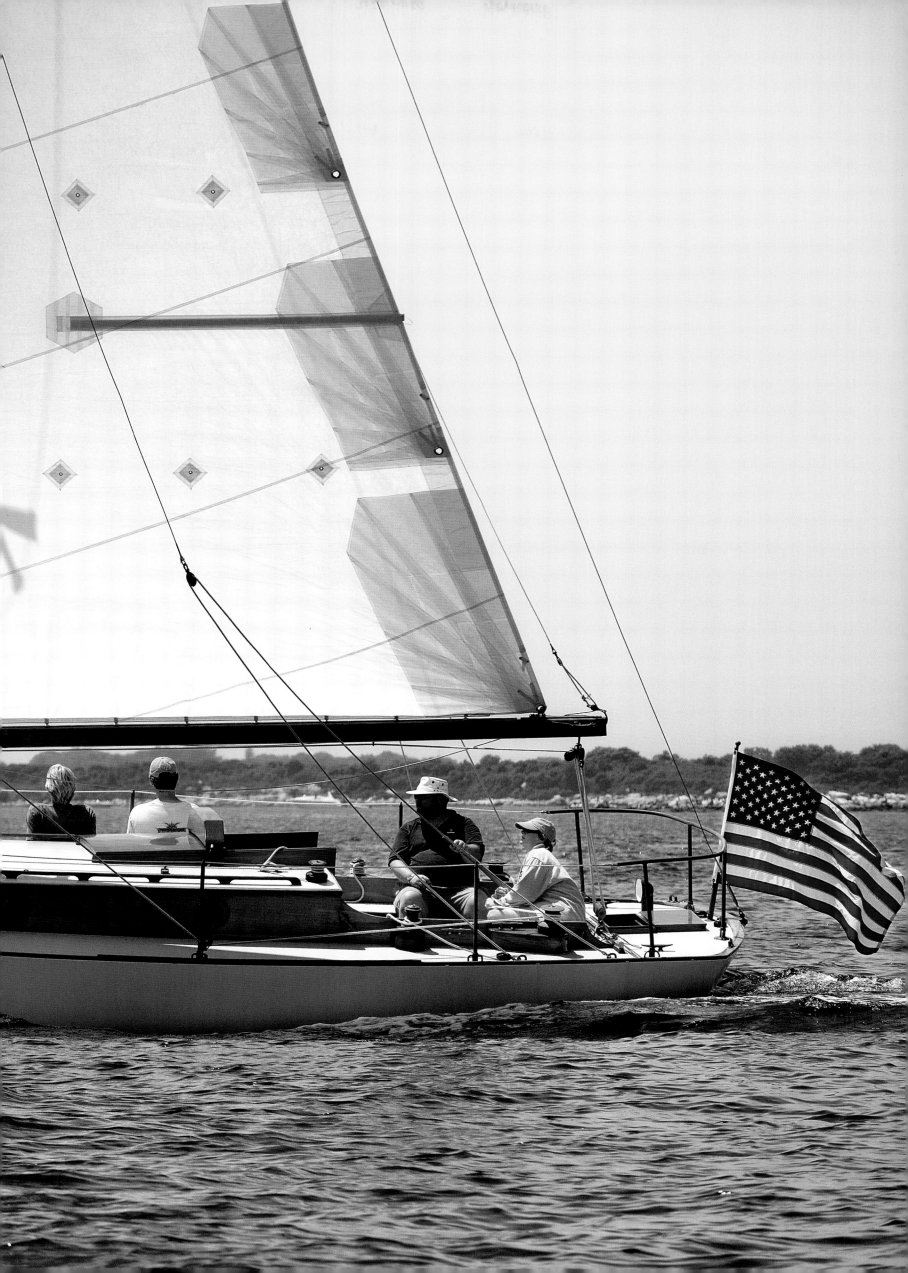

Joyant

Year of construction	1910	
Length on deck	58ft	(17.68m)
Length of waterline	30ft	(9.14m)
Beam	11ft 3in	(3.43m)
Draught	7ft 4in	(2.23m)
Designer	Nathanael Herreshoff	
Builder	Herreshoff Manufacturing Company	

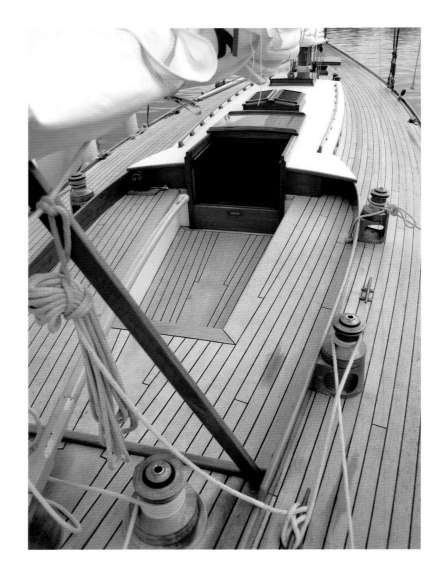

More than 30 P Class boats are still known and most are actively sailing. At the beginning of the 20th century, P Class yachts with their designed waterline length of 30 feet (9.14m), were the largest of Herreshoff's 'small' boats. Fleets were to be found in New York, Chicago and Toronto. The Herreshoff yard also produced the P Racers, built to the Universal Rule. *Joyant*, launched in 1911, was one of them.

Her renaissance began in 1999 when her sad remains, overgrown with ivy, were found in a forest near Barnstable, Massachusetts. New owner Robert McNeil decided to have her restored by Jeffrey Rutherford in Point Richmond, California, which resulted in such a complete reconstruction that it was almost a new build. *Joyant* again sparked debate between Herreshoff enthusiasts about the subtle distinctions between modernisation and restoration.

THESE PAGES *The P Class racing yacht* JOYANT *has been almost completely rebuilt under the guidance of her present owner.*

FOLLOWING DOUBLE PAGE JOYANT *returned to New England, her place of origin, in pristine condition and attracted many admirers.*

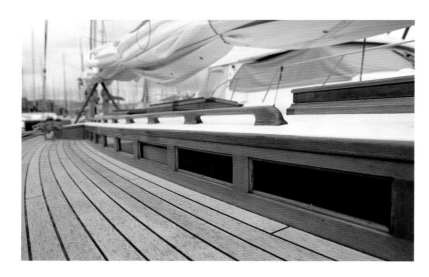

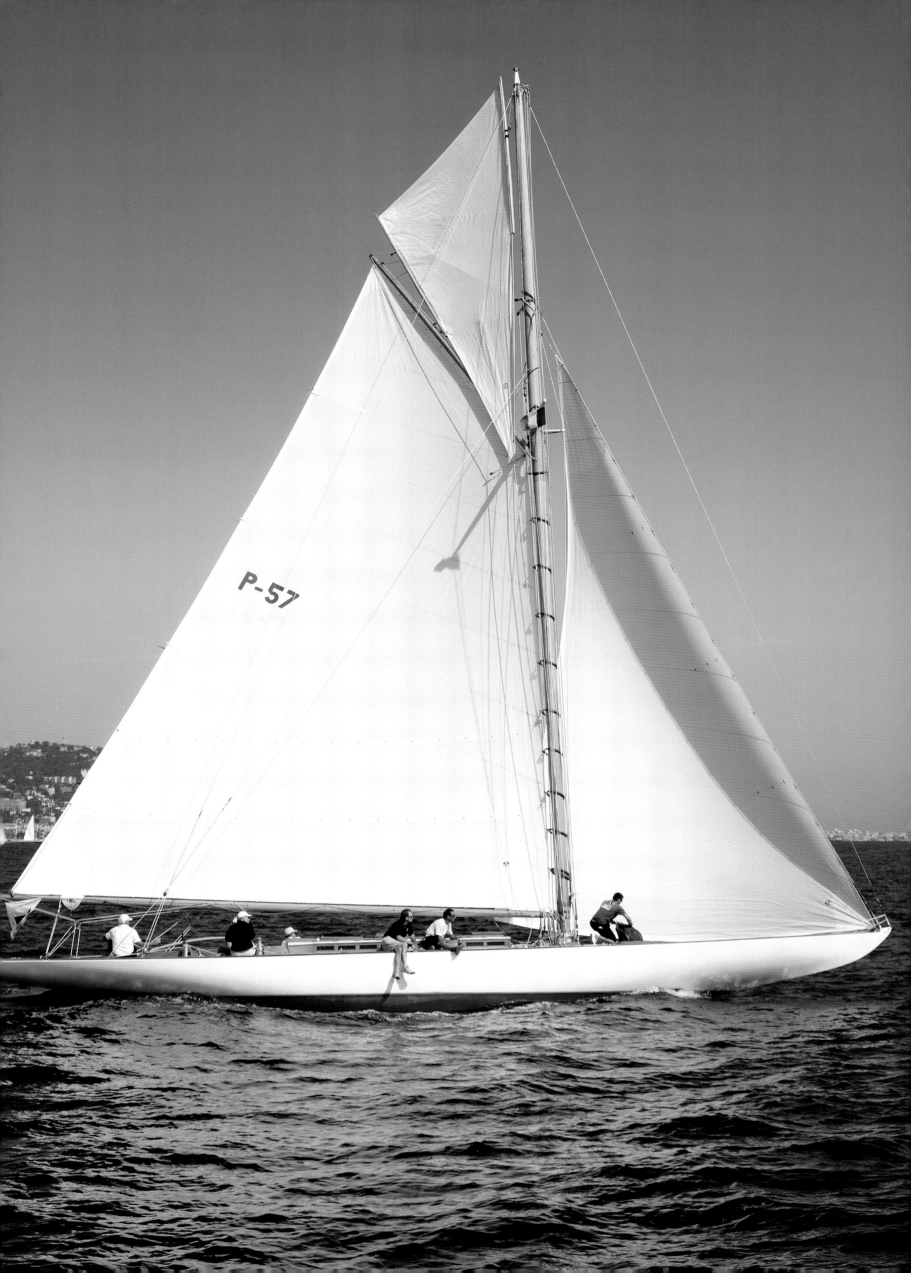

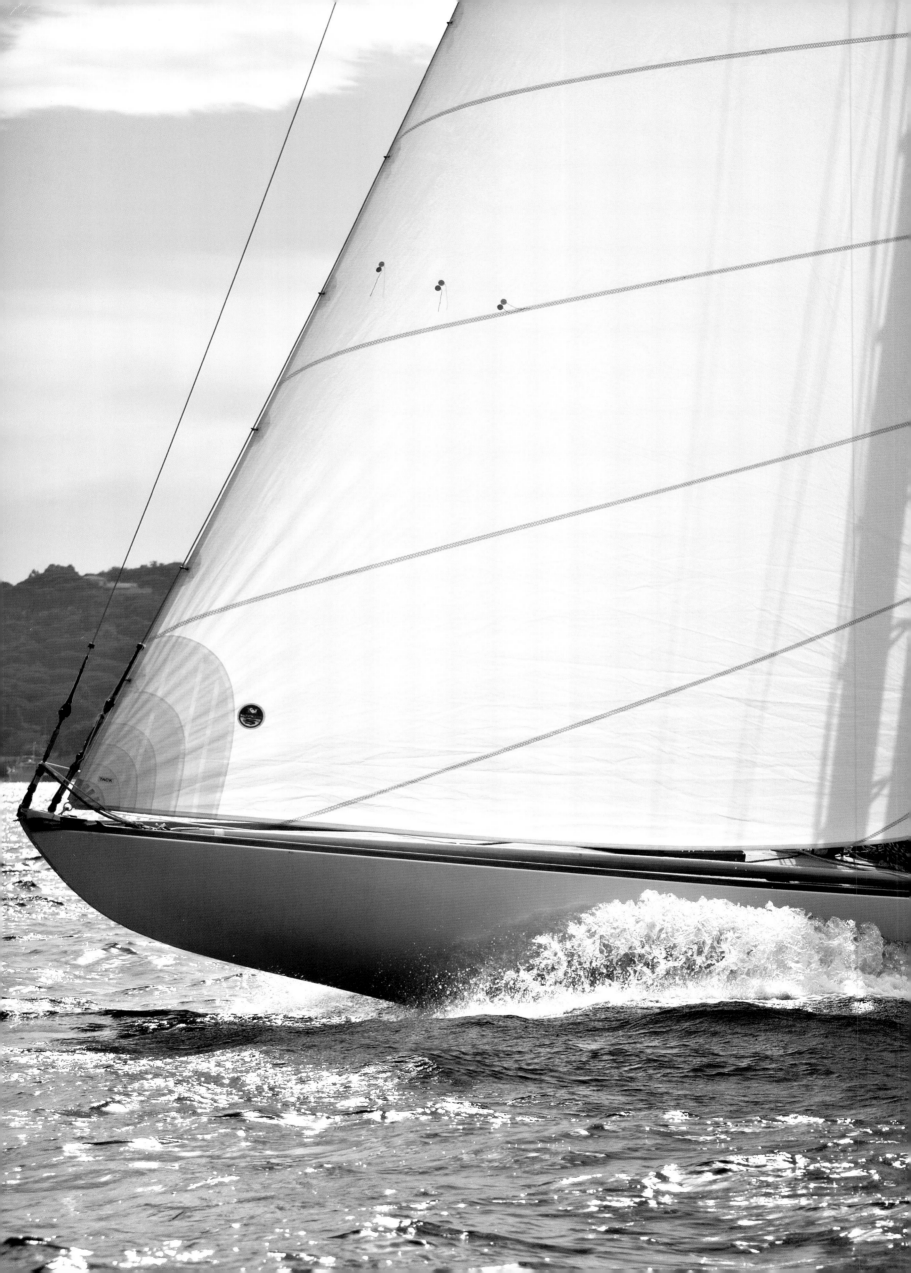

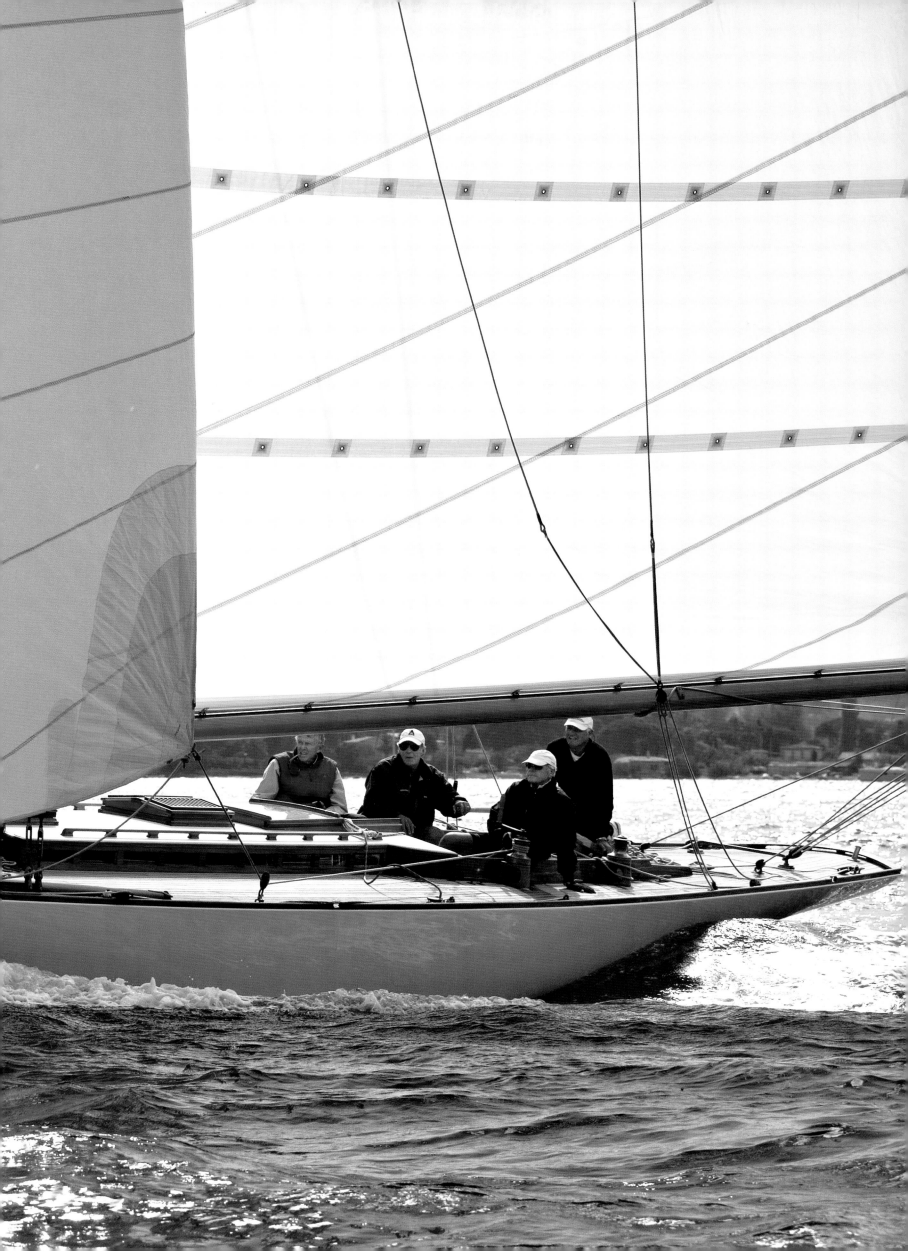

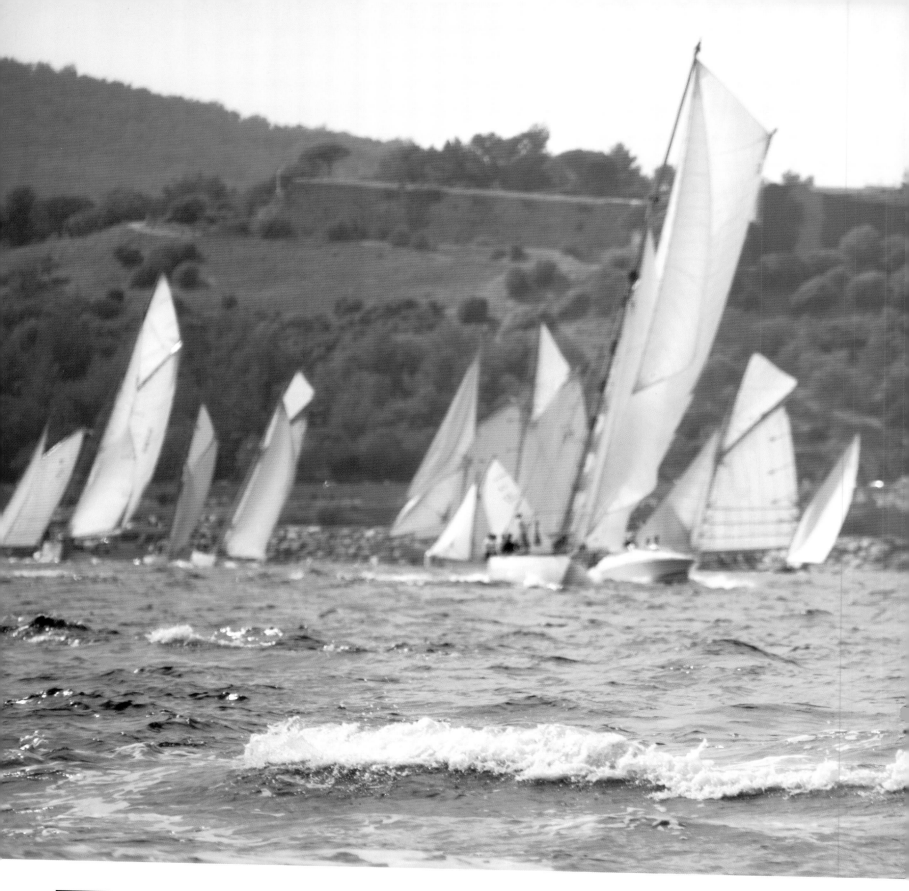

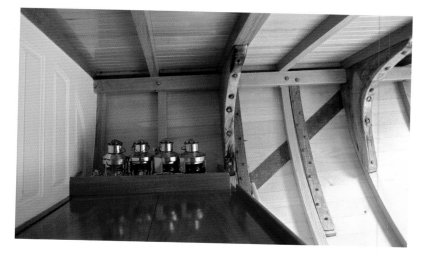

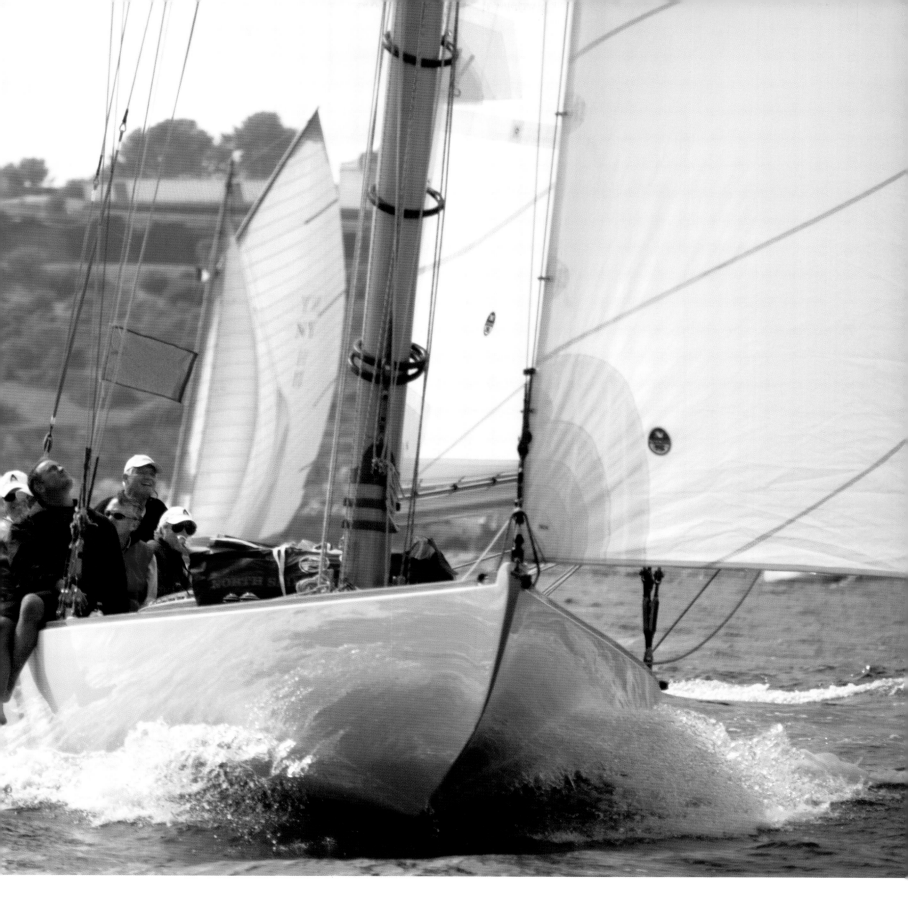

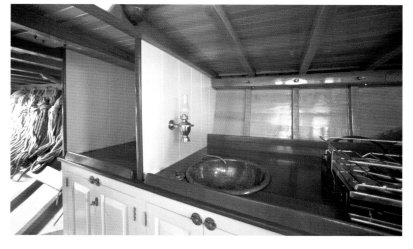

LEFT *The restoration took 18 months, during which JOYANT was virtually rebuilt. The superb results can be seen in her interior, from the new planking in the saloon to the galley with its copper sink.*

ABOVE *JOYANT's owner remains true to the P Class's competitive history. These boats are still raced very seriously, and protests are not uncommon.*

FOLLOWING DOUBLE PAGE *Formerly, the P Class yachts were the largest racing competitors in the 'small boat' classes.*

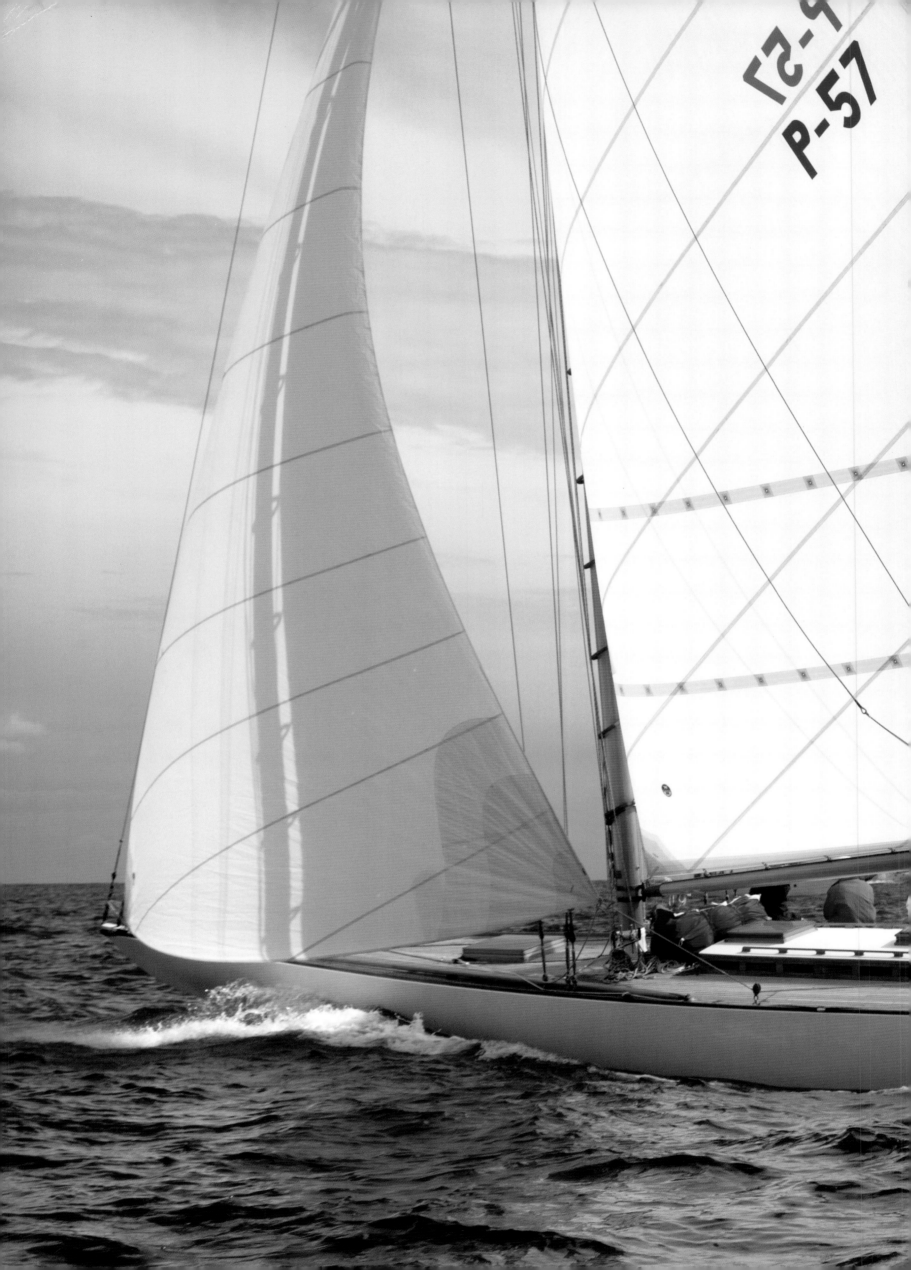

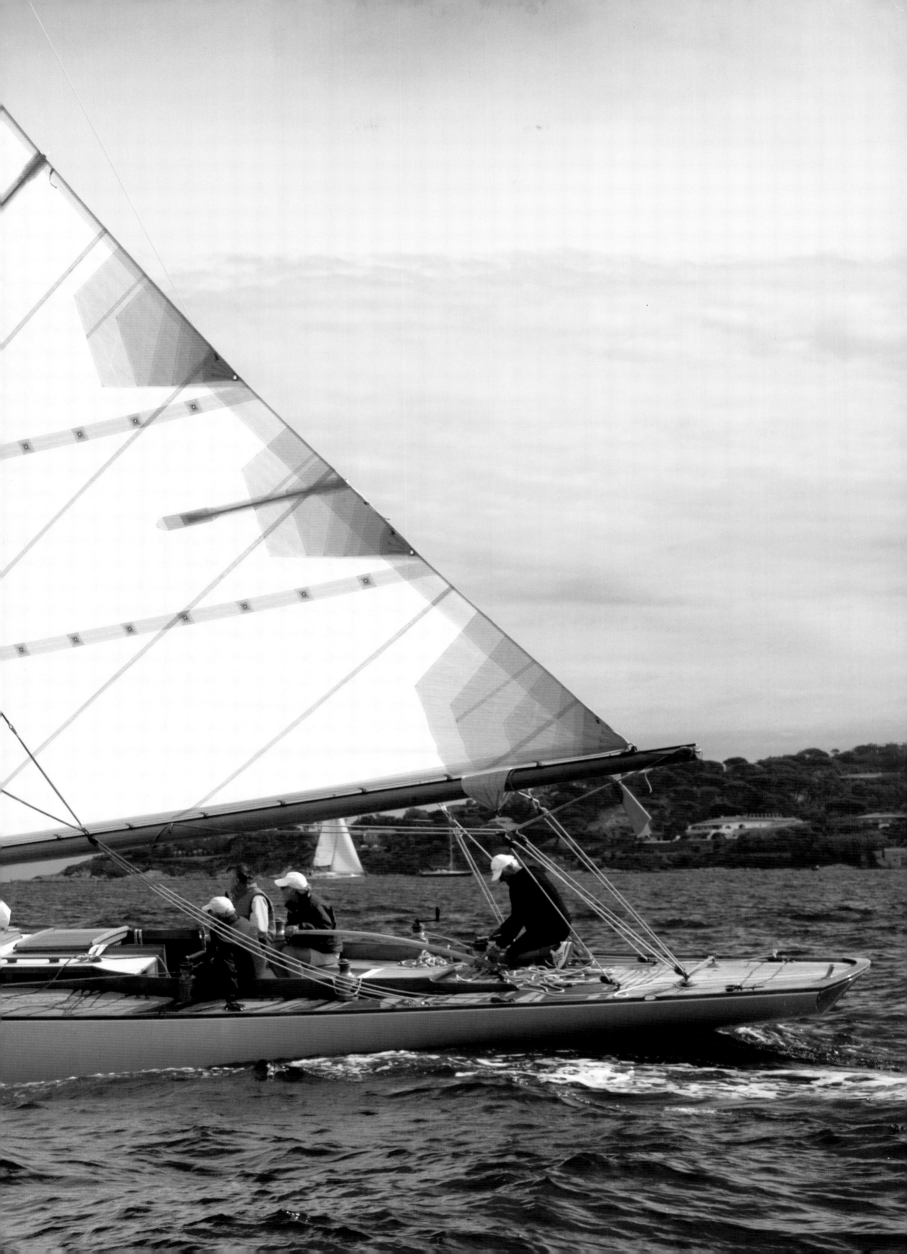

Bounty

Year of construction	1915	
Length overall	65ft	(19.81m)
Length on deck	58ft	(17.68m)
Length of waterline	50ft	(15.24m)
Beam	13ft 3in	(4.05m)
Draught	6ft 2in	(1.9m)
Sail area	1519sq ft	(141m²)
Designer	L Francis Herreshoff	
Builder	Britt Brothers, Lynn, Massachusetts	

*B*ounty's design has many admirers and her lines, drawn by Nat's son Lewis Francis, are, with modifications, still in use today. The ketch, 18 metres on deck, was Lewis Francis's design number 58, and was launched in 1933 by Britt Brothers in Lynn, Massachusetts. She was similar to *Tioga*, but at the request of her first owner, Edward Dane, was given a fixed keel, taller masts and also more sail area – 1519sq ft (141m2) when closehauled. Even so, she proved to have less race-win potential, though powerful in heavy weather. Dane was not a fan of high speed, however, and when it was time for lunch he had his crew drop the sails so that he could enjoy his meal, served on deck with tablecloth and silver cutlery. After several changes of ownership, *Bounty* now sails on the German Baltic Sea coast.

THESE PAGES *Bounty's interior is not original; after sustaining major damage during her early years whilst sailing in the Caribbean, a boatyard in New England rebuilt the interior under her designer Lewis Francis' supervision.*

Her first owner, Edward Dane was not concerned with fast sailing; instead he opted for a powerful rig designed for heavy weather.

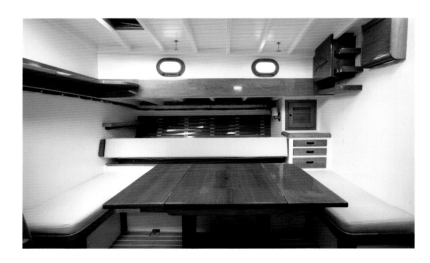

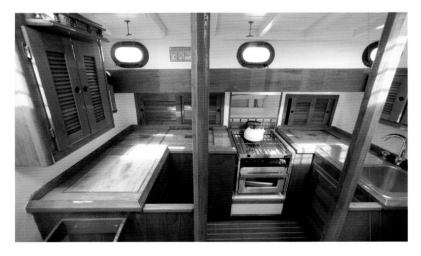

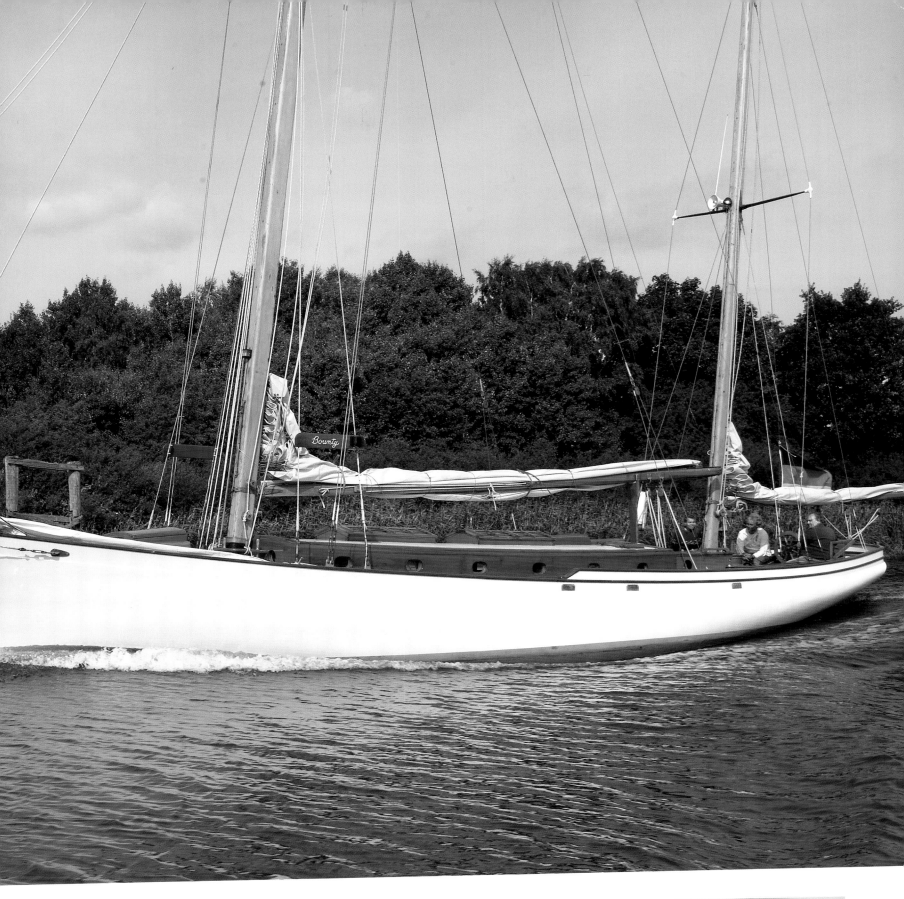

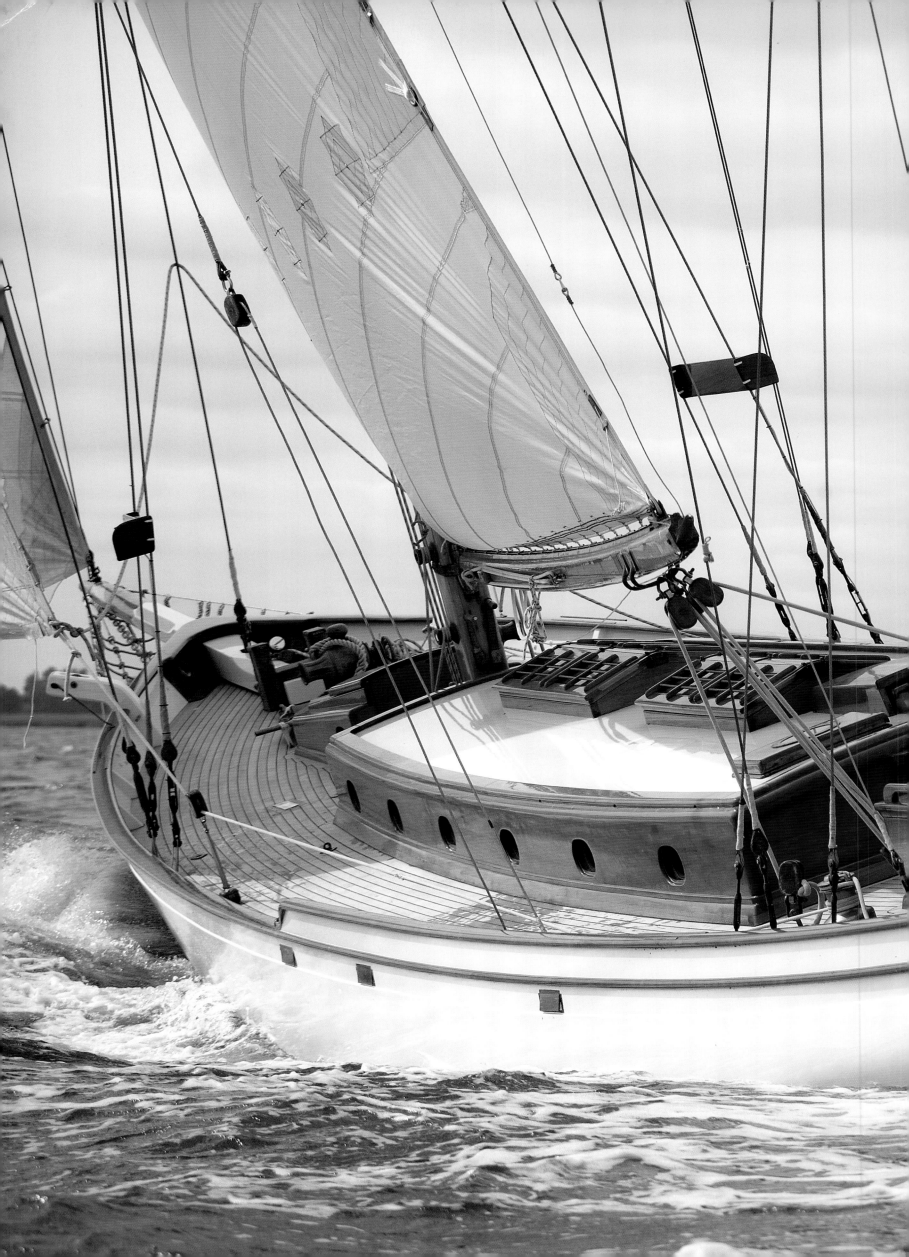

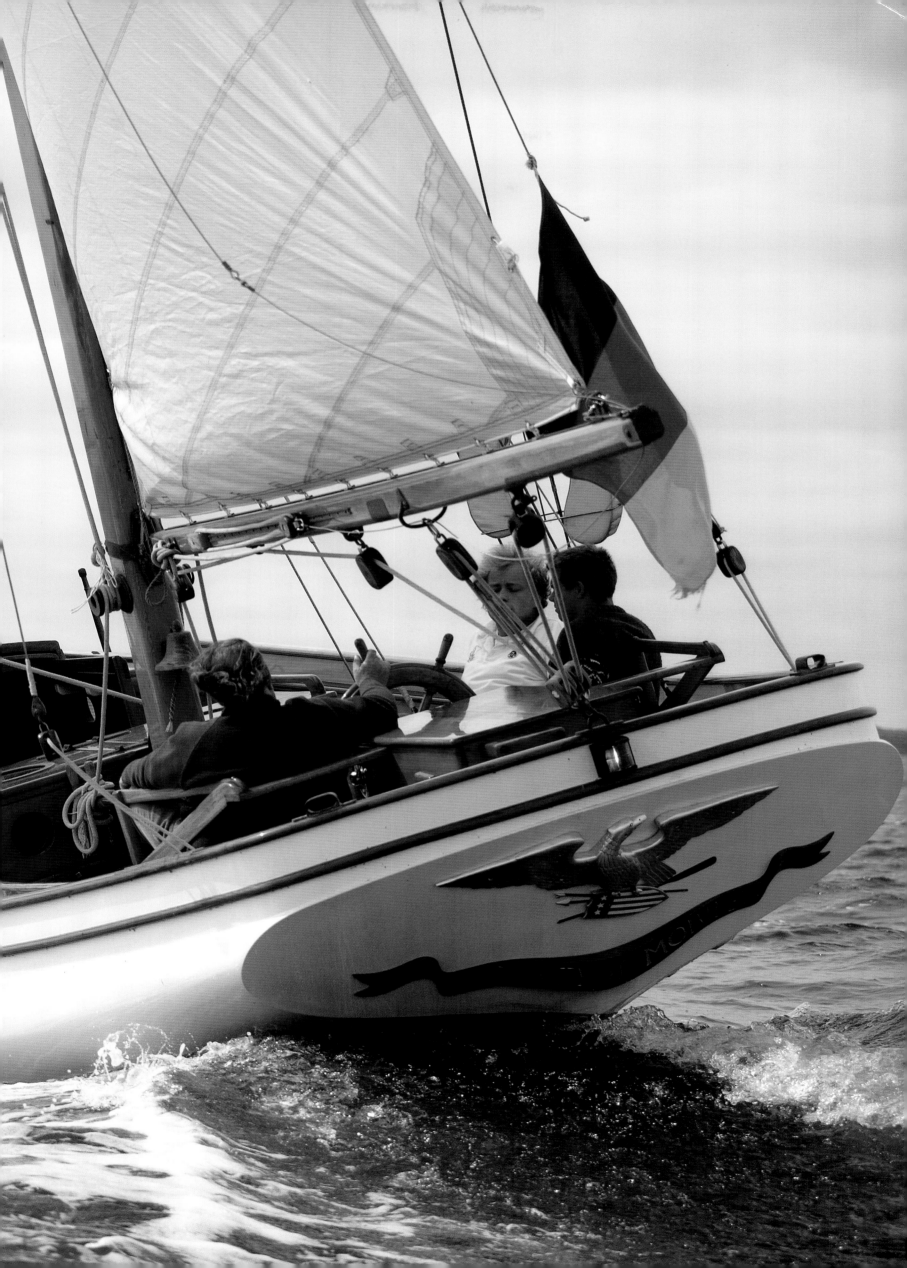

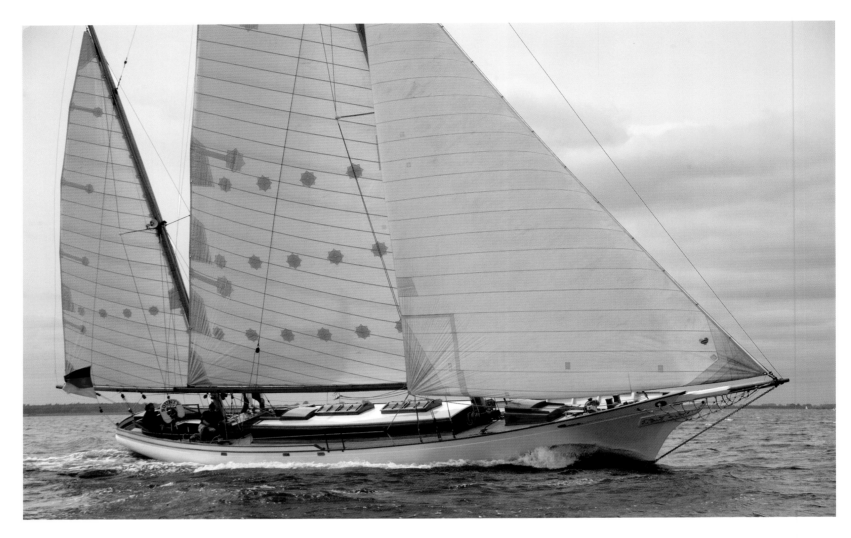

Yachts like Bounty *are the subject of many stories. It is said that* Bounty *carried plentiful supplies of fresh food when she was sailing in the Caribbean and became known as the 'milk express'. In the middle of the 20th century she served, like many other yachts, with the US Coast Guard.*

PREVIOUS DOUBLE PAGE *Correctly sailed,* Bounty *travels quickly despite her weight of 23 tons.*

RIGHT *In 2005* Bounty's *current owner commissioned the Danish yard Walstedt in Svenborg to carry out a complete overhaul but many of her fittings have lasted for decades, including her wheel, the bronze rail cap and stanchions with the ship's name, and the mast winches.*

FOLLOWING DOUBLE PAGE *Lewis Francis did not limit himself to designing a single shape, though* Bounty *shows his characteristic tumblehome and elegant stern.*

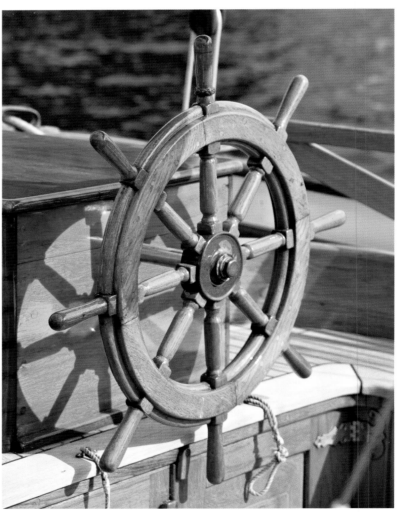

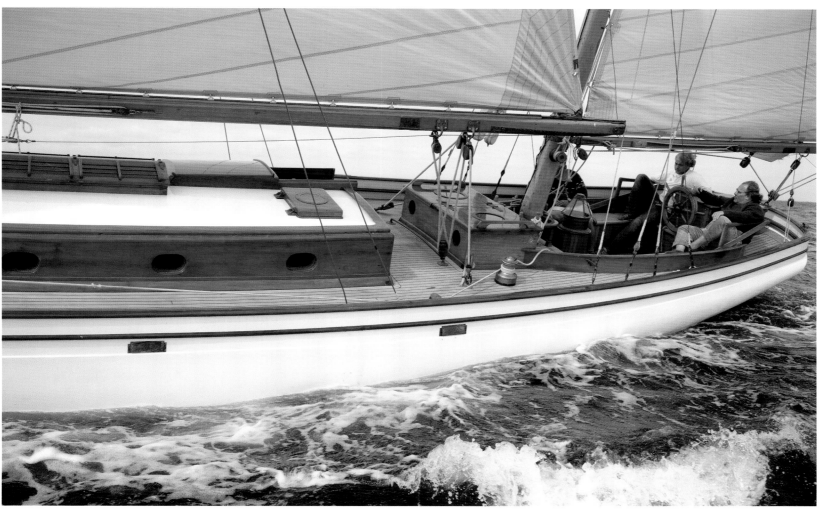

133

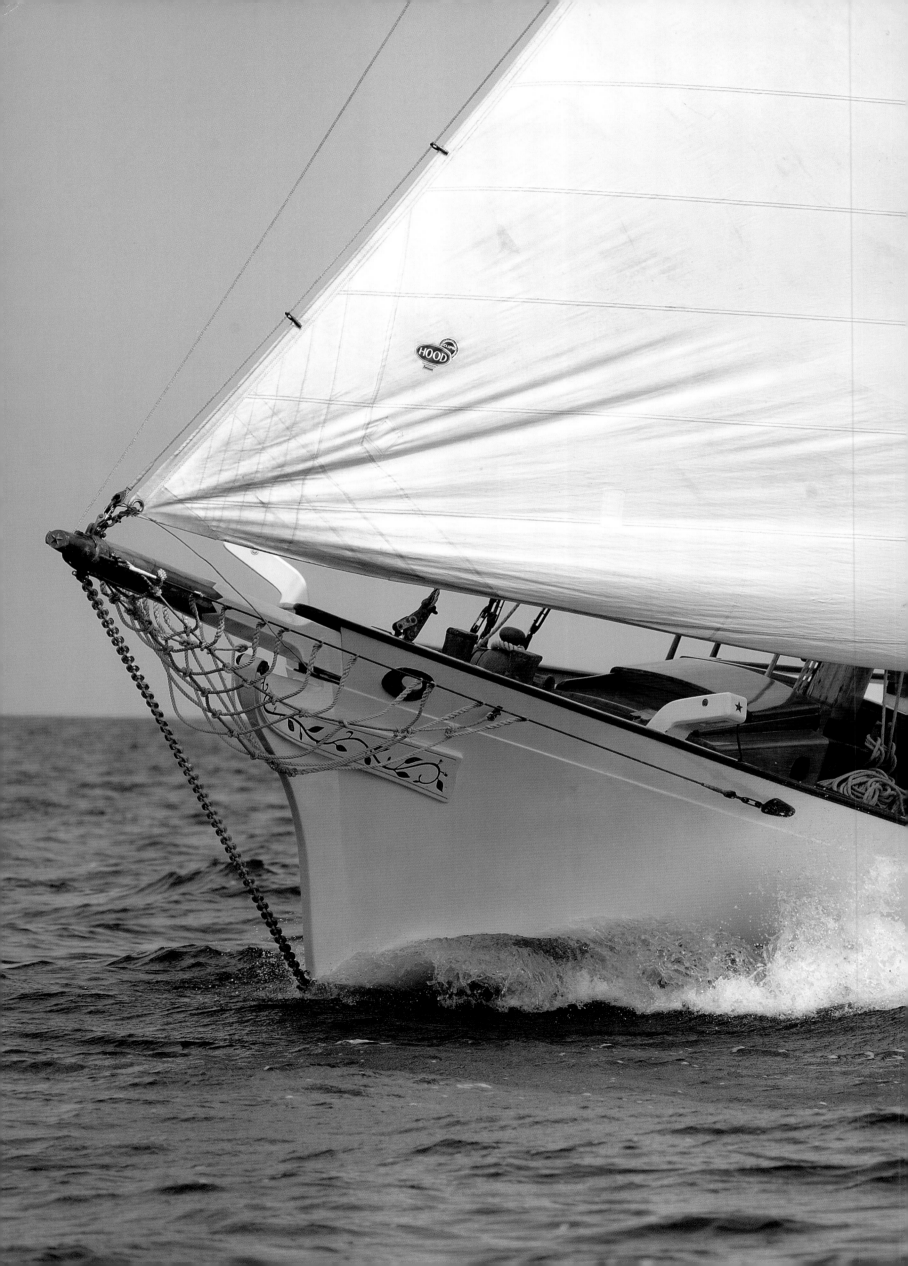

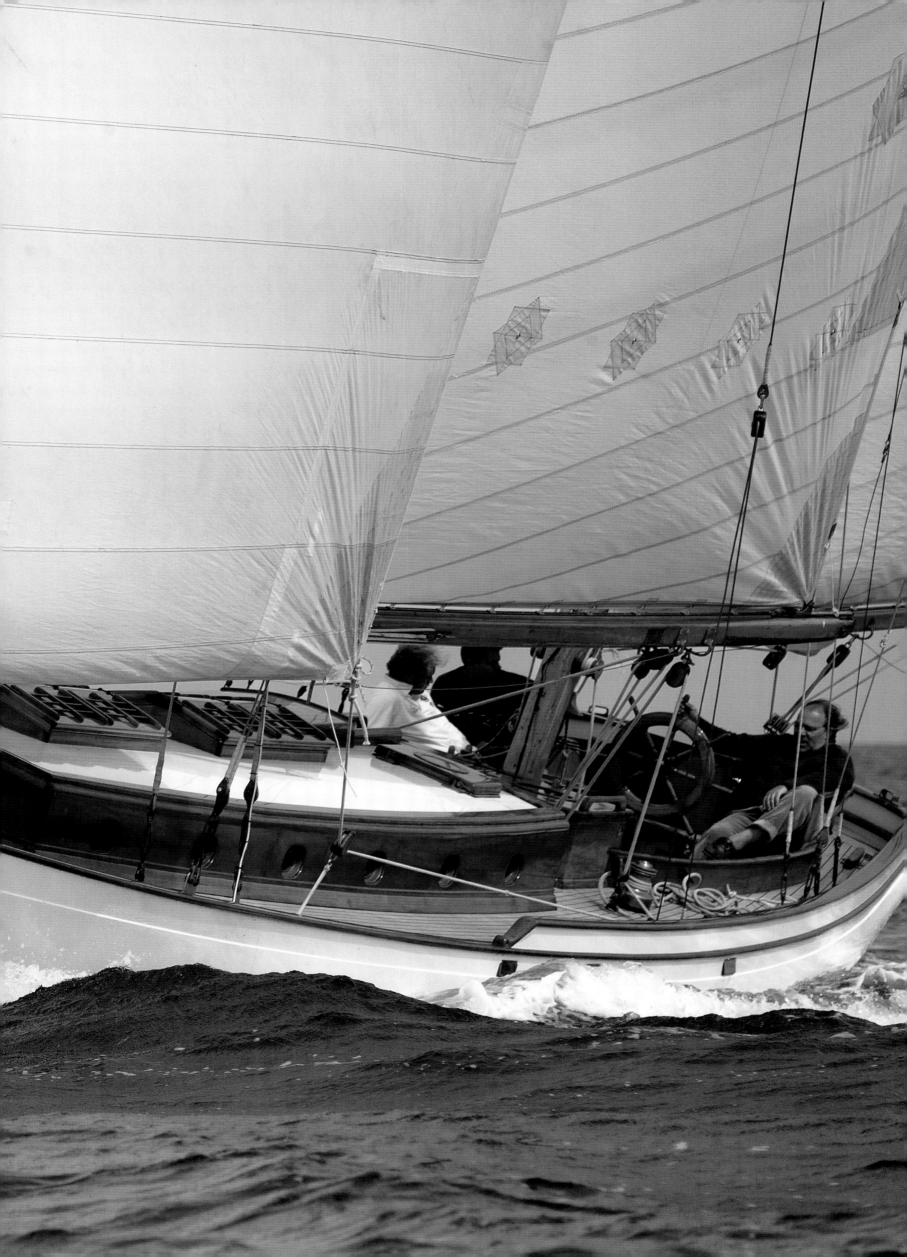

Rugosa

Year of construction	1925	
Length overall	65ft 11in	(20.1m)
Length on deck	59ft	(18m)
Length of waterline	40ft	(12.2m)
Beam	14ft 6in	(4.42m)
Draught	8ft 2in	(2.5m)
Sail area	2421sq ft	(225m²)
Designer	Nathanael Herreshoff	
Builder	Herreshoff Manufacturing Company	

Rugosa, correctly *Rugosa II*, was the second New York 40; a class intended to be more affordable and manageable than the 50-footers. In 1916 Herreshoff offered the NY 40 for $10,000, approximately $180,000 today.

THIS PAGE *Halsey Herreshoff began a long restoration in 1976. He even replaced the steering column, though retained the original wheel.* RUGOSA *is kept in Bristol, Rhode Island.*

FAR RIGHT *In 2001, on the occasion of the 150th America's Cup Jubilee, Halsey Herreshoff sailed* RUGOSA *to Cowes where he won the Vintage Class.*

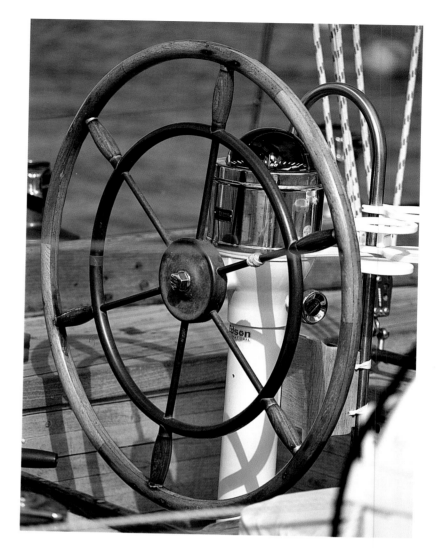

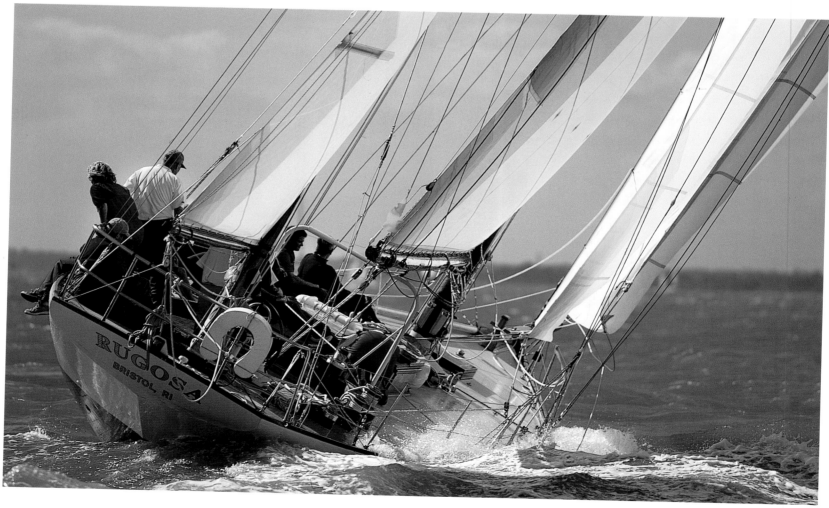

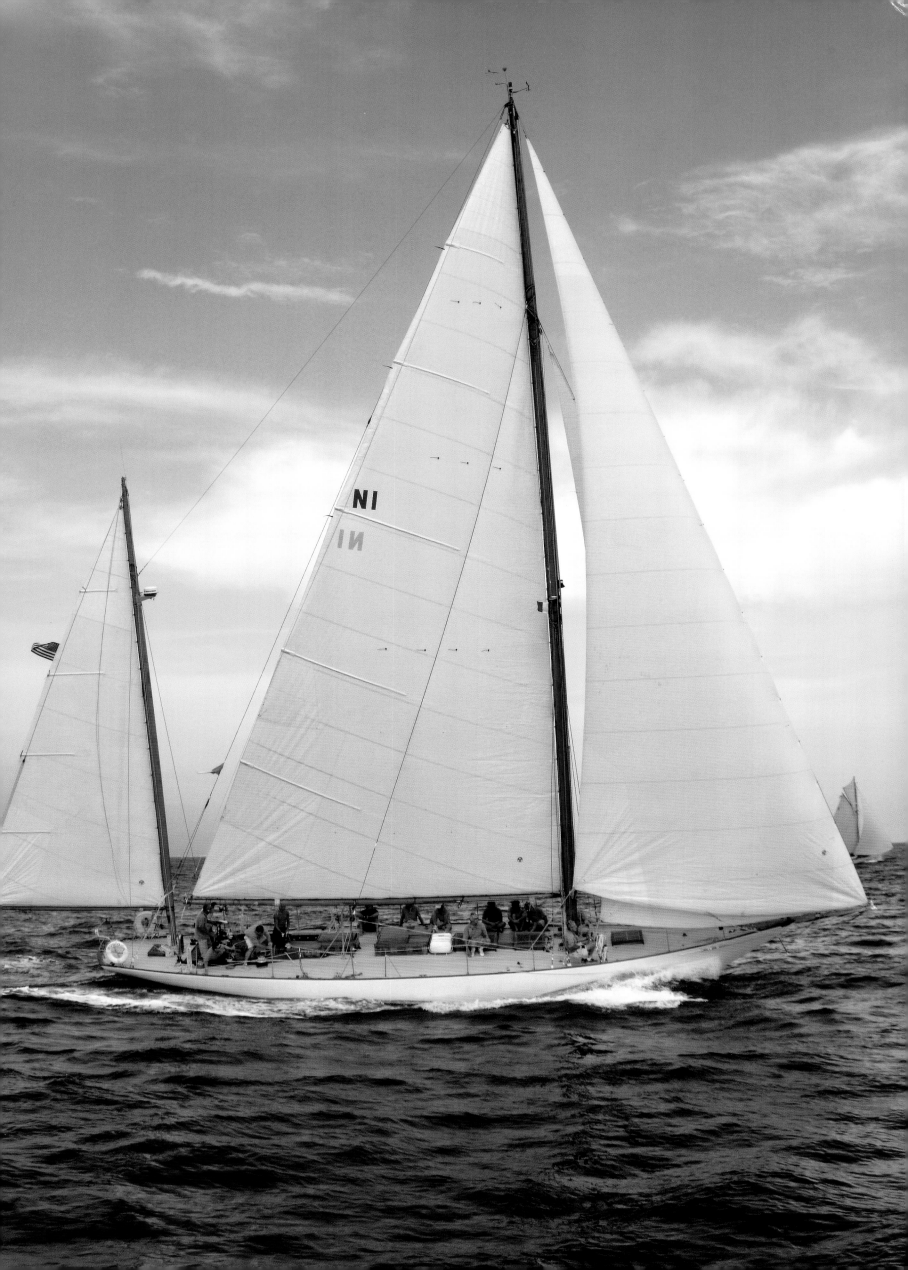

The production of twelve boats in the series began in October 1915. As with the NY 30s previously, Herreshoff produced three boats at a time in a workshop known as the North Shop. Also, like the NY 30s, the 40s proved to carry severe weather helm on trial sails, a problem which Herreshoff overcame by fitting a bowsprit. Over the next few years the design made its mark in many ocean races. In 1928, *Rugosa* won the Bermuda Race, rigged as a yawl with a Bermudan mainsail, a configuration which she still carries today. Her current rig came from the yawl *Katharina*, which was lost in a shipyard in Oyster Bay. Since 1976 *Rugosa* has been owned by Nathanael Herreshoff's grandson Halsey Herreshoff, director of the Herreshoff Marine Museum. He has already cruised her around the Baltic Sea as far as Helsinki.

THESE PAGES *These photographs show plenty of detail of the fittings and fixtures currently in place on* RUGOSA. *This New York 40's forepeak only contains sail lockers. Leecloths secure belongings – or sleeping crew – in the pilot berths.*

FOLLOWING DOUBLE PAGE *Nearly every year Cap'n Nat Herreshoff's grandson Halsey sails* RUGOSA *in the America's Cup, the Fastnet and Bermuda Race Veterans' events.*

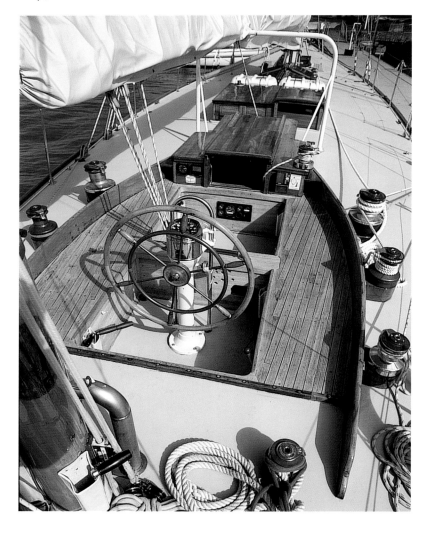

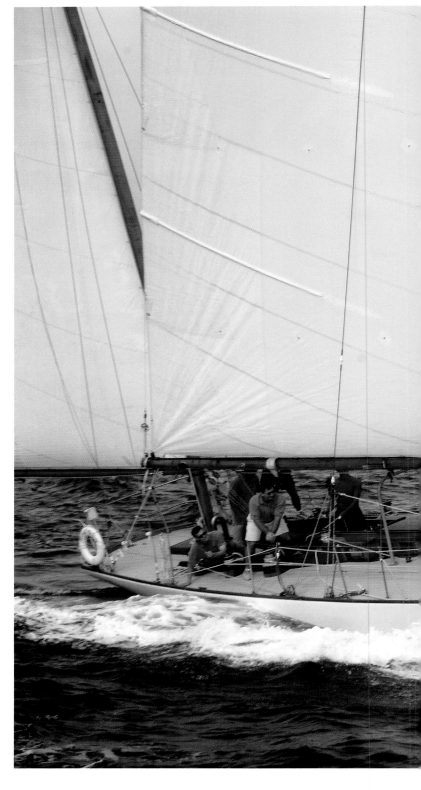

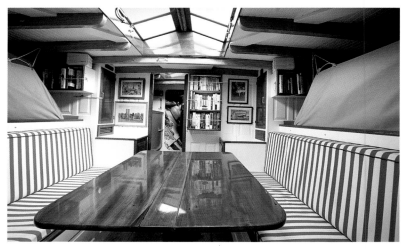

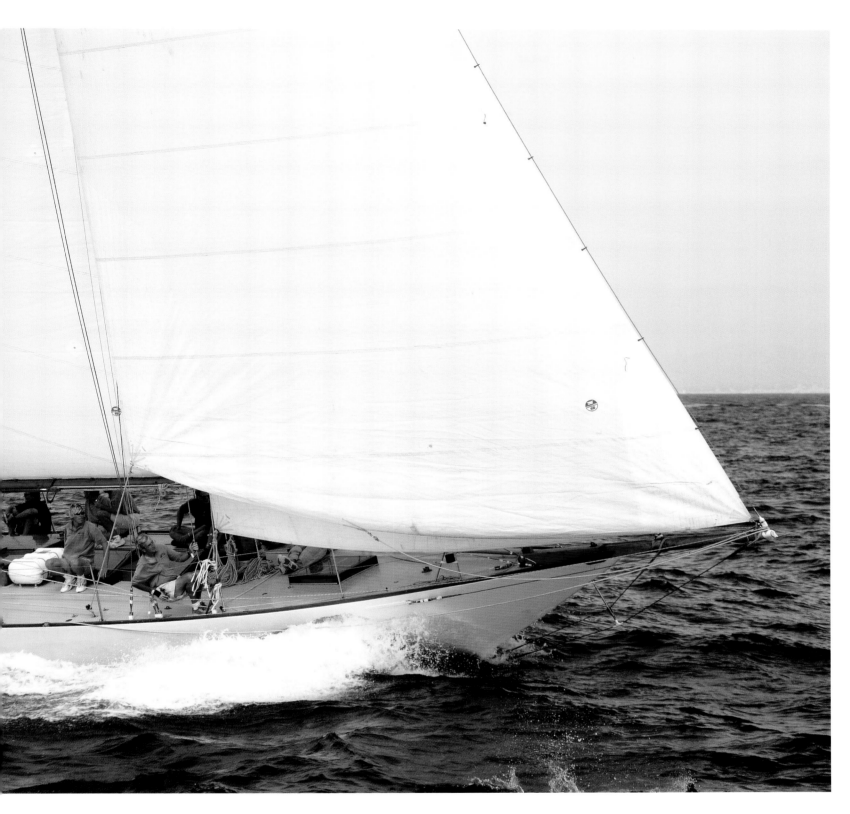

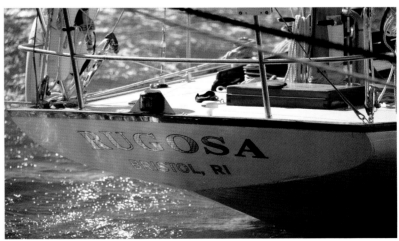

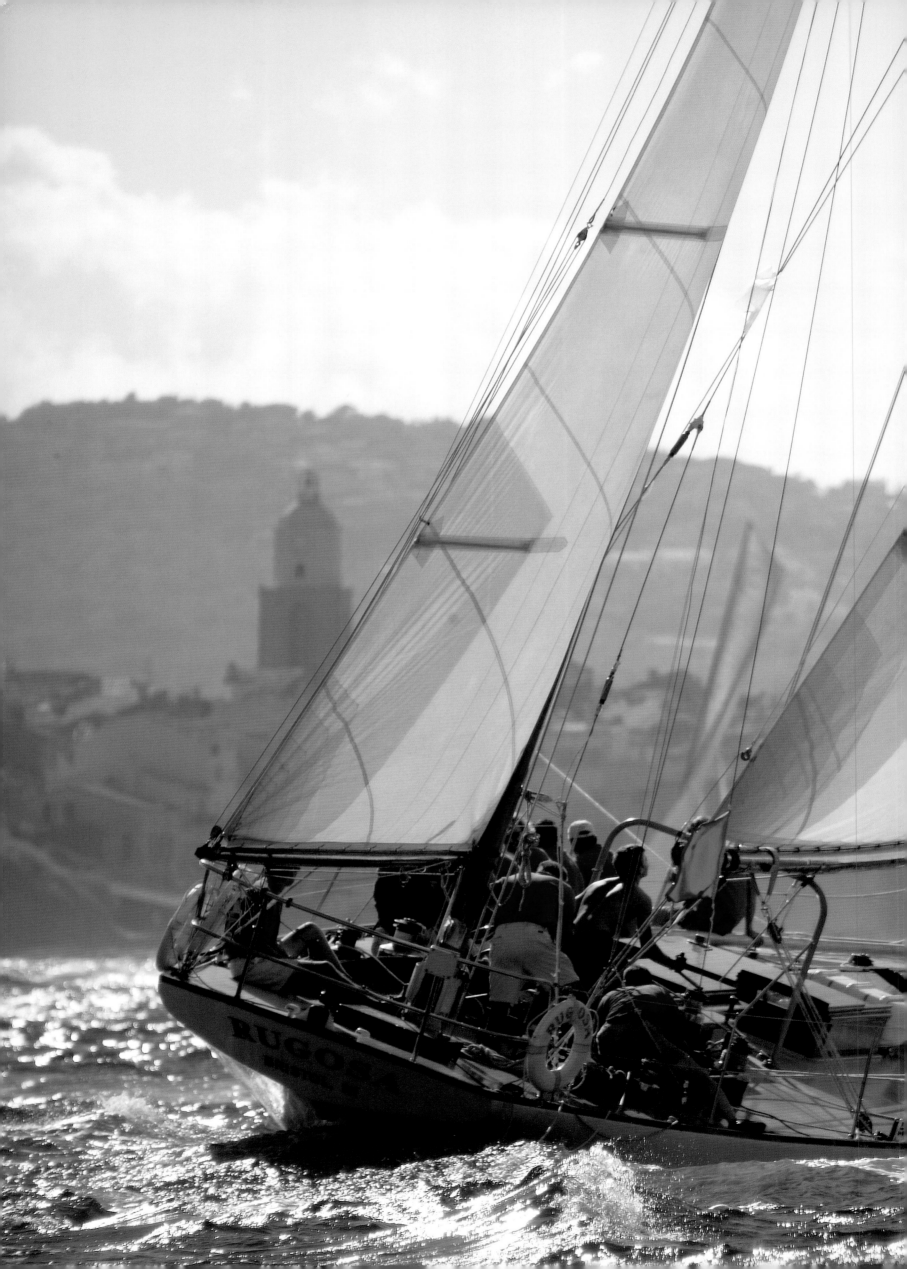

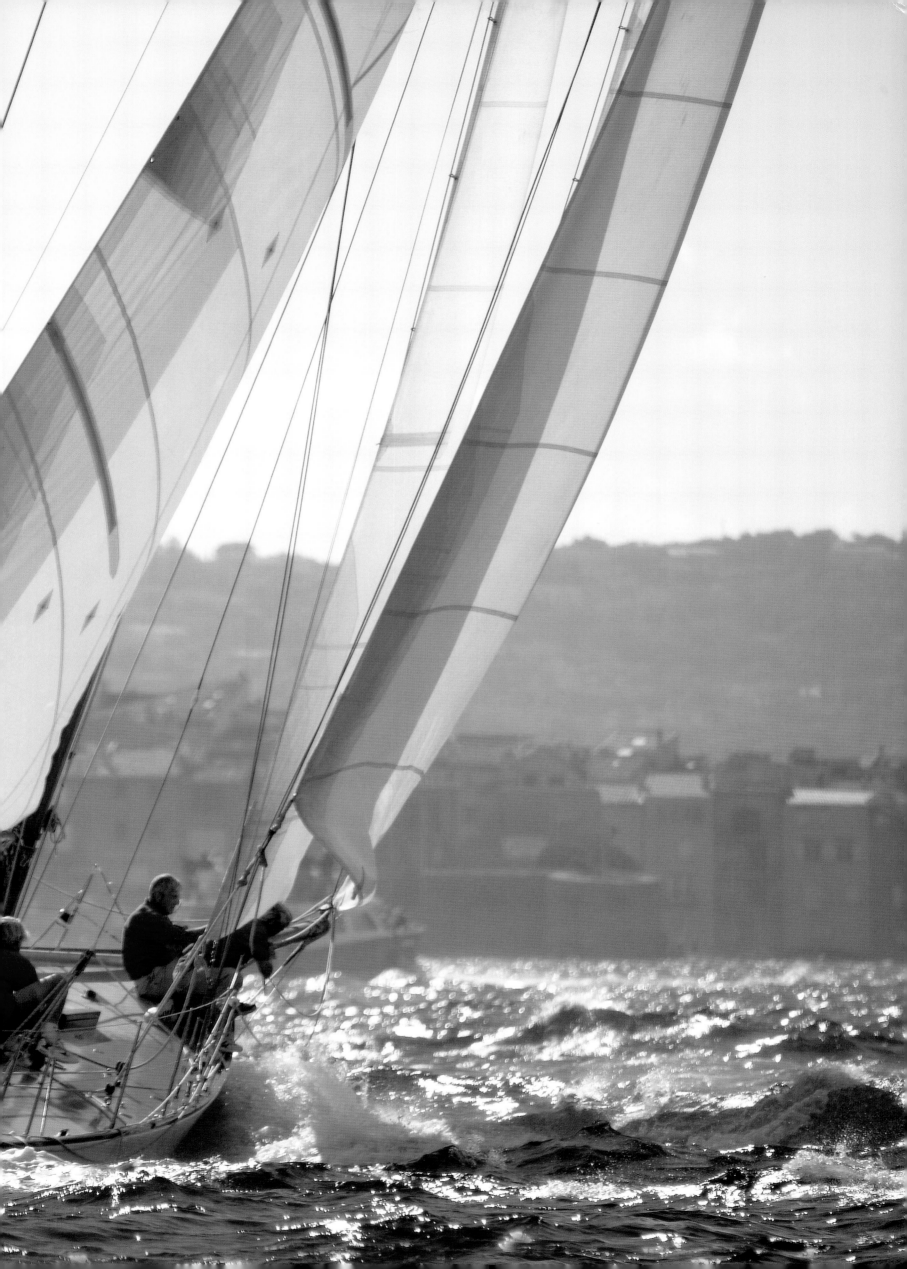

Ticonderoga

Year of construction	1936	
Length overall	85ft	(25.9m)
Length on deck	72ft	(21.9m)
Length of waterline	69ft 6in	(21.2m)
Beam	14ft 8in	(4.47m)
Draught	7ft 10in	(2.4m)
Sail area	2894sq ft	(269m²)
Designer	L Francis Herreshoff	
Builder	Quincy Adams Yacht Yard, Quincy, Massachusetts	

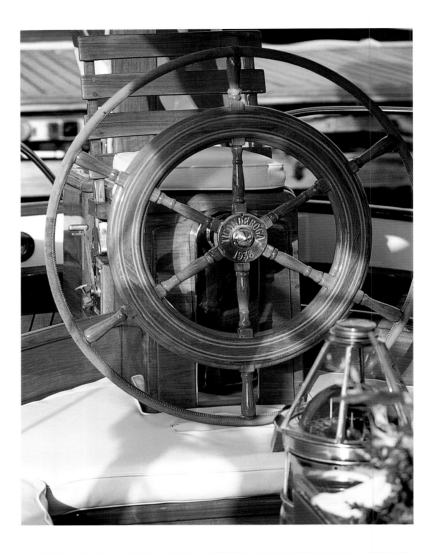

The story of *Ticonderoga* began in 1931 with the commissioning of *Tioga*, measuring 57 feet (17.5 metres) on deck and the forerunner of *Bounty*. Lewis Francis Herreshoff designed *Tioga* (named after an Iroquois word for 'fast runner') for the pilot Waldo H Brown, who participated in the project and put forward many ideas. Shortly afterwards, Harry E Noyes ordered the larger *Tioga II*.

Owner and designer had unending disputes during the construction of the 72-foot (21.9 metre) *Tioga II*. Noyes wished for a day-sailer and coastal cruiser, but he got a yacht capable of taking part in ocean races. Herreshoff concentrated on beauty and tried to ignore the rating rules, but even so, the long keeler's underwater lines were extremely effective. In 1936 the Quincy Adams Yacht Yard delivered *Tioga II* to her owner, who began to race her and won 24 of her first 37 starts. After the war, during which she was requisitioned for the Coast Guard, a new owner renamed her *Ticonderoga* (also an Iroquois word which meant 'between the lakes'). Her successful racing career continued. Since 1968 she has sailed as a charter yacht for a new owner. After the problems with *Ticonderoga*'s first owner, Lewis Francis decided not to accept any more commissions for large yachts and signed off his team.

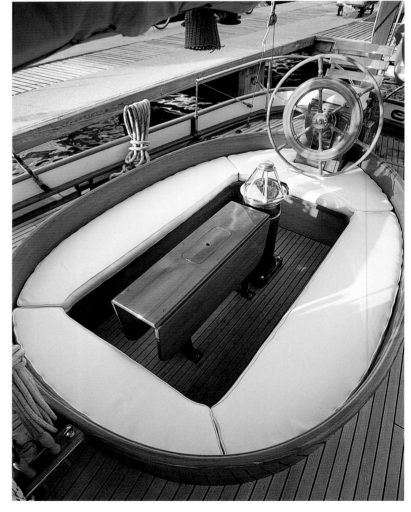

THESE PAGES *Southampton Yacht Services handled the latest refit of the 72-foot ketch, which was almost a restoration. The experienced shipyard replaced the deck and cockpit. Among Lewis Francis Herreshoff's ideas was the helmsman's seat aft of the wheel.*

The shipyard renovated the hull and replaced the deck completely. The new planking was of African mahogany, fastened by bronze screws and resin. Her rudder is of teak.

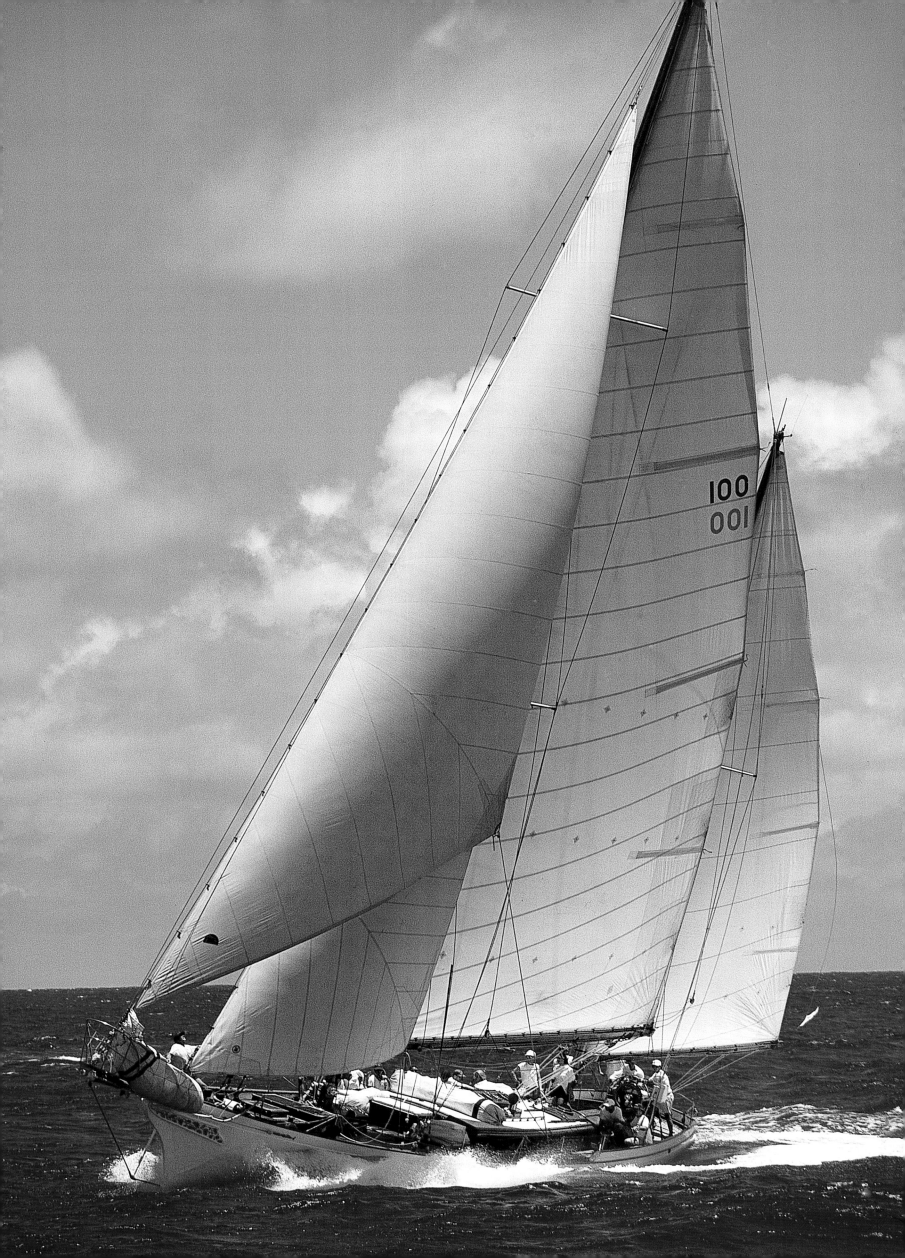

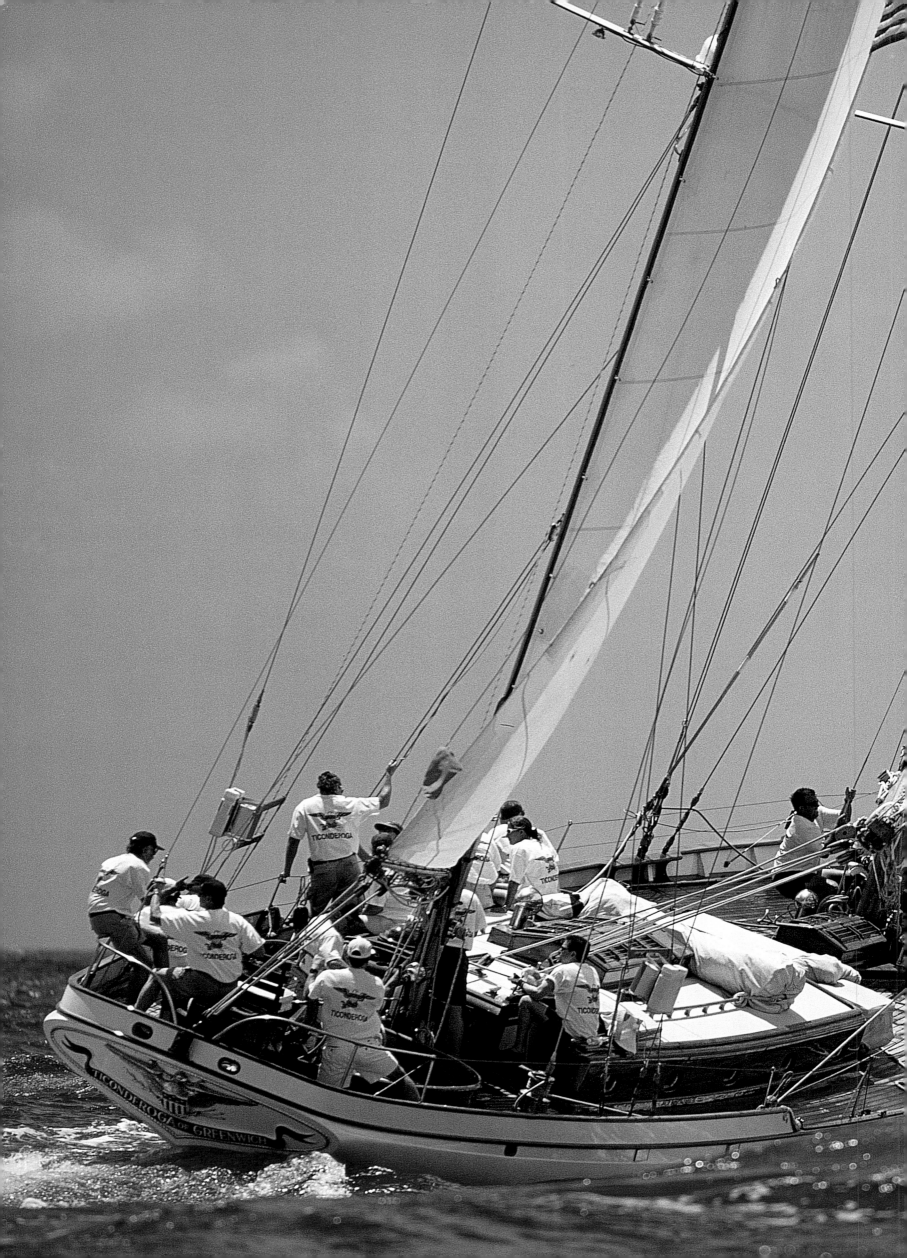

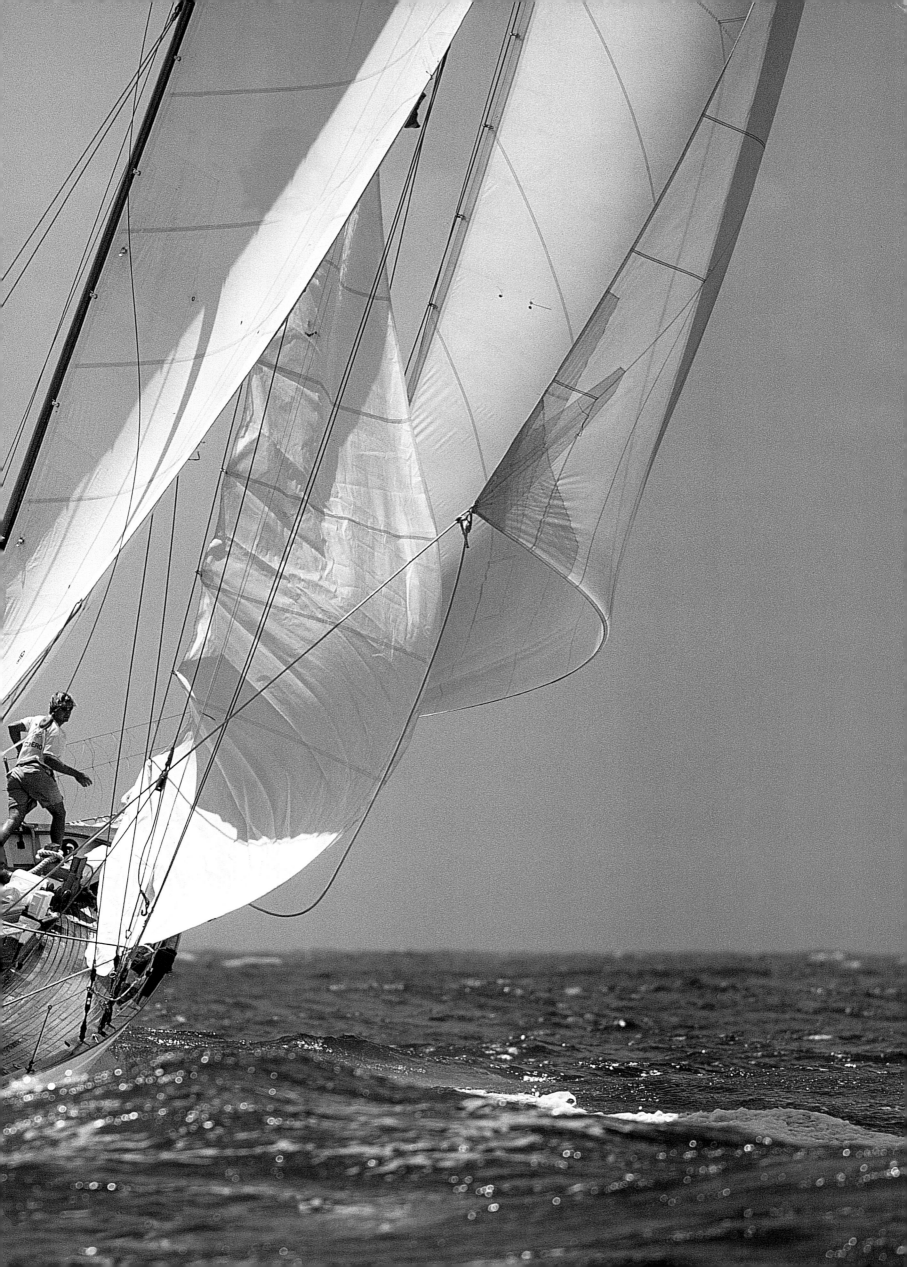

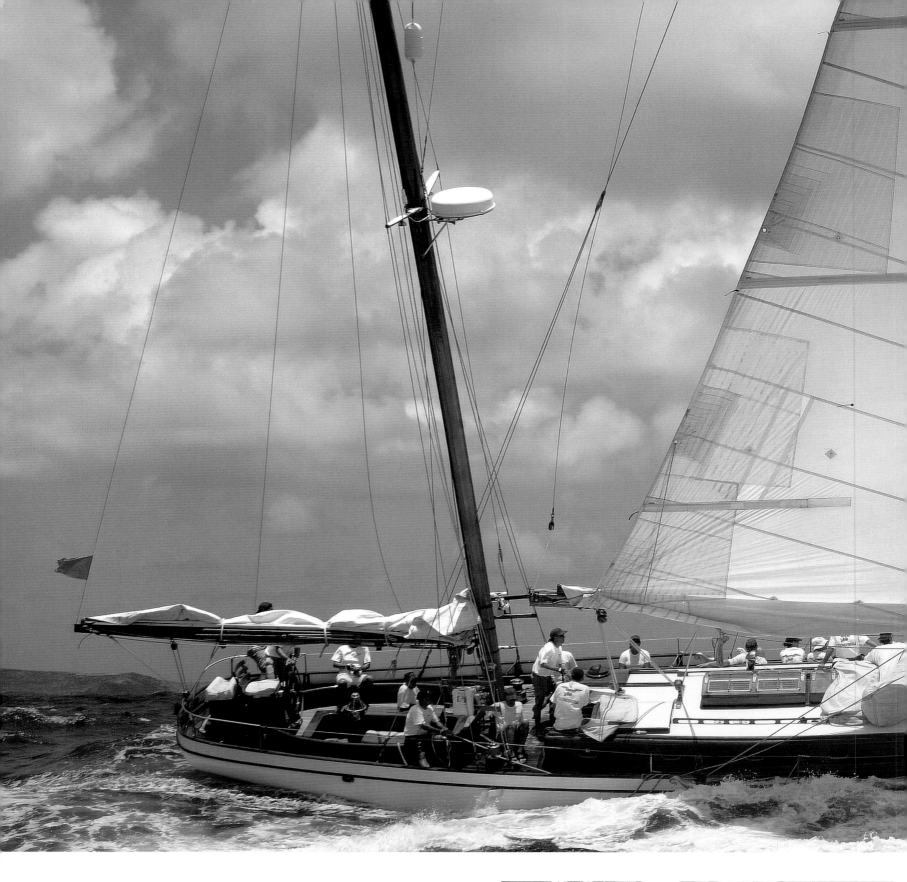

PREVIOUS DOUBLE PAGE *Ticonderoga's team hard at work trimming her sails to generate as much speed as the veteran yacht can deliver. Her stern is decorated with the American eagle and laurel leaves.*

ABOVE *Since 1936* Ticonderoga *has sailed throughout the world and set racing records in many events.*

RIGHT *The order for the interior renovation went to John Munford. This English boatbuilder, based in Southampton, is an expert at creating mahogany interiors in the style of a gentlemen's club. The owner had specified gold-plated fittings below, other than in the galley and heads.*

FOLLOWING DOUBLE PAGE Ticonderoga'*s clipper bow is often in the lead as she crosses the finishing line.*

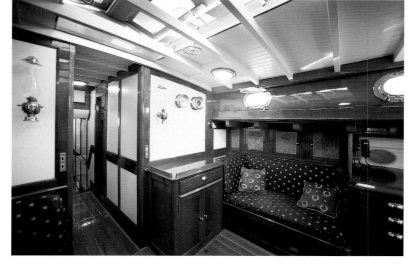

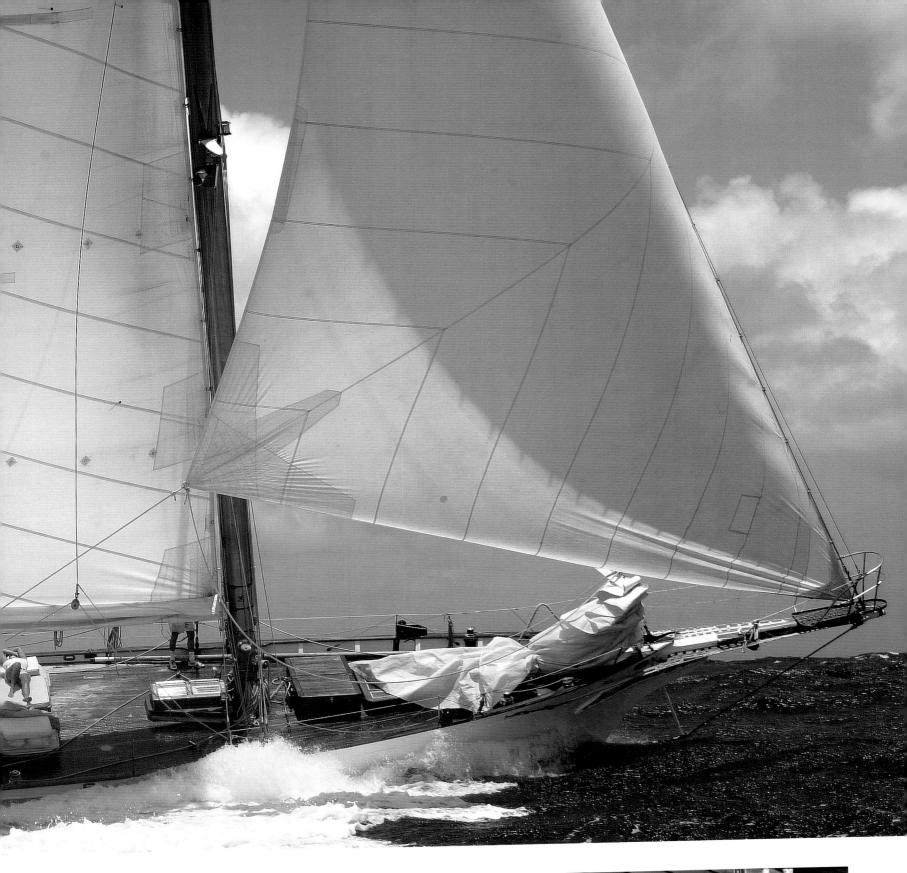

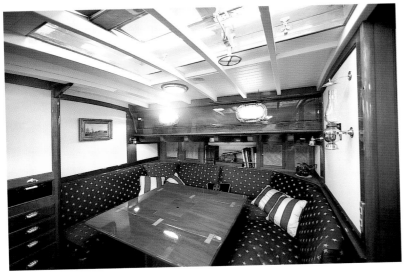

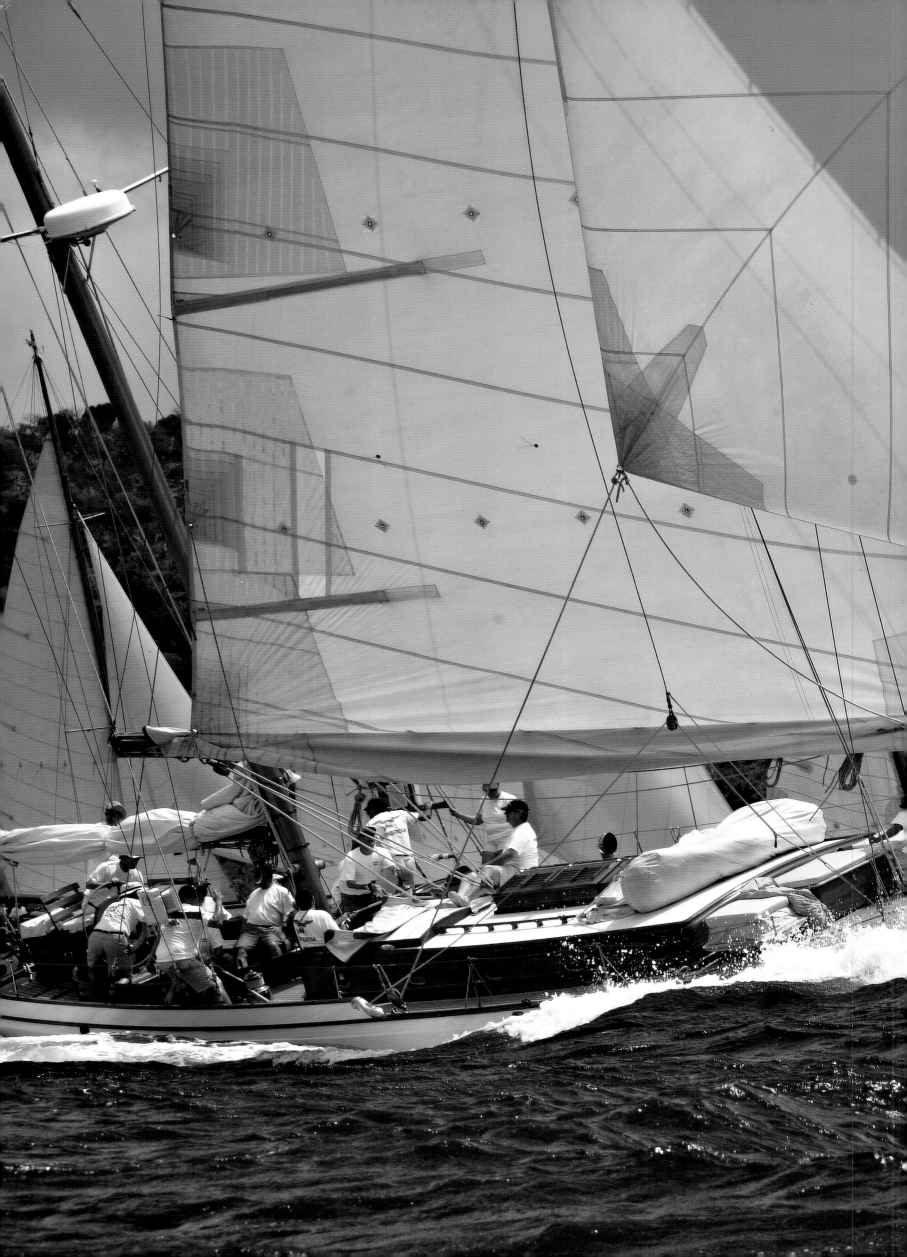

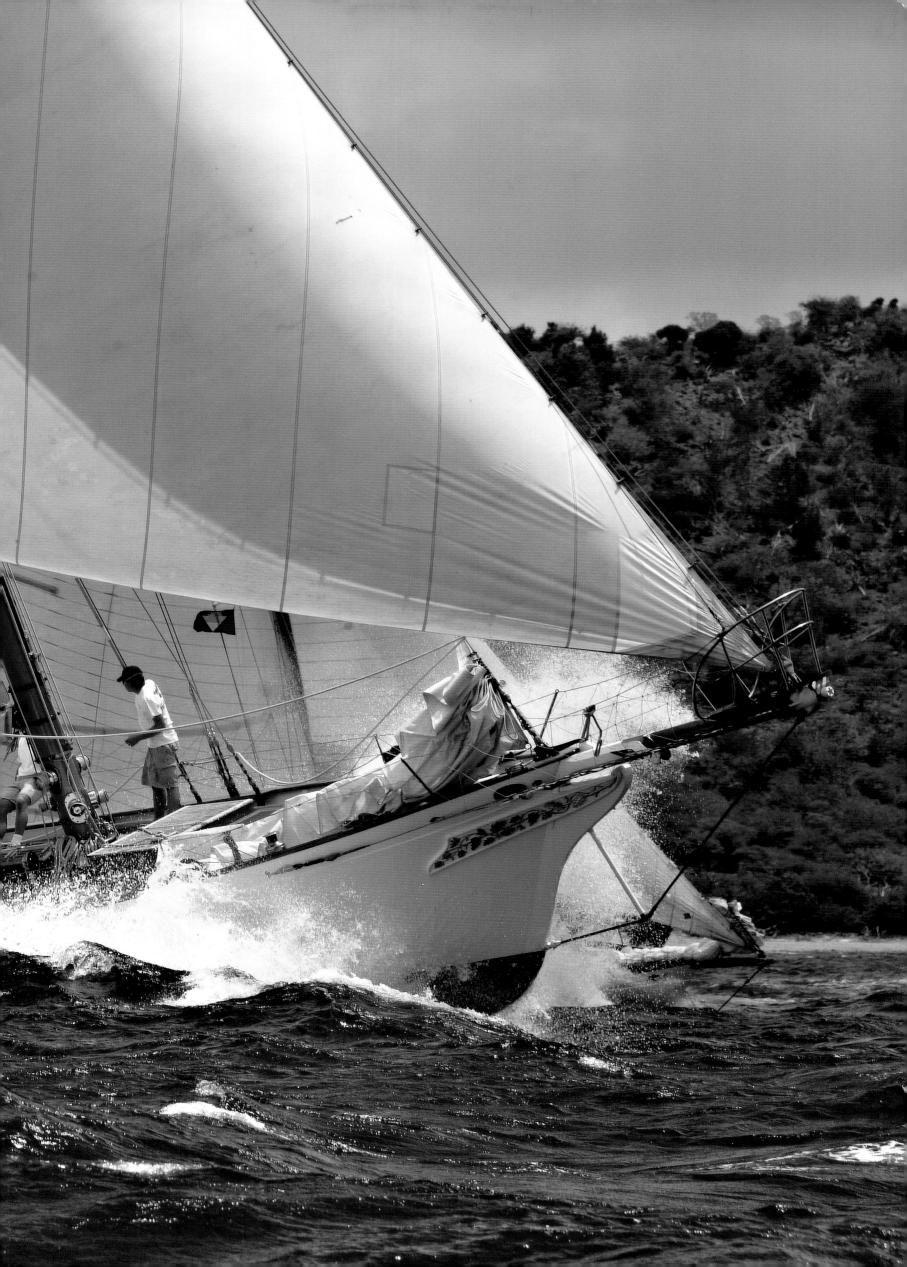

Small Boats

For many years the America's Cup was, without question, the main focus of the New York Yacht Club, due to the number of club members who ordered new yachts for its defence. Success in this prestigious racing event was, in the early days, largely inspired by the genius of Nathanael Herreshoff who designed and built many the competing yachts at his shipyard.

But one must not forget that, in addition to the commissions for large and medium-sized racing classes, he also designed small boats. In the 1880s and 1890s the yard was busy with such orders. Even as a child, Herreshoff had begun to take an interest in boat design and at the age of 11 he copied the lines from the model of a 20-foot catboat which his elder brother John Brown and his father had designed. In 1859 the brothers built the *Sprite*, Nathanael Herreshoff's first boat, assisted by a nearby boatbuilder. She has survived and today is on display in the Herreshoff Marine Museum – the oldest American catboat in existence. In 1874, together with his elder brother Lewis, he built the 17-foot sloop *Riviera* in the south of France and together they cruised several European rivers and canals. Herreshoff never lost his enjoyment of these small boats which he sailed at weekends off Rhode Island together with his friends and family.

His Buzzards Bay 15, which measures 24 feet (7.3 metres) on deck, was named after a bay south of Massachusetts. It was his second one-design class, following the Newport 30 of 1895, and became very popular. The long keel with 2 feet 4 inches (70 centimetres) of draught was supplemented by a centreboard for a better closehauled sailing performance. In 1919 Herreshoff began building the very successful S Class (27 feet 6 inches [8.4 metres]), his first boat designed with a Bermudan rig. In 1941, four years before it closed, the shipyard built the last S Class boat. However, his most successful one-design class was the little Buzzards Bay 12½.

THESE PAGES *Emma, now kept in Newport, is a rare survivor of the Buzzards Bay 15 one-design class, and was built in 1899.*

Also known as the E Class, the Buzzards Bay 15 is 24 feet (7.3 metres) on deck. The '15' refers to the waterline length. In 1899 she cost $700.

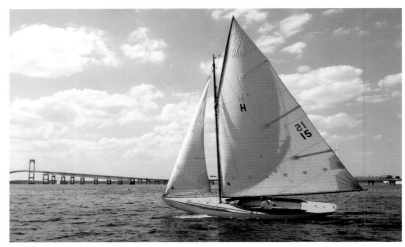

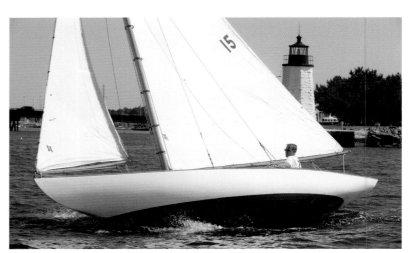

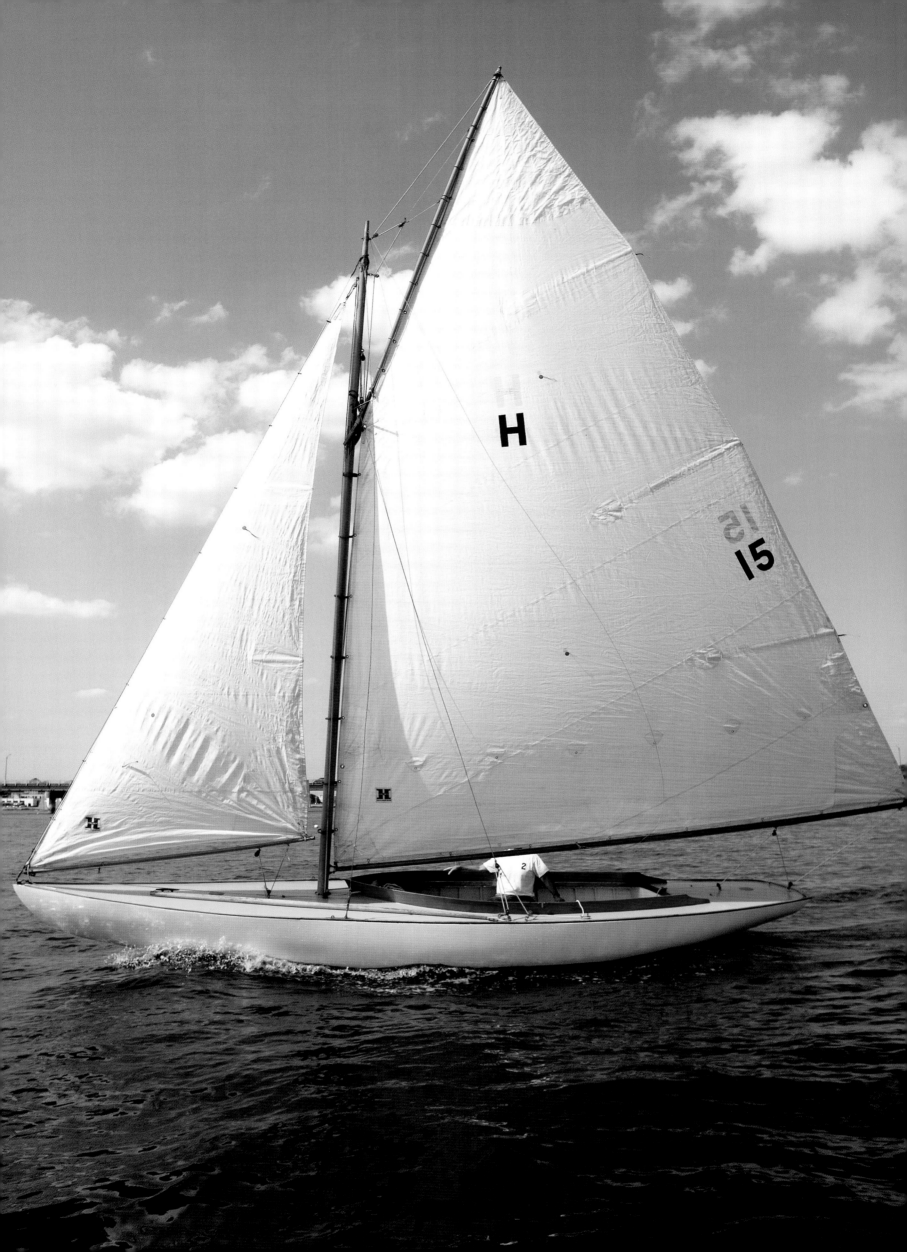

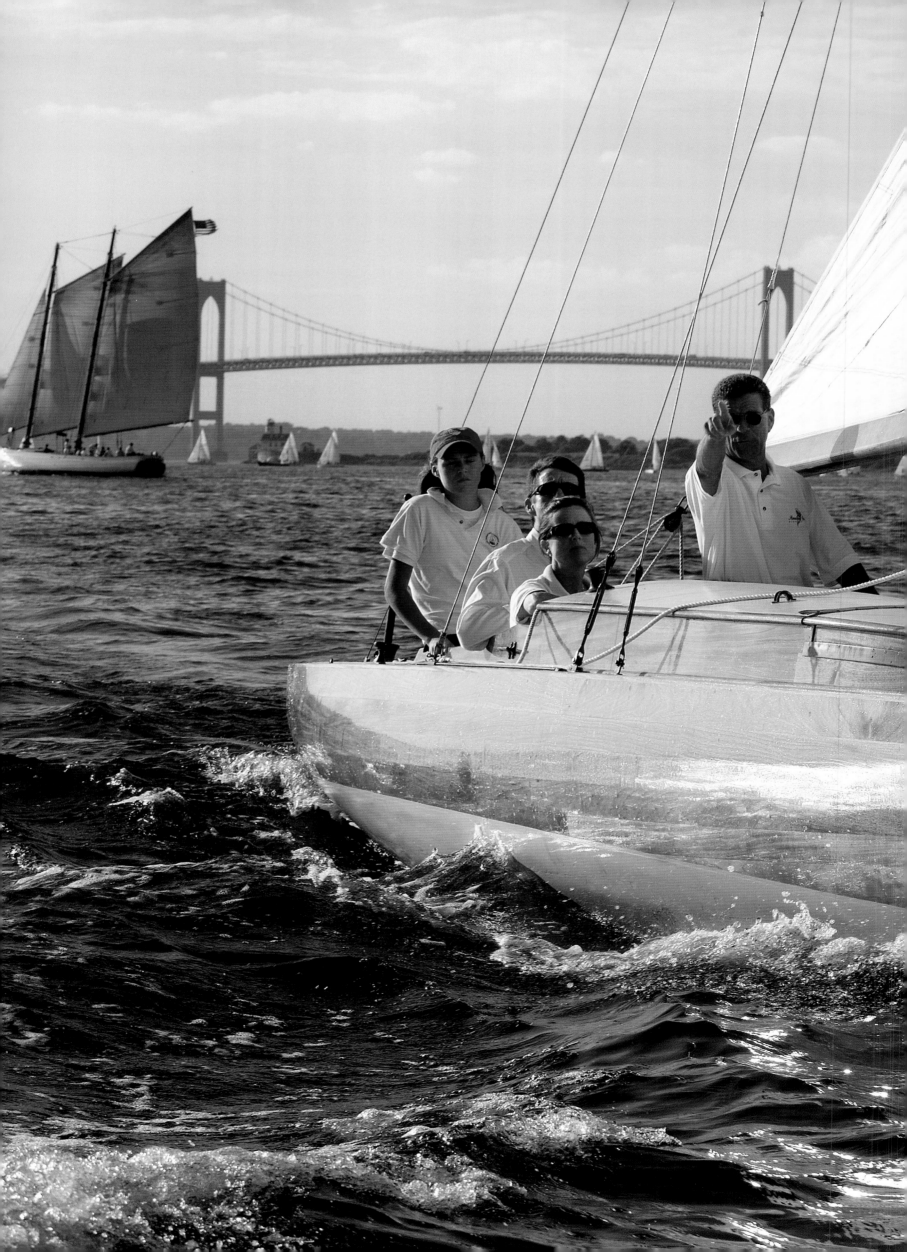

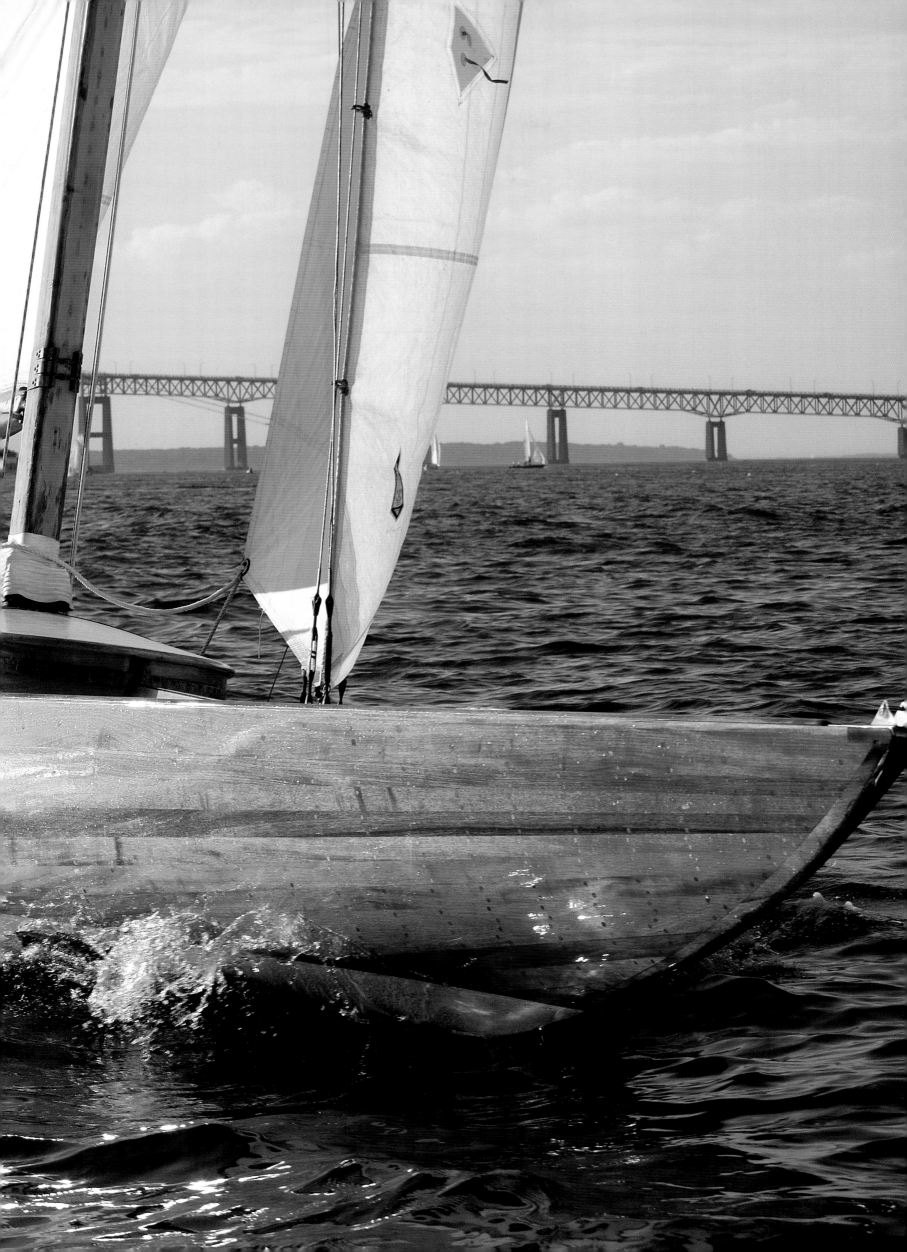

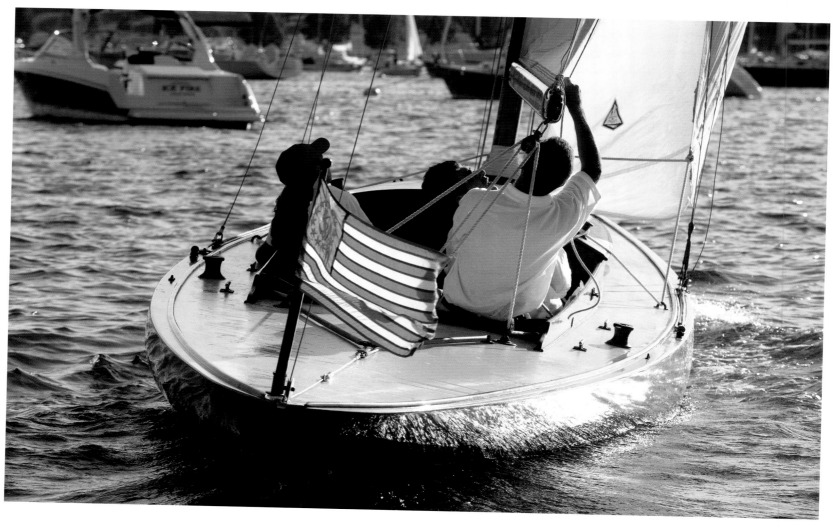

PREVIOUS DOUBLE PAGE AND THIS PAGE *Oriole II is on display in the Newport Museum of Yachting. The lines of the 39-foot sloop were drawn by Lewis Francis Herreshoff in 1930 as the successor to the skerry cruiser Oriole.*

With her extremely long stern overhang and – in relation to her length – small sail area, Oriole II is a typical example of her class.

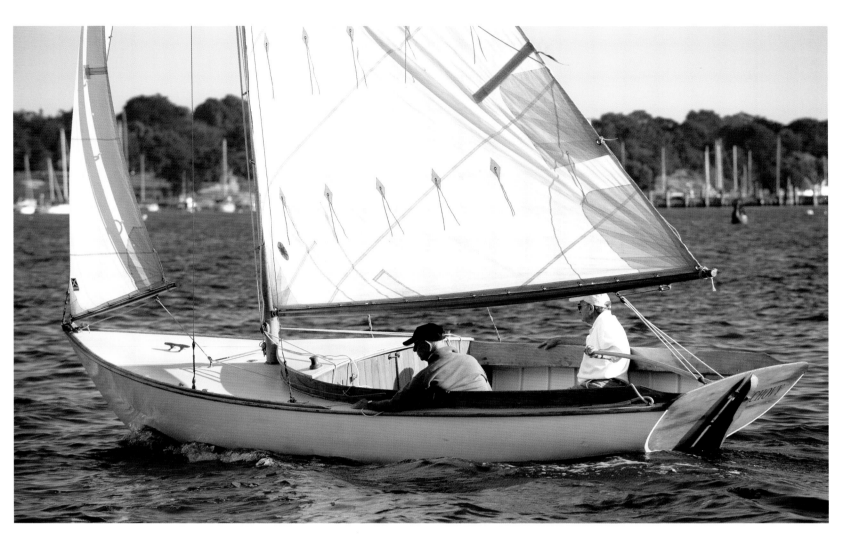

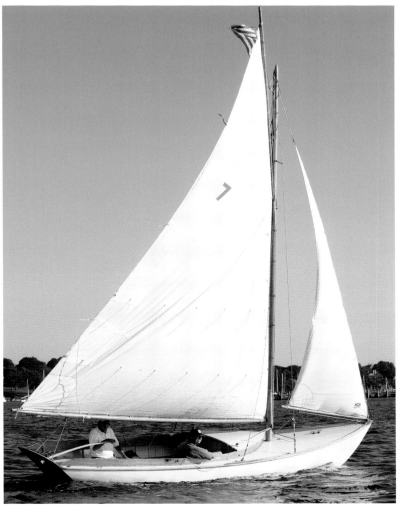

ANCHOVY *is one of the Fish Class. Herreshoff based her design on the Buzzards Bay 12½, his most successful one-design class.* ANCHOVY *is on display in the Museum of Yachting in Newport.*

In 1916 the Herreshoff Manufacturing Company delivered 22 Fish Class boats to the Seawanhaka Corinthian Yacht Club. The price per boat was $875.

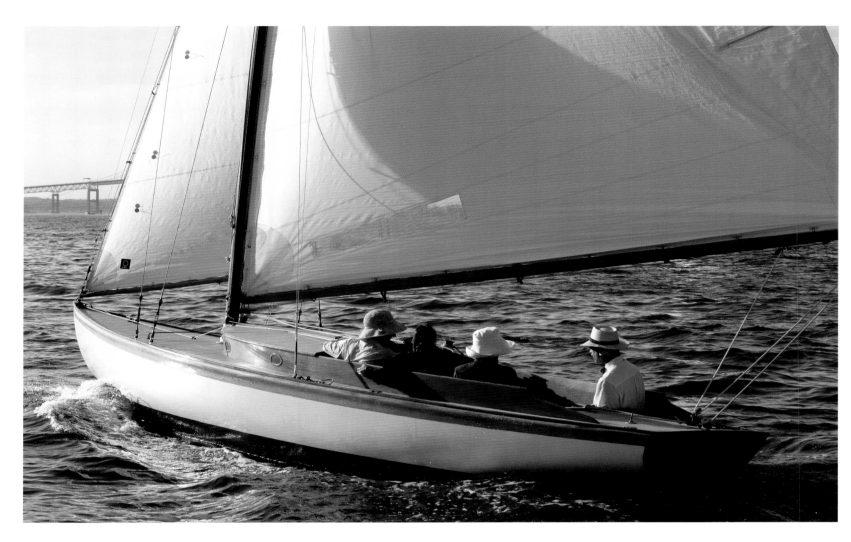

In 1920 the S Class appeared off Newport. It was the first time that Herreshoff, then aged 71, had designed a class with Bermudan rig. The S Class has a ⁵/₈th rig, only setting mainsail, self-tacking jib and spinnaker. She has a 57 per cent ballast ratio, a high coefficient even for a Herreshoff design. Several fleets still race regularly off New England.

RIGHT *The main boom of the S Class overhangs the transom, allowing the boat to carry a huge mainsail for good speed off the wind.*

FOLLOWING DOUBLE PAGE *At 33 feet (10 metres), ARAMINTA is the smallest ketch with a clipper bow designed by Lewis Francis Herreshoff; it is said to have been his favourite design.*

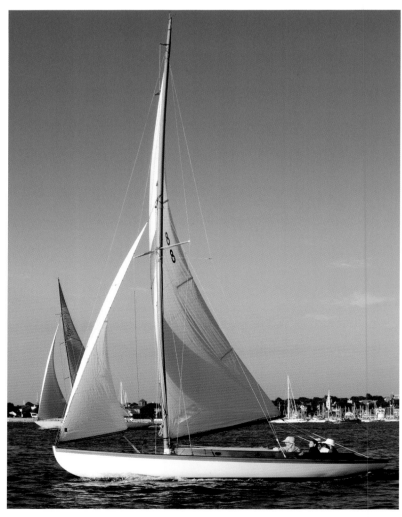

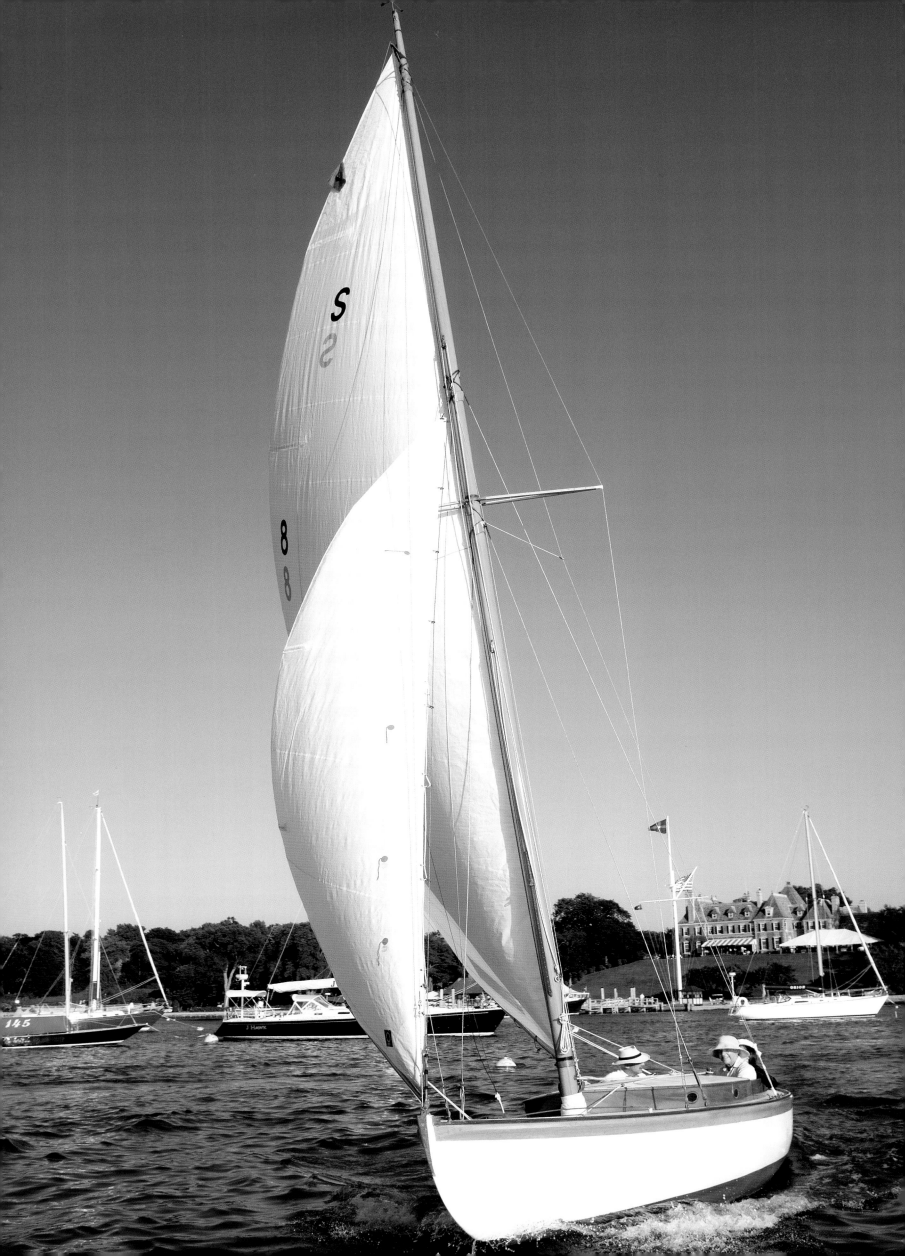

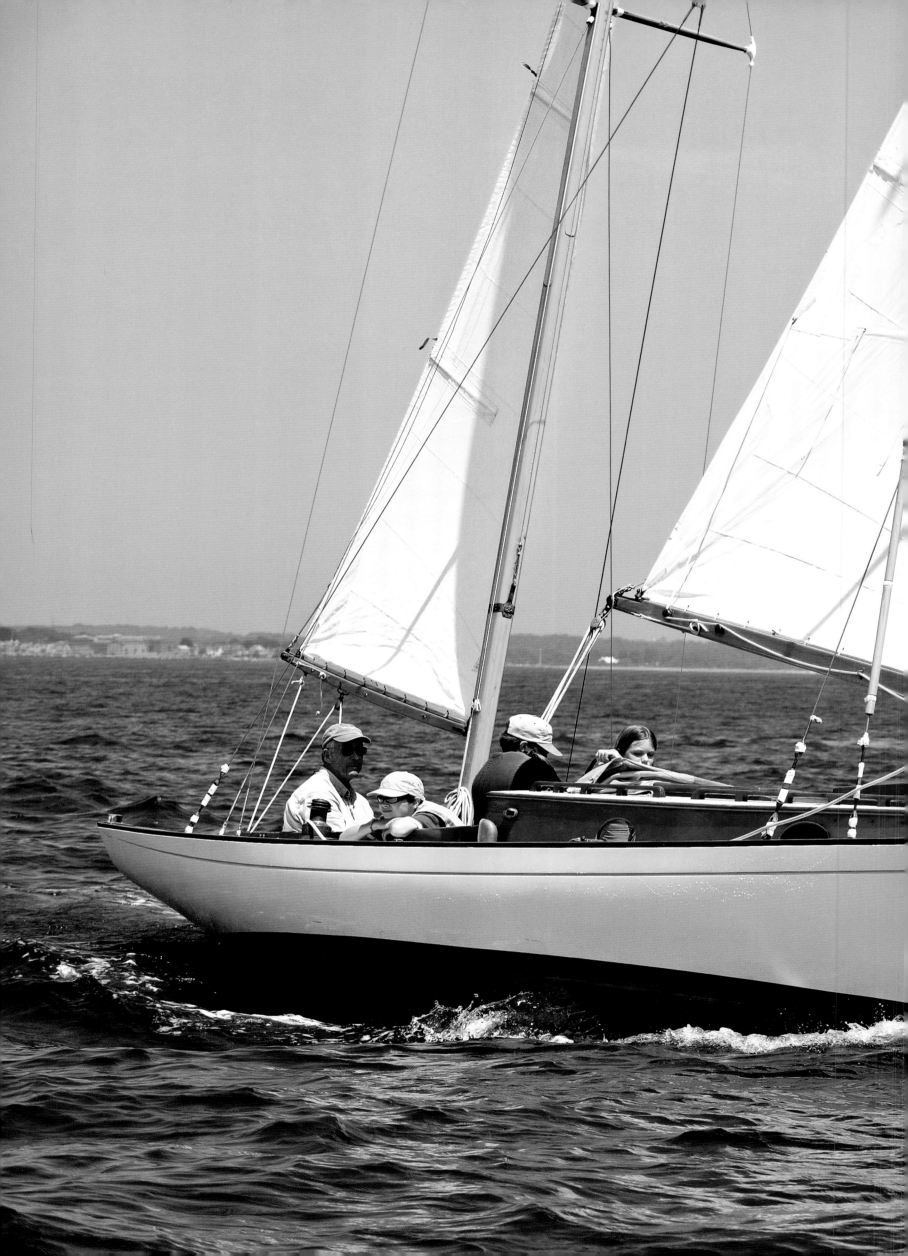

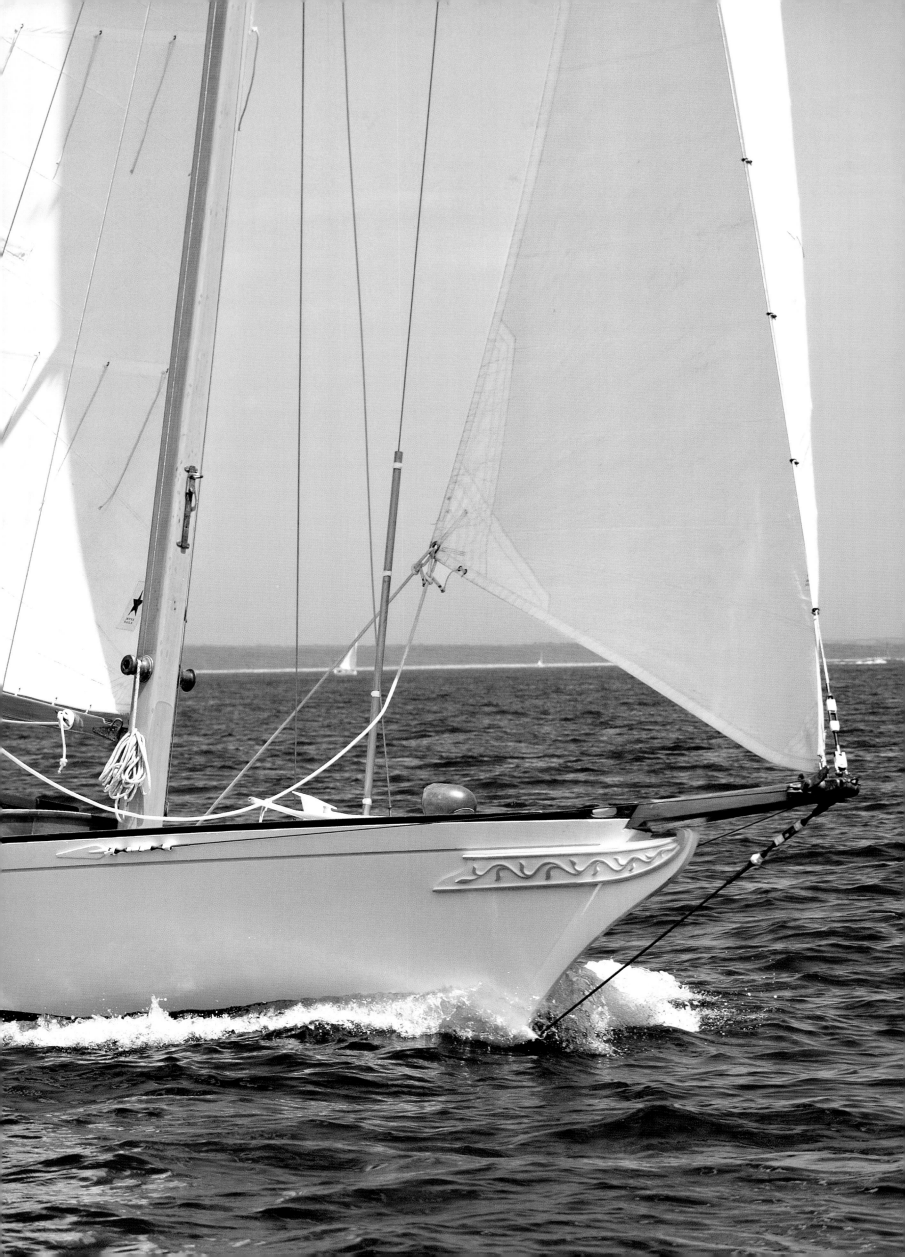

Index of Yachts